Brochures 4

An International Compilation of Brochure Design
Broschürendesign im internationalen Überblick
Une compilation internationale sur le design des brochures

CEO & Creative Director: B. Martin Pedersen

Publisher: Doug Wolske
Publications Director: Michael Gerbino

Editors: Andrea Birnbaum, Michael Porciello
and Heinke Jenssen

Art Director: Lauren Slutsky
Design & Production: Joseph Liotta
and Nicole Recchia

Published by Graphis Inc.

(opposite: Brochure design by Jennifer Sterling Design for David Maisel)

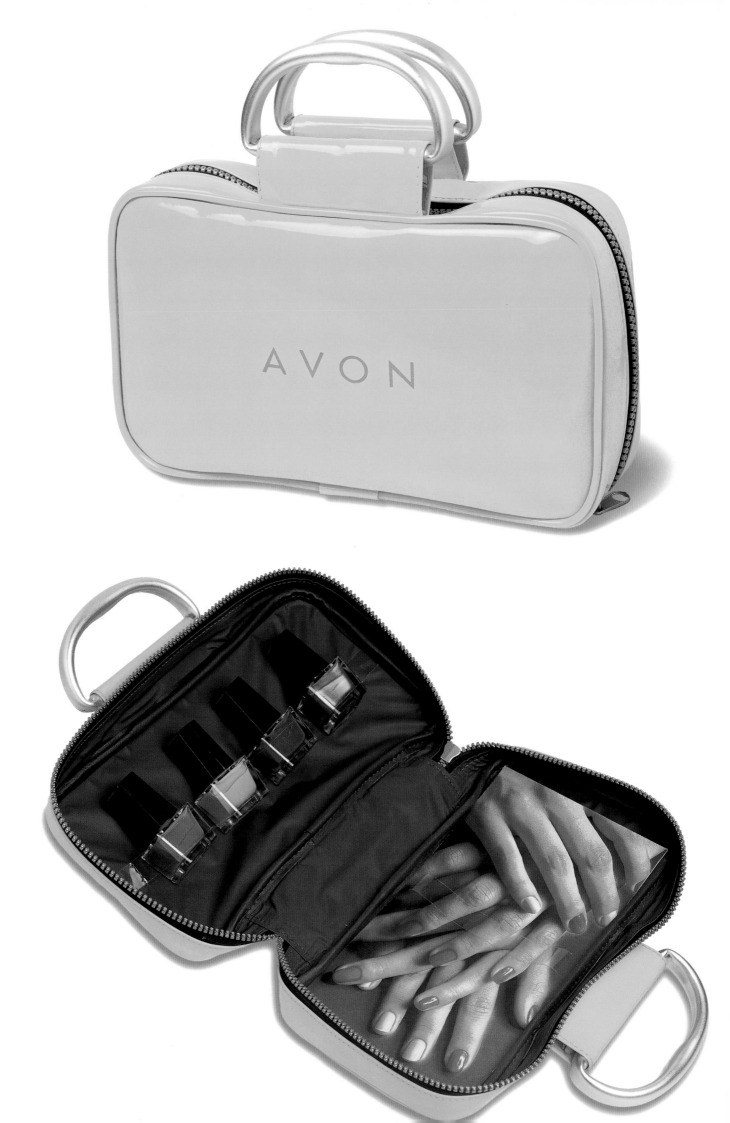

ContentsInhaltSommaire

Remarks: We extend our heartfelt thanks to contributors throughout the world who have made it possible to publish a wide and international spectrum of the best work in this field. Entry instructions for all Graphis Books may be requested from: Graphis Inc., 307 Fifth Avenue, Tenth Floor, New York, NY 10016, or visit our Web site at www.graphis.com. Anmerkungen: Unser Dank gilt den Einsendern aus aller Welt, die es uns ermöglicht haben, ein breites, internationales Spektrum der besten Arbeiten zu veröffentlichen. Teilnahmebedingungen für die Graphis-Bücher sind erhältlich bei: Graphis Inc., 307 Fifth Avenue, Tenth Floor, New York, NY 10016. Besuchen Sie uns im World Wide Web, www.graphis.com. Remerciements: Nous remercions les participants du monde entier qui ont rendu possible la publication de cet ouvrage offrant un panorama complet des meilleurs travaux. Les modalités d'inscription peuvent être obtenues auprès de: Graphis Inc., 307 Fifth Avenue, Tenth Floor, New York, NY 10016. Rendez-nous visite sur notre site web: www.graphis.com. © Copyright under universal copyright convention copyright © 2001 by Graphis Inc., 307 Fifth Avenue, Tenth Floor, New York, NY 10016. Jacket and book design copyright © 2001 by Graphis, Inc. No part of this book may be reproduced in any form without written permission of the publisher. ISBN: 1-888001-51-8. Printed in Hong Kong.

(opposite: Brochure design by ISSA D/A for Avon)

The brochure as a graphic typology in evolution by Garry Emery, Emery Vincent Design

Brochure: a small pamphlet; a booklet (from French brocher, to sew).

It is not difficult to see in its etymological derivation that the brochure shares its origins with the early pamphlet and handbill. The pamphlet, usually a political or partisan tract, was unbound and without a hard cover. The single sheet handbill, even more ephemeral, advertised the current theatrical play, sale of goods or forthcoming public execution. These documents were essentially typographic in character, although the satirical pamphlet might include cartoons. And each was essentially disposable.

The pamphlet and handbill continued to be useful, popular graphic typologies and retaining their essential characteristics of immediacy and transience. In modern times, Constructivist posters and handbills derived their visual impact from the stunning fusion of the emblematic power and meaning of letterforms, conveying the potency and urgency of political messages. In contrast with this objective to convey excitement and energy through typography, the Swiss typographers of post-World War II developed the most direct, rational, elegant methods to ensure clarity and legibility. These dual objectives—of visual impact on the one hand and legibility of information on the other—are contradictions central to the function of the brochure.

Today's brochure tends to be commercial rather than satirical or ideological. Its function is to convey precise technical information while inspiring desire for a particular product or experience. The two functions are at odds in terms of design. Information, much of it complex, demands legibility; but the projection of a seductive corporate or product image demands a more evocative, emotive manipulation of graphic elements. The designer of the brochure must satisfy both requirements, and also work within the exacting constraints of space and budget. Designing successful brochures is something like tightrope walking: maintaining a delicate balance is everything. Destined for the litterbin, even the most glamorous brochure is likely to be discarded as soon as its purpose is served.

Ephemeral in another way, a web site can be projected as a new sort of brochure. Much of the information conveyed on the screen is fleeting, expendable and experienced in real time. Click and it's gone.

Mass-produced, disposable, ephemeral: the brochure as a specific graphic typology is celebrated in the Graphis Brochures book. Graphis offers here an international snapshot of brochure design excellence. Given the wealth of different images and ideas, we could be forgiven for using this publication principally as a treasure trove. But its real value lies in recording the variety of current design discourses, and in promoting a critical reading of contemporary design. And in the back of our minds we carry a memory of the brochure as a functional type reaching back to the earliest days of printing and forward via the newest forms of media, a tradition in a continuing evolution.

The brochure, pamphlet, catalogue and booklet share the qualities of reduced size, comparative brevity, and the condensed graphic impact they need to generate in order to make their presence felt. I enjoy the booklet form. It allows me to experiment with book and typographic ideas without committing to the extended planning, writing and designing that go into making a book.

Emery Vincent Design's promotional booklets also allow us to produce mini-monographs on our work, concentrating on just a single area of interest or a specific service we offer. These little publications are more than a brochure, less than a book. *ci* and *idiom* prefigured our recent extensive monograph, *Emery Vincent Design* (Images Publishing). *ci*—corporate identity—contains an essay that explains the benefits and processes of a corporate identity program as well as examples of our work in this specialist field. *idiom*—the title suggesting a characteristic style or way of working—is a scrapbook of our graphic ideas. The intention with the booklet is to be impressionistic rather than didactic. In both of these instances, we were our own client, so we could make the result fit ideas that we particularly wanted to explore at that time.

Working closely with friends also grants us freedom to investigate design ideas formally. The catalogue for an exhibition by Susan Cohn, one of Australia's most eminent jewellery makers, is an occasion to collaborate with a designer we respect and to translate her design ethos into two-dimensional representation. Cohn's trademark, the doughnut bracelet form, becomes a graphic device that recurs throughout the catalogue. The bands of text are placed eccentrically, suggesting the whimsical and disruptive qualities of her work.

We work within a reinvented modernist design canon that values clarity and elegance as much as wit and waywardness. Always underpinning our design approach is a sense of the creative collision of the rational and the absurd, from which some new force emerges that could not have been anticipated. We design to discover.

Die Evolution der Broschüre als graphische Gattung von Garry Emery

Die Etymologie des Wortes Broschüre (vom französischen "brocher", nähen) zeigt, dass sie mit den Pamphleten und Flugblättern früherer Zeiten verwandt ist: eine Druckschrift im Umfang weniger Bogen, vereinigt durch Heften, ohne Einbanddecke. Das Pamphlet, normalerweise eine politische Streitschrift, war ebenfalls weder gebunden, noch mit einem festen Umschlag versehen. Den jeweils aus einem einzelnen Blatt bestehenden Flugblättern war ein noch kürzeres Leben beschieden, waren sie doch vor allem für die Ankündigung von Theateraufführungen, für den Verkauf von Waren oder Bekanntmachungen öffentlicher Hinrichtungen bestimmt. Diese Dokumente bestanden zum grössten Teil aus Schrift, auch wenn bei satirischen Pamphleten hier und da Karikaturen verwendet wurden. Es waren ihrer Natur nach kurzlebige Wegwerfprodukte.

Das Pamphlet und das Flugblatt sind noch immer eine nützliche, beliebte graphische Gattung, und sie sind im Prinzip geblieben, was sie immer waren: direkt und von begrenzter Gültigkeit. Zu Beginn des zwanzigsten Jahrhunderts bezogen die Plakate und Flugblätter der russischen Konstruktivisten ihre visuelle Aussagekraft aus der verblüffenden Verschmelzung von Symbolik und Bedeutung der Buchstaben, womit sie für Durchschlagskraft und Dringlichkeit der politischen Botschaften sorgten. Ganz anders dagegen das Anliegen der Schweizer Typographen nach dem zweiten Weltkrieg: Ihnen ging es nicht darum, Stärke zu suggerieren und die Massen zu begeistern – sie entwickelten eine unmittelbare, rationale Methodik und Eleganz, um Klarheit und Lesbarkeit zu erreichen. Diese beiden Ziele – die visuelle Wirkung auf der einen Seite und Lesbarkeit der Information auf der anderen – sind Widersprüche, die der Funktion der Broschüre innewohnen.

Heute hat die Broschüre vor allem kommerziellen Charakter, nur selten ist sie satirischer oder ideologischer Natur. Ihre Aufgabe ist es, einerseits genaue technische Informationen zu liefern und andererseits den Wunsch nach einem bestimmten Produkt oder einer Dienstleistung bzw. einem Erlebnis zu wecken. Diese beiden Funktionen bedingen zwei gegensätzliche gestalterische Ansätze. Information, meistens komplexer Natur, verlangt Lesbarkeit, aber um ein Produkt oder eine Dienstleistung verführerisch darzustellen, ist ein evokatives, gefühlsbetontes Design notwendig. Der Designer einer Broschüre muss beiden Anforderungen gerecht werden und gleichzeitig innerhalb der gegebenen Grenzen von Format und Budget operieren. Die Gestaltung einer erfolgreichen Broschüre ist ein Tanz auf dem Seil, ein Balanceakt, bei dem es allein auf das Gleichgewicht einander widerstrebender Kräfte ankommt.

Sobald sie ihren Zweck erfüllt hat, landet selbst die schönste Broschüre früher oder später im Papierkorb.

Auf eine andere Art vergänglich, kann eine Website als neue (elektronische) Form der Broschüre behandelt werden. Ein grosser Teil der Information auf dem Bildschirm ist flüchtig, ein Klick mit der Maus genügt, und sie verschwindet. Sie wird in Realzeit wahrgenommen, doch sie ist jederzeit veränderbar.

Die Broschüre, ein vergängliches, in grosser Anzahl hergestelltes Wegwerfprodukt, wird in Graphis Brochures als eine spezifische graphische Gattung zelebriert. Graphis bietet hier eine Momentaufnahme hervorragenden Broschüren-Designs aus aller Welt. Angesichts der Fülle von Bildern und Ideen unterschiedlichster Art sei uns vergeben, wenn wir diese Publikation vor allem als Schatztruhe betrachten. Ihr wahrer Wert liegt jedoch im Aufzeichnen der Vielfalt gegenwärtiger Design-Diskurse sowie in der Förderung kritischer Betrachtungen des zeitgenössischen Designs.

Noch immer haben wir im Hinterkopf die Vorstellung einer Broschüre aus den frühen Tagen der Druckgeschicht, von einem funktionalen Instrument der Kommunikation, auch wenn wir unterdessen ihre unaufhaltsame Evolution in den modernen Medien erleben.

Ob Broschüre, Pamphlet, Katalog oder Prospekt, allen gemeinsam ist die beschränkte Grösse, der vergleichsweise kompakte Inhalt und die durchschlagende graphische Wirkung, die sie haben müssen, um bemerkt zu werden. Mir gefällt diese Form sehr. Sie erlaubt mir, mit Ideen für die Buchherstellung und Typographie zu experimentieren, ohne mich mit der relativ aufwendigen Planung der Herstellung und des Schreibens eines Buches befassen zu müssen.

Die Promotionsbroschüren für Emery Vincent Design erlauben uns, Mini-Monographien unserer Arbeit zu produzieren, indem wir uns auf nur ein Interessensgebiet oder auf eine bestimmte Dienstleistung unserer Firma konzentrieren. Diese kleinen Publikationen sind mehr als nur eine Broschüre, aber weniger als ein Buch. Quasi als Vorläufer unserer kürzlich publizierten Monographie "Emery Vincent Design" (Images Publishing) sind ci und idiom erschienen: ci – Corporate Identity – enthält eine Abhandlung über Nutzen und Abläufe eines Corporate Identity Programms sowie Beispiele unserer Arbeit in diesem speziellen Bereich, und idiom – der Titel verweist auf einen charakteristischen Stil und auf eine spezielle Arbeitsweise – ist ein Skizzenbuch unserer graphischen Ideen, eher illustrativ als didaktisch. In beiden Fällen sind wir selbst die Auftraggeber, und so konnten wir mit Ideen experimentieren, die uns zu jener Zeit besonders interessierten.

Auch eine enge Zusammenarbeit mit Freunden gibt uns die Möglichkeit zu formalen Experimenten. Bei der Gestaltung eines Ausstellungskatalogs für Susan Cohn, eine der bekanntesten und von uns sehr geschätzten Schmuck-Designerinnen in Australien, stellte sich uns die Aufgabe, ihr formales Ethos auf eine zweidimensionale Ebene zu übertragen. Cohns Markenzeichen, der ringförmige Armreifen, wird zum graphischen Element, das sich durch den gesamten Katalog zieht. Die exzentrische Anordnung der Textpartien reflektiert den eigenwilligen, bruchstückartigen Stil ihrer Arbeiten.

Wir arbeiten innerhalb eines neu interpretierten, modernistischen Design-Kanons, bei dem Witz und Eigenwilligkeit ebenso viel Bedeutung zukommt wie Klarheit und Eleganz. Unserem kreativen Ansatz liegt immer ein Widerstreit des Rationalen und des Absurden zu Grunde, und daraus entstehen neue Kräfte, die weder im voraus geplant noch absehbar waren. Wir gestalten um zu entdecken.

La brochure: modèle de typologie graphique évolutive par excellence par Garry Emery

L'étymologie du mot "brochure" [de "brocher": coudre] nous indique qu'elle était à l'origine cousine des pamphlets et prospectus : feuilles volantes ou peu nombreuses assemblées par une couture. Les pamphlets, le plus souvent véhicules de propagande politique, n'étaient pas reliés et donc exempts de couverture rigide. Le tract ou prospectus, plus volatile encore, annonçait un événement imminent telles une représentation théâtrale, une vente publique ou une exécution capitale. Le message contenu dans ces feuillets était essentiellement typographique (textuel), mais le pamphlet satirique pouvait être illustré de dessins humoristiques ou caricatures. Leur nature voulait qu'ils fussent, l'un et l'autre, pareillement destinés à la corbeille.

Le pamphlet et le prospectus constituent, aujourd'hui encore, des catégories très communément employées du design graphique, conservant ce caractère de médiateur provisoire qu'ils avaient à l'origine. Au XXème siècle, les affiches et autres instruments de propagande élaborés par les Constructivistes russes puisent la force de leur message visuel dans la fusion parfaite du symbole et du sens de la lettre, traduisant ainsi de façon percutante l'urgence de leur message politique. Par opposition à ce prosélytisme autoritaire qui recourt aux polices de caractères pour véhiculer l'enthousiasme et entraîner l'adhésion, les méthodes élaborées par les typographes suisses au lendemain de la Seconde Guerre mondiale sont d'une élégance directe et rationnelle, gage d'une clarté et d'une lisibilité typographiques optimales. Bien que ces deux objectifs soient antithétiques — l'un voué à l'irrésistible impact du message visuel, l'autre à une lisibilité sans faille de l'information — on ne saurait s'étonner de les trouver réconciliés dans la brochure, elle même conspiration des deux genres.

La brochure d'aujourd'hui a une visée généralement commerciale. Elle n'a plus, comme autrefois, de message satirique ou idéologique à transmettre. Sa double fonction consiste à véhiculer des informations précises (techniques ou non) et, simultanément, éveiller l'intérêt du public pour un produit ou une manifestation quelconques. En termes de design, ces deux fonctions sont incompatibles. En effet, pour "faire passer" une information complexe, une clarté élémentaire est requise ; en revanche, la présentation d'une image de marque ou d'un produit suppose, pour séduire, la manipulation d'éléments graphiques qui entrent en résonance avec la mémoire, l'évocation et l'affect. Le designer chargé d'une maquette de brochure doit tenir compte, non seulement de ces deux exigences contradictoires, mais encore des contraintes imposées par le budget et l'espace. Aussi peut-on assimiler le designer au funambule qui, grâce à un dosage subtil des forces contraires, réussit son parcours sur la corde raide.

Une fois sa mission accomplie, la brochure — aussi luxueuse soit-elle — achève sa brève existence dans la corbeille à papier.

Le site web, lui aussi éphémère (mais d'une autre manière), peut être élaboré à la façon d'une brochure d'un genre nouveau (électronique). L'information véhiculée sur l'écran est, d'une façon générale, fugace. Il suffit d'un clic de souris pour l'escamoter et la faire disparaître. Si elle se lit en temps réel, elle n'en est pas moins provisoire et sera demain révisée, voire complétée.

Ainsi la brochure, catégorie graphique particulière, fabriquée en série et jetable, a-t-elle un destin aléatoire. C'est considérée sous l'angle de cette précarité — la beauté du papillon — que que Graphis Brochures lui rend hommage cette année. Graphis profite de cette occasion pour présenter un panorama mondial de l'excellence en matière typo brochure. On lui pardonnera, je pense, d'avoir exposé les ressources inépuisables de cette forme spécifique du design dans un ouvrage qui, par la profusion des images et

des concepts illustrés, se présentera davantage comme le catalogue d'un trésor qu'un traité didactique. C'est de la multiplicité des approches contemporaines, de leur illustration, que l'on tirera le meilleur enseignement de cette catégorie contemporaine du design.

Chemin faisant, nous avons gardé à l'esprit le souvenir de ce que fut la brochure à l'époque de Gutenberg : cet instrument de communication qu'elle est toujours restée, mais qui s'est adaptée au fil du temps pour circuler désormais sur les autoroutes de l'information. L'image ultime qui se dégage de cet ouvrage est celle d'un médium en constante évolution.

Les caractéristiques communes à la brochure, au pamphlet, au catalogue et au manuel reposent sur le format réduit, le volume relatif et la nécessité pour chacun de véhiculer un message graphique efficace, à même de frapper les imaginations. Personnellement, la forme du manuel m'enchante; elle me permet de mettre en œuvre des stratégies typographiques et iconographiques sans exiger de moi le lourd investissement que suppose la réalisation complète d'une maquette de livre (articulation sophistiquée, rédaction et mise en page).

Les brochures destinées à la promotion de l'ouvrage Emery Vincent Design (publié par Images Publishing) nous ont fourni l'occasion de réaliser des petites monographies consacrées à nos travaux, mais illustrant chaque fois isolément un seul domaine de nos prédilections, ou bien un service particulier offert à notre clientèle. Plus volumineuses qu'une brochure standard, ces petites publications sont moins épaisses qu'un livre. La parution de Emery Vincent Design a pour ainsi dire été préfigurée par deux petits manuels: ci (corporate identity: profil corporatif) et idiom . Le premier comporte un essai sur les bénéfices du profil corporatif et la manière dont celui-ci s'élabore; à l'appui sont donnés quelques exemples empruntés à notre expérience dans cette spécialité. Idiom (par ce titre nous suggérons l'étude du style et de la méthode de travail propres à l'agence) se présente en quelque sorte comme l'album de famille de nos concepts graphiques. L'objectif est ici plus illustratif que didactique. Mais dans un cas comme dans l'autre, nous avons réalisé une commande dont nous étions tout bonnement les commanditaires. Aussi le résultat obtenu allait-il chaque fois comme un gant aux idées que nous souhaitions mettre en vedette.

La collaboration étroite avec des confrères qui sont aussi des amis nous permet d'examiner ensemble, de tous les points de vue, la bonne tenue de nos concepts graphiques. Le catalogue d'une exposition de Susan Cohn, qui est l'un des plus grands créateurs de la joaillerie australienne fut pour nous l'occasion de collaborer avec un éminent designer et de réussir à traduire dans les deux dimensions son ethos formel. L'image de marque de Susan Cohn — bracelet en forme de torque (ellipse ouverte sur un côté) — devient, en l'occurrence, un leitmotiv graphique, une ponctuation iconique, que l'on rencontre d'un bout à l'autre du catalogue. Le texte, sous forme de bandeaux, est disposé à la périphérie des illustrations, suggérant ainsi l'originalité d'une œuvre en rupture avec le classicisme de la joaillerie traditionnelle.

Le cadre graphique dans lequel nous travaillons est celui d'un modernisme revisité qui privilégie élégance et clarté mais aussi humour et fantaisie. Notre approche créative est toujours à la jonction souterraine du rationnel et de l'irrationnel, du réaliste et du surréaliste, et de ce point de rencontre jaillit une étincelle, une forme de dynamique nouvelle, qui était imprévisible un moment plus tôt.

Pour nous, le design n'est pas "territoire conquis", mais "continent à explorer ".

c h n

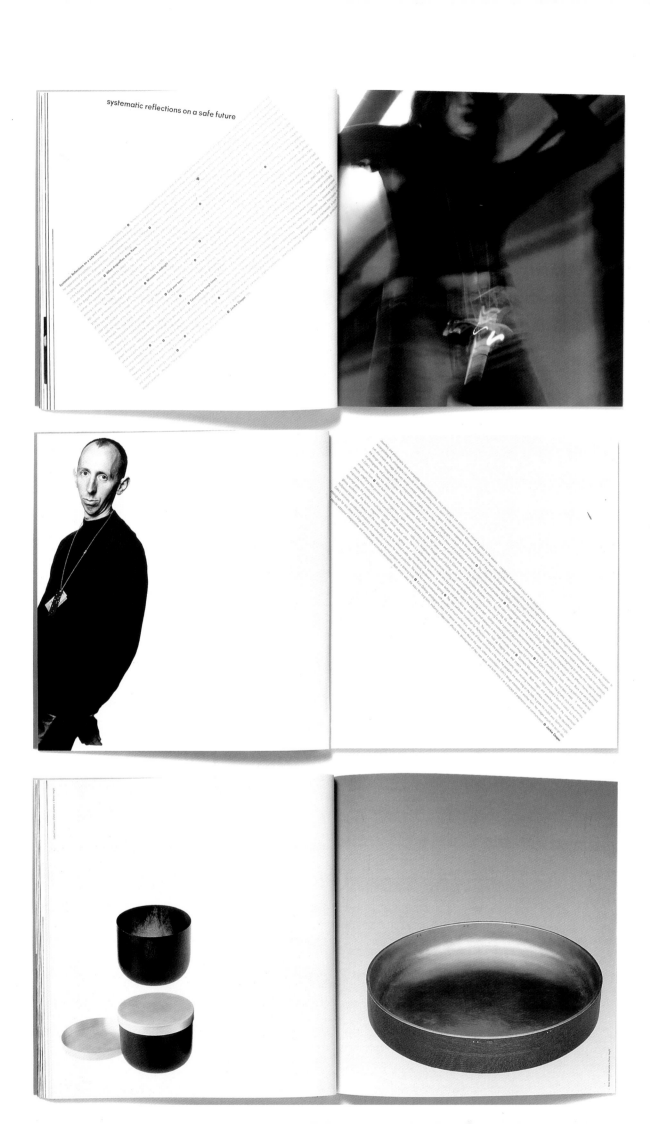

systematic reflections on a safe future

Way Past Real Anna Schwartz Gallery 1998

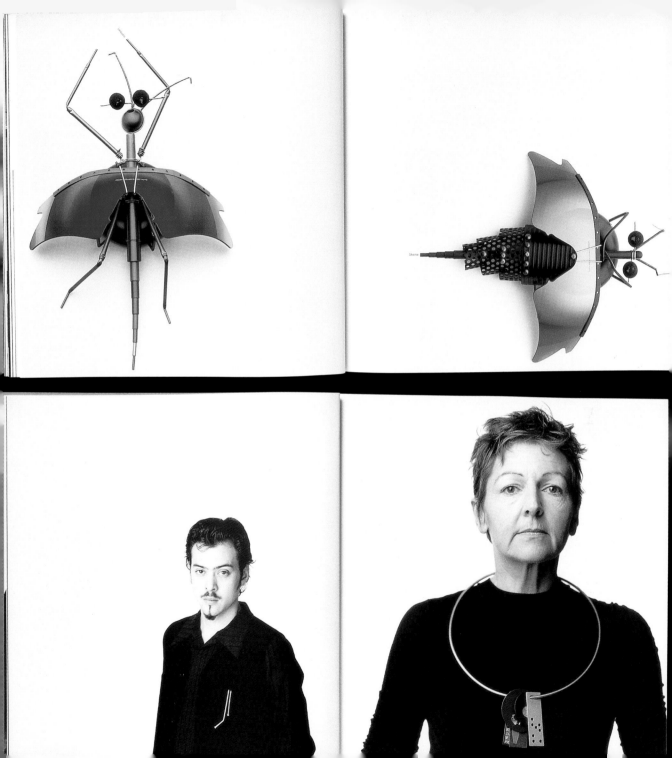

want
recognition

A corporate identity
programme can be a driving
force behind the
establishment of a unique
and meaningful position
for an organisation.
It can project who you are,
what you do and how
you do it.

ci

Emery Vincent Design

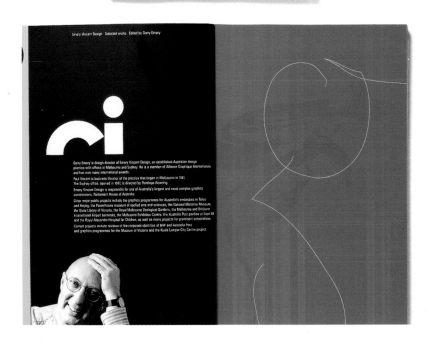

Emery Vincent Design Selected works Edited by Garry Emery

ci

Garry Emery is design director of Emery Vincent Design, an established Australian design
practice with offices in Melbourne and Sydney. He is a member of Alliance Graphique Internationale
and has won many international awards.

Paul Vincent is business director of the practice that began in Melbourne in 1981.
The Sydney office, opened in 1982, is directed by Penelope Bowring.

Emery Vincent Design is responsible for one of Australia's largest and most complex graphics
commissions, Parliament House of Australia.

Other major public projects include the graphics programmes for Australia's embassies in Tokyo
and Beijing, the Powerhouse museum of applied arts and sciences, the National Maritime Museum,
the State Library of Victoria, the Royal Melbourne Zoological Gardens, the Melbourne and Brisbane
International Airport terminals, the Melbourne Exhibition Centre, the Australia Post pavilion at Expo '88
and the Royal Alexandra Hospital for Children, as well as many projects for prominent corporations.

Current projects include reviews of the corporate identities of BHP and Australia Post
and graphics programmes for the Museum of Victoria and the Kuala Lumpur City Centre project.

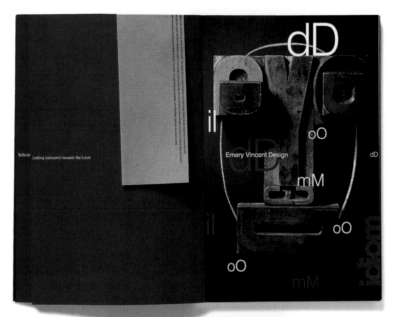

dD

il

oO

Emery Vincent Design

dD

mM

il

oO

mM

idiom

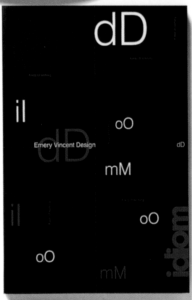

dD

Reflects Looking backwards towards the future

Emery Vincent Design

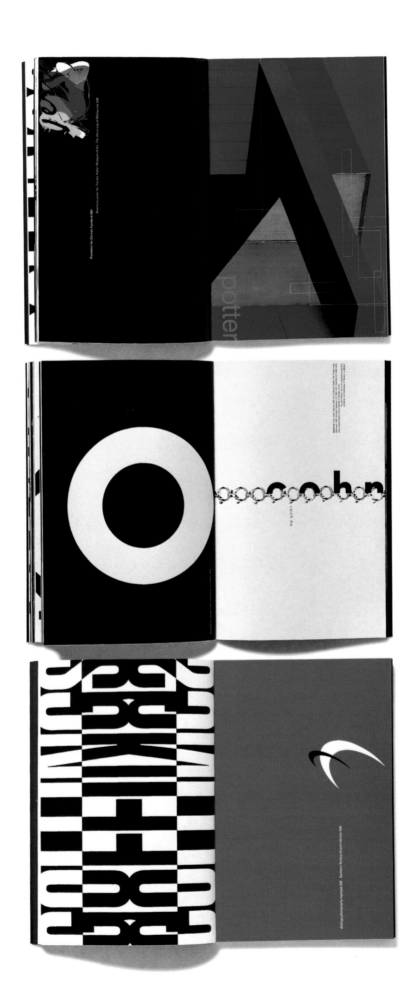

Today's graphic images are like the rock carvings of former ages—pictures and symbols that contain coded meanings, from which those who view them are able to interpret and learn. These images are not concrete, but rather hints and suggestions of events, to which informed individuals react. A magazine, catalogue or poster is, by way of its layout, a figurative expression of the originator's personality, style and mood—with "mood" playing an especially important role in today's language. It's a bit like humming the first few lines of a song and then saying, "you know the rest!" Today audiences know exactly the style and expression of the rest of the song. They instinctively know which 'roots' the song comes from.

In an age where spectators are bombarded daily with a mass of complex and varied impressions, the use of graphics has gained considerable scope and opportunity for self-expression as a message bringer in its own right.

course the spontaneous appearance of a modern graphics language is more complex, but the meaning of the message is still very much the same: an expression of our status and where we belong.

Graphics can communicate a message profiling a serious banking business or selling streetwear shoes, but it is the evolutionary and stylistic preference implied in the graphics that determines and influences our decisions. We do not react merely to what is spontaneously presented, but tend to make up our minds depending on the proposition and style represented by the image, just as a whimsical rococo chair will always evoke a different feeling compared to its modern carefully-constructed Werner Panton equivalent.

Shape by ECCO is a perfect example of the creation of a language of expression—a language that the company previously did not possess, par-

Today people do not merely read the headline, they also decode the meaning behind the way it looks and how it is laid out. Style, and the way it is used in a layout, significantly influences the way content is understood. In this way graphics has gained a wider and subtler meaning than that of merely informing us, for example, where to find a toilet.

As a follow-on from the postmodernist trend, expression as a total entity now plays a far more important role than the individual components of the message. We make up our minds about things as a whole. Take for example the world of fashion and sportswear, where graphics are used as a form of decoration, very akin to Indian body painting and African tattoos. Graphics form part of a complex expression structure that reflects our group membership and identity. Everything from Nike caps and Louis Vuitton logos transmits messages about our status and language. One is tempted to call this 'neo-symbolism'—a rediscovery of sign language. Of

ticularly as ECCO was uniquely known for its sensible footwear products. With Shape, ECCO has revealed a new mythological, unpredictable and dramatically sexy-multifaceted side to itself—an expression of many of the irrational things we spend our time on. Shape has become a language with a style where photo-images are nearly as typographic as the typography is photographic. Shape is everything, invisible to the eye and open to fantasy. Shape takes as its reference point the shape of a form—a form shaped in an aesthetical and exciting way. Not least in a way that hopefully will please all those who look at it.

Anders Majgaard was born in Copenhagen in 1962. After graduating from the Danish Design School in 1986, he went to work at Leo Burnett in Copenhagen, working with such clients as Kellogg's, Bang & Olufsen, and McDonald's. He also produced notable works for the Skandinavian fashion industry, the Danish government, and the environmental industry in Denmark. In 1995, he joined the management at Black Pencil, an agency with 20 employees that is partly owned by Leo Bunett. Black Pencil is well known for its graphic communication, and Anders Majgaard is the leading profile. Previous spread: Anders Majgaard with stylist Uffe Buchard and model Britt Bennett Hansen on location for Ecco Shape Catalogue Spring/Summer 2000, courtesy of Black Pencil

shaped by
SILENCE

shaped by
LIGHT

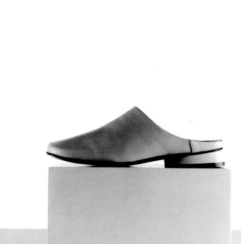

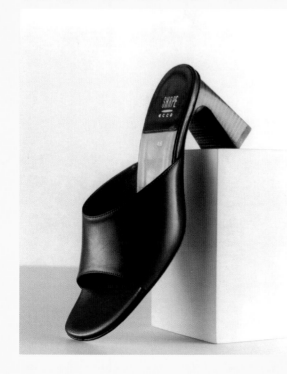

shaped by
PASSION

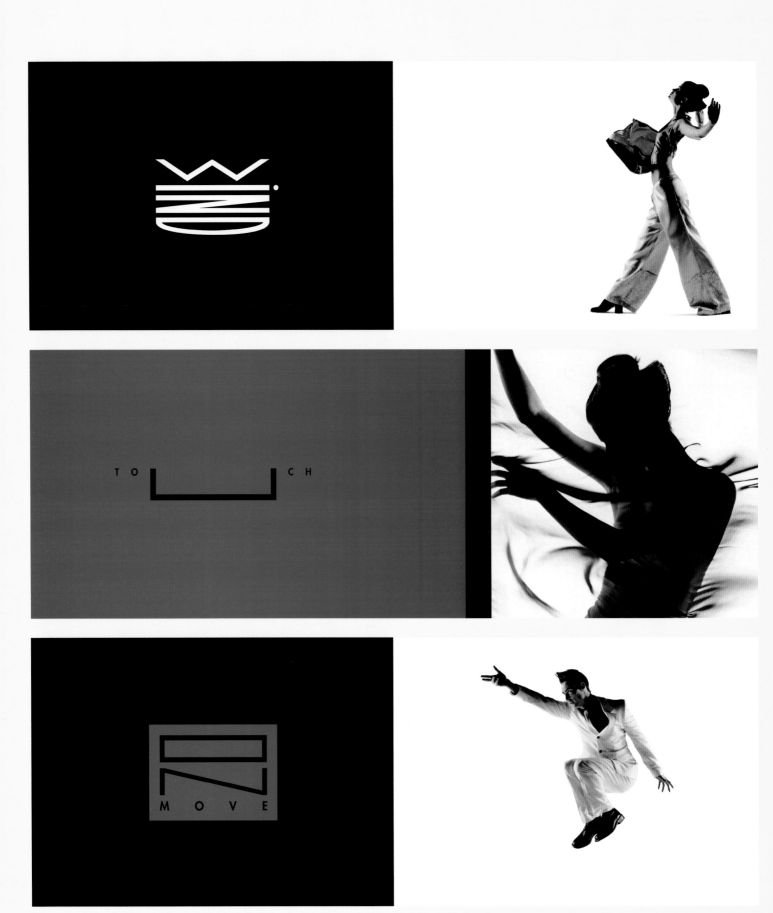

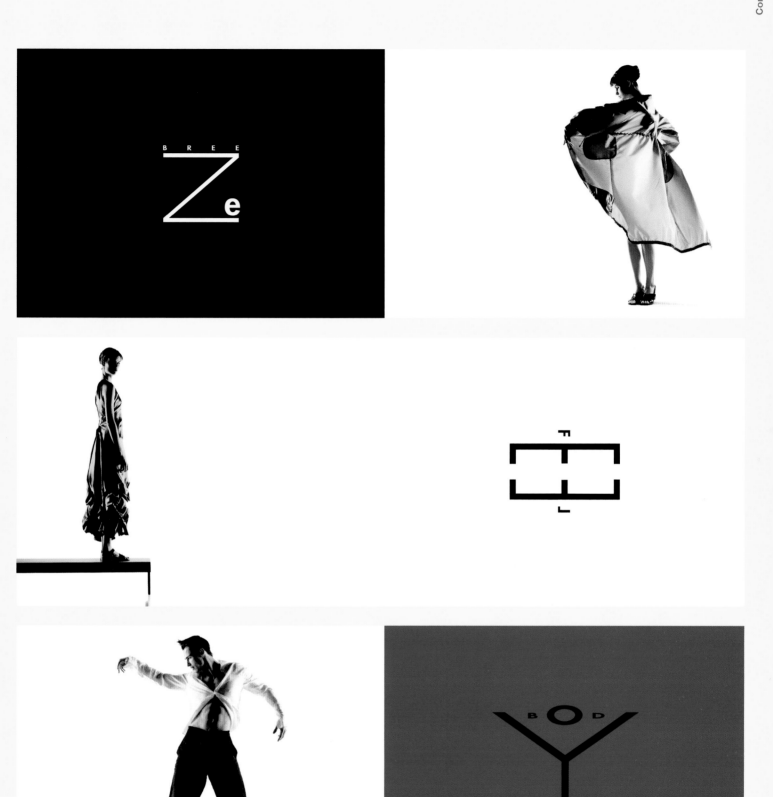

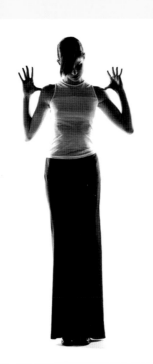

ecco

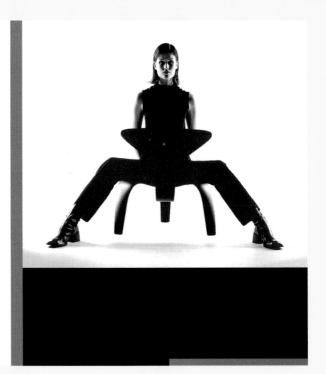

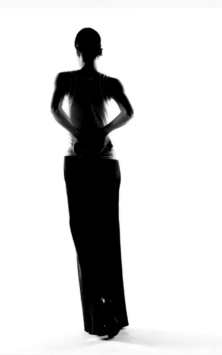

THE THEME OF
TONIGHT IS

BLACK

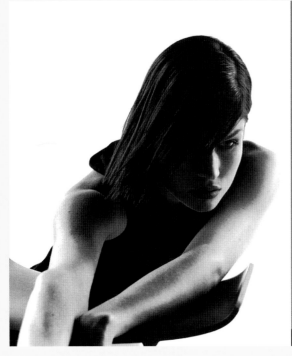

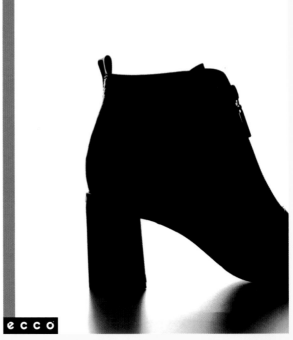

ecco

YOU SEE HIM RIGHT BEHIND YOU
ON THE SIDEWALK YOU SEE HER FROM THE CORNER OF YOUR EYE IN THE LIGHT FROM THE STREETLAMP

HE IS DANCING ON THE

WALL

MEN

WOMAN

Symbolismus–in Sprache und Ausdruck des Graphic Designs von Anders Majgaard

Im Prinzip ist das, was wir heute unter Graphic Design verstehen, nichts anderes als die Felsmalereien vergangener Zeiten – Bilder und Symbole mit kodierten Bedeutungen, die von allen interpretiert werden können. Es geht nicht um die Visualisierung konkreter Fakten, sondern eher um Hinweise und Andeutungen. Es ist in etwa so, als wenn man die ersten Noten einer Melodie summt und dann sagt: "Ihr wisst, wie es weiter geht!" Das Publikum kennt Stil und Ausdruck des restlichen Liedes genau, weil es instinktiv weiss, woher es kommt, was seine "Wurzeln" sind. Die Gestaltung eines Kataloges, einer Broschüre oder eines Prospektes sind Ausdruck der Persönlichkeit, des Stils und der Stimmung ihres Urhebers. Und gerade "Stimmung" spielt heute ein besonders wichtige Rolle im Design.

In einer Zeit, in der das Publikum täglich mit einer Unmenge von komplexen Informationen der unterschiedlichsten Art bombardiert wird, kommt Graphic Design eine grosse und bedeutende Rolle zu; es ist zu einer eigenständigen Botschaft geworden, und die Ausdrucksmöglichkeiten sind grösser denn je. Die Leute lesen heute nicht einfach eine Überschrift oder eine Schlagzeile, sie entschlüsseln die Botschaft, die durch den optischen Eindruck vermittelt wird. Stil und die Art, wie er in einem Layout zum Tragen kommt, hat grossen Einfluss auf die Interpretation des Inhalts. Das bedeutet, dass es bei Graphic Design längst nicht mehr nur um die Information von Fakten geht, es kann viel subtilere und weiterreichende Botschaften vermitteln.

Als Folge des postmodernistischen Trends spielt der Gesamtausdruck heute eine viel grössere Rolle als die einzelnen Teile einer Botschaft. Wir beurteilen die Dinge als Ganzes. Man denke z.B. an Mode und Sportbekleidung. Graphik wird ähnlich wie die indianischen Körperbemalungen oder die afrikanischen Tätowierungen als eine besondere Form von Dekoration eingesetzt, als Teil einer komplexen Struktur von Ausdrucksformen, die unsere Gruppenzugehörigkeit und unsere Identität reflektieren. Alles, von Nike-Mützen bis zu Louis-Vuitton-Logos, enthält Botschaften über unseren Status und unsere Sprache. Man ist versucht, diese Entwicklung Neo-Symbolismus zu nennen, eine Wiederentdeckung der Zeichensprache. Natürlich sind Bedeutung und Wirkung der modernen graphischen Sprache viel komplexer, aber die Botschaft ist im Grunde noch immer dieselbe: Sie ist Ausdruck unseres Status und unserer Gruppenzugehörigkeit. Graphic Design kann eine Botschaft über das Wesen einer seriösen Bank sein, es kann aber auch Strassenschuhe verkaufen. Was unsere Entscheidung beeinflusst, sind vor allem der Stil und die damit verbundenen historischen Assoziationen. Wir reagieren nicht nur auf die direkte Botschaft, sondern bilden uns eine Meinung aufgrund von Darstellung und Stil des uns präsentierten Bildes: Ein Rokoko-Stuhl vermittelt uns ein völlig anderes Gefühl als ein moderner, sorgfältig konstruierter Stuhl von Werner Panton.

"Shape" von Ecco ist ein perfektes Beispiel für die Schaffung einer visuellen Sprache – einer Sprache, die Ecco vorher nicht besass. Die Firma war ausschliesslich für ihre soliden Schuhe bekannt, und mit der neuen Schuhkollektion "Shape" präsentiert sie sich auf ganz neue Art. Shape ist geheimnisvoll, unberechenbar und ungeheuer sexy – es ist Ausdruck jener irrationalen Dinge, die uns ständig beschäftigen. Shape ist zu einer Sprache geworden, einem Stil. In den Katalogen und Broschüren wird Photographie typographisch eingesetzt, und die Typographie hat photographischen Charakter. Shape kann alles bedeuten, unsichtbar für das Auge und offen für die Phantasie. Ausgangspunkt für Shape ist Form – eine Form, die auf ästhetische und aufregende Art präsentiert wird, und das nicht zuletzt in der Absicht, dem Betrachter zu gefallen.

Anders Majgaard wurde 1962 in Kopenhagen geboren. Nach Abschluss der Danish Design School im Jahre 1986 ging er zu Leo Burnett in Kopenhagen, wo er für Kunden wie Kellogg's, Bang & Olufsen und McDonald's arbeitete. Wichtige Arbeiten entstanden auch für die skandinavische Modebranche, die dänische Regierung und die Umweltbranche in Dänemark. 1995 schloss er sich Black Pencil an, einer Agentur mit 20 Angestellten, an der Leo Burnett Anteile besitzt. Black Pencil hat sich in der graphischen Kommunikation einen Namen erworben, und dazu hat Anders Majgaard wesentlich beigetragen.

Le symbolisme dans le langage et l'expression graphiques par Anders Majgaard

Ce que nous désignons aujourd'hui par design graphique peut être assimilé aux peintures rupestres d'antan – des images et des symboles à la signification codée pouvant être librement interprétés par chacun. Les représentations graphiques ne livrent pas des faits concrets, mais suggèrent, procèdent par insinuations. Cela revient un peu à entonner un air et à dire: "Vous connaissez la suite!" Les gens reconnaissent le genre musical, le style d'expression, parce qu'ils parviennent instinctivement à en identifier les "racines". Un catalogue, une brochure ou un prospectus expriment, de par leur conception, la personnalité, le style et l'humeur de leur auteur. Et l'"humeur" joue un rôle essentiel dans le langage graphique actuel.

A une époque où les gens sont bombardés au quotidien d'informations complexes et opposées, la portée du design graphique a considérablement gagné en importance: celui-ci est devenu un message en soi, et les possibilités d'expression n'ont jamais été aussi étendues. De nos jours, les gens ne se contentent pas de lire un slogan publicitaire, ils déchiffrent également le message contenu dans le visuel. Le style et la façon dont celui-ci est traduit dans le visuel exercent une grande influence sur l'interprétation du contenu. Le graphisme ne se limite plus à transmettre des informations – par exemple, où se trouvent les toilettes –, mais véhicule des messages bien plus subtils dont l'impact est beaucoup plus vaste.

Conséquemment à la tendance postmoderniste, l'expression en tant qu'entité revêt davantage d'importance que les composantes individuelles du message. Nous jugeons l'ensemble, comme c'est le cas dans le domaine de la mode ou des tenues de sport. Le graphisme est utilisé comme une décoration, à l'image des peintures corporelles des Indiens ou des tatouages africains. Il fait partie d'une structure complexe de formes d'expression qui reflètent notre identité et notre appartenance à un groupe. Toute chose, des casquettes Nike au logo Louis Vuitton, transmet des informations sur notre statut et notre langage. On serait tenté d'appeler cette évolution "néosymbolisme", une redécouverte du langage des signes. Bien entendu, les réactions engendrées par le langage graphique moderne et sa signification sont beaucoup plus complexes mais, dans le fond, le message reste le même: il exprime notre statut et notre appartenance. Le design graphique peut véhiculer un message sur une banque réputée ou faire la promotion de chaussures de ville. Seuls le style et les associations historiques en résultant influencent notre décision. Nous ne réagissons pas seulement à un message direct, mais nous faisons une opinion sur la base du style et du type d'image; un fauteuil rococo opère différemment qu'une chaise moderne et bien conçue de Werner Panton.

La collection de chaussures Shape du fabricant Ecco illustre parfaitement ce qu'est la création d'un langage visuel – un langage qui, par le passé, faisait défaut à la société. Ecco, uniquement connu à ce jour pour ses chaussures solides, s'est présenté sous un tout autre jour avec sa nouvelle collection Shape. A la fois mystérieuse, imprévisible et incroyablement sexy, Shape est l'expression de ces aspects irrationnels qui nous préoccupent constamment. Shape est devenue un langage, un style. Dans les catalogues et brochures de la marque, les photographies sont aussi typographiques que la typographie est photographique. Shape peut tout signifier, l'imagination ne connaît aucune limite. Shape prend comme point de départ les contours d'une forme – une forme présentée de façon esthétique et excitante qui, espérons-le, plaira à tout un chacun.

Anders Majgaard est né à Copenhague en 1962. Après avoir achevé ses études à l'Ecole de design danoise en 1986, il a débuté sa carrière professionnelle chez Leo Burnett, Copenhague, où il a travaillé pour des clients tels que Kellogg's, Bang & Olufsen, McDonalds. Il a également réalisé des travaux remarquables pour l'industrie de la mode scandinave, des organisations environnementales et le gouvernement danois. En 1995, il rejoignait la direction de Black Pencil, une agence de 20 employés en partie détenue par Leo Burnett. Black Pencil est réputée pour sa communication graphique dont Anders Majgaard est le grand artisan

Brochures 4

Brochures 4

more than 800,000 people undergo conventional open-chest heart surgery each year

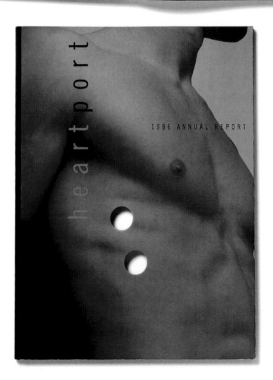

heartport

1996 ANNUAL REPORT

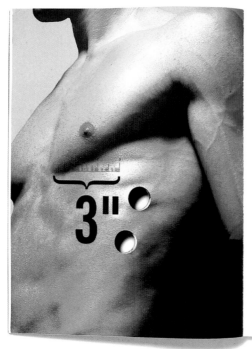

3"

Port-Access™ Systems enable surgeons to perform a wide range of heart operations through small incisions between the ribs

Design Firm: **Cahan & Associates** Creative and Art Director: **Bill Cahan** Designer: **Craig Bailey** Photographers: **Ken Schles, Tony Stromberg** and **William McLeod** Copywriter: **Jim Weiss** Client: **Heartport, Inc.**

an Creative Director: Bob Price and Paul Curtain Designer: Clark Richardson Copywriter: Paul Curtain Art Director: Paul Curtain and Paul Price Illustrator: Bob Rice Photographer: Bill Abranowicz Client: Ameristar Casinos Inc. Annual Reports 283

Design Firm: **Pentagram Design** Art Director: **Lowell Williams** Designers: **Julie Hoyt** and **Wendy Carnegie** Illustrator: **Wendy Carnegie** Client: **DA Consulting Group**

NEWS
IEWS
NEWS

on ERP software within the year.

Chairman, pg. 2; President, pg. 5; Good News, pg. 9; Financials, pg. 20

1998 Financial Highlights
DA Consulting Group, Inc.*

Years ended December 31.

(Consolidated amounts in thousands, except per share amounts and number of employees)	1996	1997	1998
Operating Data:			
Revenue	$26,202	$44,204	$80,132
Operating income*	2,212	2,756	7,090
EBITDA* (Earnings Before Interest, Taxes, Depreciation and Amortization)	2,465	2,990	7,948
Net income*	1,441	1,606	4,299
Number of employees	353	568	863
Balance Sheet Data:			
Cash and cash equivalents	$ 2,199	$ 3,664	$ 9,971
Working capital	1,629	4,101	25,585
Total assets	8,549	20,135	48,903
Total debt	731	3,970	–
Shareholders' equity	3,071	7,943	34,944
Per Share Data (Diluted):			
Net income*	$ 0.32	$ 0.32	$ 0.69
Net income	$ 0.01	$ 0.28	$ 0.69
Weighted average shares outstanding	4,462	5,053	6,233

*Before employee stock-related charges

1998 At A Glance

February	DACG acronym adopted for worldwide marketing use, replacing DA Consulting Group, Inc.
April	**Became a public company on April 24.**
June	Mexico City office opened to service clients in Mexico. Caracas office opened to meet demands in Venezuela and other Latin American countries. **At mid-year, revenue nearly doubled to $19.7 million from $9.9 million in 1997.**
August	Board of Directors elected Nicholas Marriner to Chairman and Patrick Newton to President.
September	Launched "e-learning" for business systems training. New training tool, DA FIT/Fast Implementation Toolkit™, introduced to support demand for faster SAP™ implementations.
October	SAP software selected to manage DACG's internal business information systems.
November	Became SAP AG Global Consulting Partner. Licensed SAP's training tool "InfoDB" and incorporated into DACG training solutions. The Hague sales office opened to serve Belgium, The Netherlands and Luxembourg.
December	Became PeopleSoft Global Education Services Alliance Partner. Dilip Keshu joined DACG as EVP of Asia Pacific Division. **Record year-end revenues of $80.1 million, reflecting an 80% increase over 1997.**

1

GOOD
BAD N
GOOD

Fortune 500 companies all over the world will spend 3.8 billion dollars

Most of them won't know how to use it.

We're there to teach them. DACG 1998 Annual Report

MORE
GOOD
NEWS

Mobile Then Global, page 10; Fortune 500, page 12;

Between Our Ears, page 14; We Hear You, page 16;

Staying Ahead, page 18.

9

037

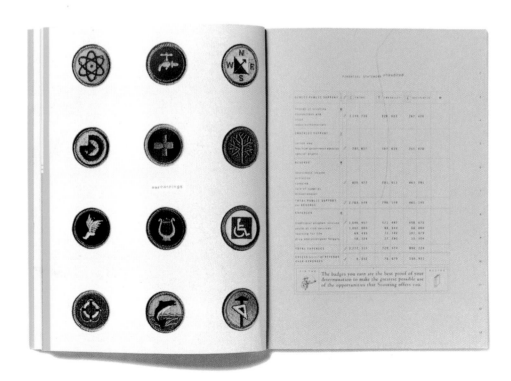

Design Firm: **Slaughter Hanson** Art Director and Designer: **Marion English Powers** Copywriter: **Gary Brandon** Illustrator: **David Webb** Photographers: **Don Harbor** and **Fredrik Broden** Client: **Greater Alabama Boy Scout Council** Annual Reports 30,31

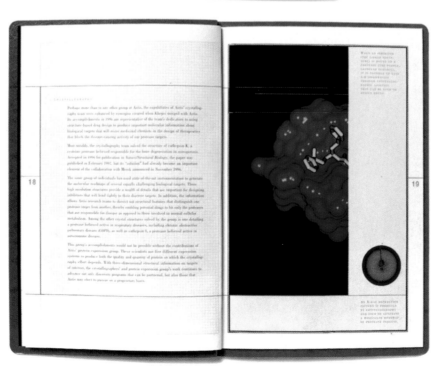

Advanced baseband chipsets for digital communications.
Wireless. Personal. Worldwide. Using digital signal processing
technology to develop and deliver application specific integrated
circuits and software. Providing handset manufacturers the technical
expertise they need to gain and maintain the competitive edge.
DSP Communications. The soul of the phone. ™

Inside

We Make It Work

DSP *Communications* / THE SOUL OF THE PHONE™
1998 ANNUAL REPORT

Outside

It Could Be Anything

9 8

Design Firm: **Jennifer Sterling Design** Creative Director, Art Director and Designer: **Jennifer Sterling** Photographer: **Marko Laurisha** Copywriter: **Eric LaBrecque** Client: **DSP Communications**

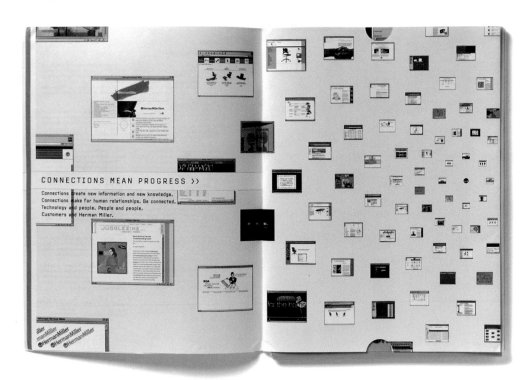

CONNECTIONS MEAN PROGRESS >>

Connections create new information and new knowledge.
Connections make for human relationships. Be connected.
Technology and people. People and people.
Customers and Herman Miller.

⊙HermanMiller MAKE CONNECTIONS >>

FINANCIAL GOALS CONNECT US >>

To a certain reality. To investors around the world. To our
ability to fund the future at Herman Miller. In the past year, we
introduced several new products, results of past and current
investments. We also made considerable investments in
Herman Miller's electronic infrastructure. This year, more results
will follow.

⊙HermanMiller

Connect: Host www.hermanm

WEB SITE >>
The modern connection. Everybody seems
to have one. (But ours has won several
awards for its graphics and ease of use.)
A link to everybody all the time. Investors
to corporations. The curious to the informed.
Customers to Herman Miller for the Home.
Herman Miller to anybody who's interested.
Learn more about your company—or learn
how to become part of Herman Miller.
Check it out.

(this spread) Design Firm: **Herman Miller, Inc.** Creative and Art Director: **Stephen Frykholm** Designer: **Yang Kim** Copywriter: **Clark Malcolm** Client: **Herman Miller, Inc.**

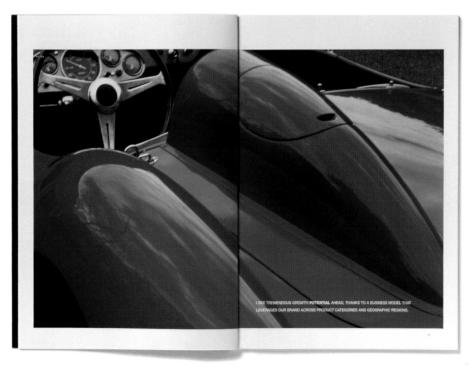

Design Firm: **Slaughter Hanson** Art Director and Designer: **Marion English** Photographer: **Don Harbor** Illustrator: **David Webb** Copywriter: **Kathy Oldham** Client: **Greater Alabama Boy Scouts Council**

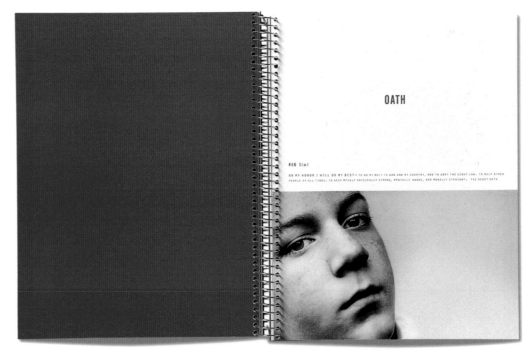

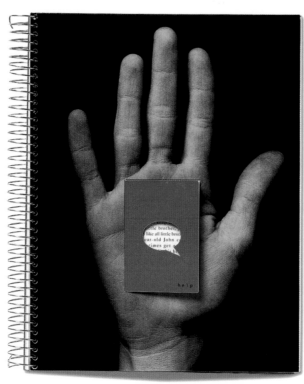

Leveraging Our Global Presence

Workstations from France.
Tables from England.
Chairs from the United States.

Destination: Mumbai.

Reliance Industries, headquartered in Mumbai (formerly Bombay), is one of India's proudest and most successful enterprises. Its founder, Mr. Dhirubhai Ambani, was named India's "Businessman of the Century," and his two sons, Mr. Mukesh Ambani and Mr. Anil Ambani, are building on his achievements expanding this integrated energy refining company beyond India's borders into markets around the world.

Reliance turned to Steelcase to help outfit its new headquarters, The Reliance Centre. The assignment: a high-performance work environment that would give the staff all the support they needed to help the company attain its ambitious goals.

Steelcase responded by tapping its own global capabilities. TNT workstations and Please and Arpeggio chairs from its Strafor unit in France; conference tables from its Gordon Russell unit in England; Sonata™ chairs from its Turnstone unit in the U.S.; and La Costa® chairs from Brayton International, a U.S.-based Steelcase Design Partnership company.

And Mumbai gained another state-of-the-art workplace.

18

Leveraging Our Dealer Network Worldwide

SANTIAGO, CHILE

Steelcase dealer helps his nation's airline take wing.

Steelcase dealer, Luis Fernando Moro.

Once, the headquarters employees of Chile's illustrious Lan Chile airline worked in several different facilities in different parts of the Santiago area and communicated with one another by fax and phone.

Today, they all work at a three-building campus near the Santiago International Airport, and they do most of their communicating face-to-face – with significant boosts in morale and productivity.

The move was part of Chief Executive Officer Mr. Enrique Cueto's comprehensive program to re-energize the airline, and he enlisted Steelcase dealer Luis Fernando Moro to help.

Together with a team of architects, they created bright, airy work environments that include Montage® and Avenir® workstations; Rally, Protégé and Criterion® chairs; and a variety of products from Steelcase Design Partnership companies.

And Lan Chile is flying higher than ever.

19

2000 Annual Report

REVOLUTION
WORK
TRANSFORMATION

Steelcase

Steelcase Inc.

STEELCASE INC

Information for Our Investors

Steelcase Inc. common stock is traded on the New York Stock Exchange under the symbol SCS. The following table shows the high and low stock prices by quarter for fiscal years 2000 and 1999. There were 14,254 Class A Common Stock shareholders and 245 Class B Common Stock shareholders of record as of April 14, 2000. The Class B Common Stock is not publicly traded, but is convertible to Class A Common Stock on a one-for-one basis.

TRADING AND DIVIDEND INFORMATION

Year Ended	Feb 25, 2000			Feb 26, 1999		
	High	Low	Cash Dividend Declared	High	Low	Cash Dividend Declared
First quarter	$ 20.750	$ 13.625	$ 0.11	$ 38.375	$ 28.000	$ 0.10
Second quarter	20.000	14.500	0.11	29.875	18.125	0.10
Third quarter	15.500	12.250	0.11	19.750	12.750	0.10
Fourth quarter	13.750	10.250	0.11	18.438	13.313	0.11

SHAREHOLDER ACCOUNTANT ASSISTANCE
Registered shareholders who wish to change their addresses or ask questions about other stock administration matters should contact the transfer agent at:

Bank of Boston, N.A.
c/o Boston EquiServe, L.P.
P.O. Box 8040
Boston, MA 02266-8040
(800) 958-6931

If outside the continental U.S. and Canada:
(781) 575-3120.

TDD for those who are hearing or speech impaired:
(800) 952-9245

Internet: www.equiserve.com

INDEPENDENT CERTIFIED PUBLIC ACCOUNTANTS
BDO Seidman, LLP
Grand Rapids, Michigan

SHAREHOLDER AND INVESTOR INQUIRIES
For additional financial information, including the company's Form 10-K and Form 10-Q reports and additional copies of this annual report, visit the Steelcase Website, www.steelcase.com, or contact:

Steelcase Investor Relations
CH.2E.02
P.O. Box 1967
Grand Rapids, MI 49501-1967

Telephone (616) 247-2200
Fax (616) 475-2270

CORPORATE HEADQUARTERS
Mailing Address:
Steelcase Inc.
P.O. Box 1967
Grand Rapids, MI 49501
(616) 247-2710

Street Address:
901 44th Street
Grand Rapids, Michigan 49508

NEW ELECTRONIC VOTING
Shareholders can now vote their proxies by telephone or via the Internet. Their proxy card explains how. This proxy card's instructions also explain how shareholders can receive their annual report and proxy statement electronically in the future. Shareholders who choose to do this will receive an e-mail notifying them that these materials have been posted on the Steelcase Website. They will not receive printed versions of these materials unless they request them.

INVESTOR RELATIONS WEBSITE
Shareholders who wish to receive Steelcase investor information as soon as it is published should visit the investor relations section of the company's Website at www.steelcase.com.

CONSUMER AFFAIRS
For your nearest Steelcase dealer's address and telephone number or for information about Steelcase products, call (800) 333-9939, or visit the company's Website.

If you have questions, comments, problems, or special requests, call your dealer or Steelcase Line 1 at (888) 783-3552 (888-STEELCASE). Outside the U.S. call (616) 247-2500.

ANNUAL MEETING
The annual shareholders' meeting to review the fiscal year that ended February 25, 2000, begins at 11A.M. EDT on June 15, 2000, in the Systems II Building adjacent to Steelcase Corporate Headquarters at 1111 44th Street S.E., Grand Rapids, Michigan.

60

Steelcase Offerings Around the World

Steelcase North America
- Steelcase
- Olestra Hauserman
- Steelcase Wood
- Turnstone
- Steelcase Services

Steelcase International
- Airborne (France)
- Gordon Russell (UK)
- Pohlschröder (Germany)
- Strafor (France)
- Waiko (Germany)
- Werndl (Germany)
- Steelcase

Steelcase Design Partnership
- Brayton International
- Details
- Metro
- Vecta
- Wigand

Steelcase Surfaces Partnership
- DesignTex
- J.M. Lynne

Other Ventures
- IDEO
- Attenex
- Workstage

Steelcase

Design Firm: **Genesis Inc.** Creative Director: **Jim Adler** Art Director and Designer: **Beth Kreimer** Copywriter: **David Hill** Client: **Steelcase Inc.**

Annual Reports 38,39

Bartlett & Associates designs interior spaces.

We solve problems creatively.

Inside

Talk to us.
We're good listeners.

We embrace change.

We thrive on chaos.

We consider ergonomics.

We create workplaces where people are at
their most productive.

Design Firm: **Concrete Design Communications** Art Directors: **Diti Katona** and **John Pylypczak** Designer: **John Pylypczak** Client: **Bartlett & Associates**

Architecture 40, 41

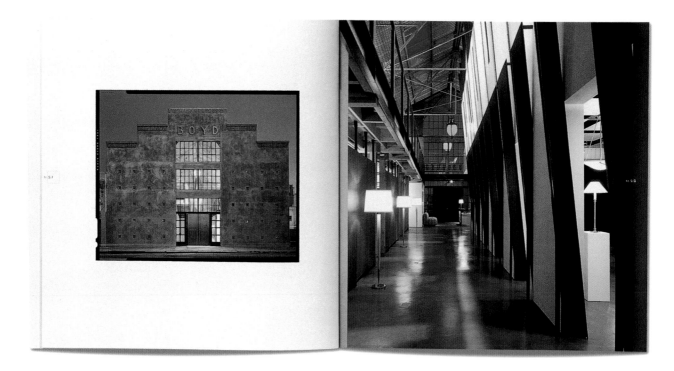

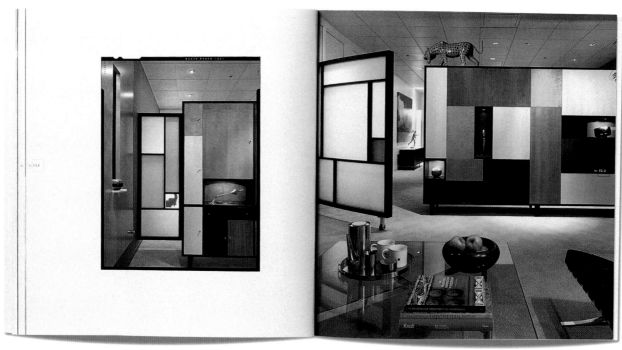

> "
> If you renovate it }
> If you reposition it } will they come
> "
> ?

now what?

FOR SALE
or LEASE
SOLD

building
exteriors
& interiors

site signage
& graphics

tenant
signage

marketing
materials

" A theme park like nobody's business. "

Creative Directors: **Rick Vaughn** and **Foster Hurley** Art Director and Designer: **Rick Vaughn** Photographer: **Michael Barley** Production Artist: **Chip Wyly** Copywriter: **Foster Hurley** Client: **Dekker/Perich/Sabatini**

Architecture 42,43

Design Firm: **Vaughn Wedeen Creative**

Surf's up.

SLK

This transmission has got you figured out. It won't take long for the SLK's driver-adaptive electronically controlled 5-speed automatic to get you down cold. Go ahead and drive the way you've always imagined driving a roadster. Let your right foot dance the tango with the gas pedal, stepping gently at times, pressing swiftly to the floor at other times, lifting suddenly when the situation calls for it. You'll be amazed how much it feels in sync with your driving desires. This is, as *Car and Driver* attests, "a fascinating machine that is better able to change its character to match the mood of the driver than any other sports car."

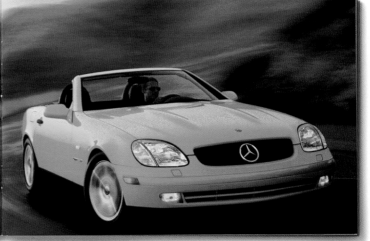

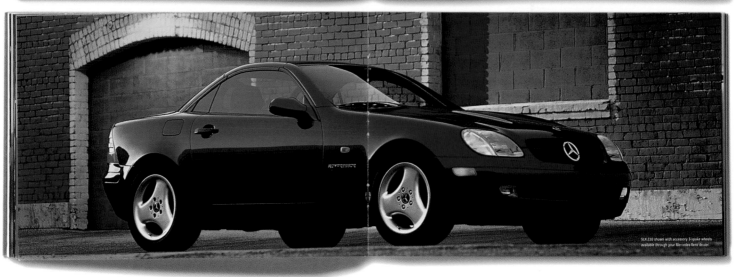

SLK 230 shown with accessory 3-spoke wheels available through your Mercedes-Benz dealer.

(this spread) Design Firm: **The Designory, Inc.** Art Director and Designer: **Andrea Schindler** Photographers: **Vic Huber** and **Michael Rausch** Copywriters: **Theo Wallace** and **Rich Conklin** Client: **Mercedes Benz of North America**

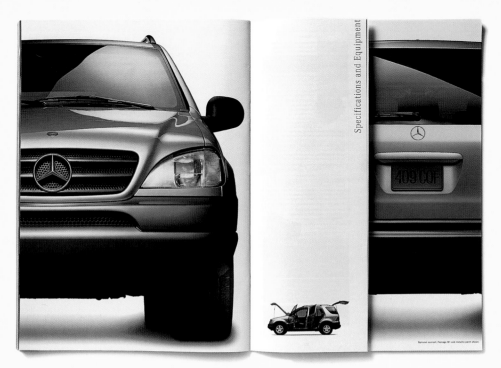

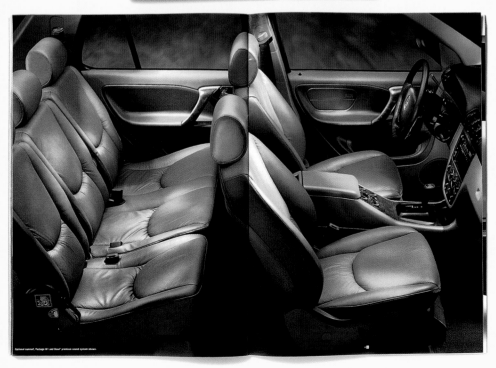

Es kommt nicht
auf die Größe an.
Sondern auf die Technik.

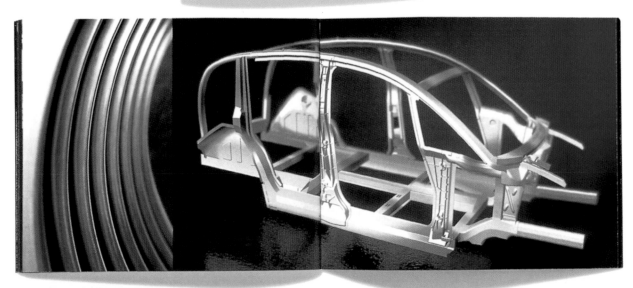

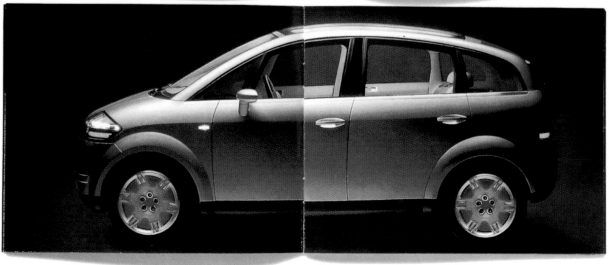

(this spread) Design Firm: **JVM Werbeagentur GmbH** Creative Directors: **Mathias Jahn** and **Heiner Rogge** Art Director: **Jörg Barre** Photographers: **Iver Hansen** and **Sigi Kercher** Client: **Audi AG**

2000 MITSUBISHI MONTERO SPORT

2000 MITSUBISHI DIAMANTE

2000 MITSUBISHI MONTERO

2000 MITSUBISHI GALANT

Design Firm: **Design Deutsch** Creative Director: **David Tanimoto** Art Directors: **Karen Knecht** and **Debra Girand** Designer: **Bill Tom** Photographers: **Paul Taylor, Michael Rausch** and **Charles Hopkins** Illustrator: **James Brown** Client: **Mitsubishi Motors USA**

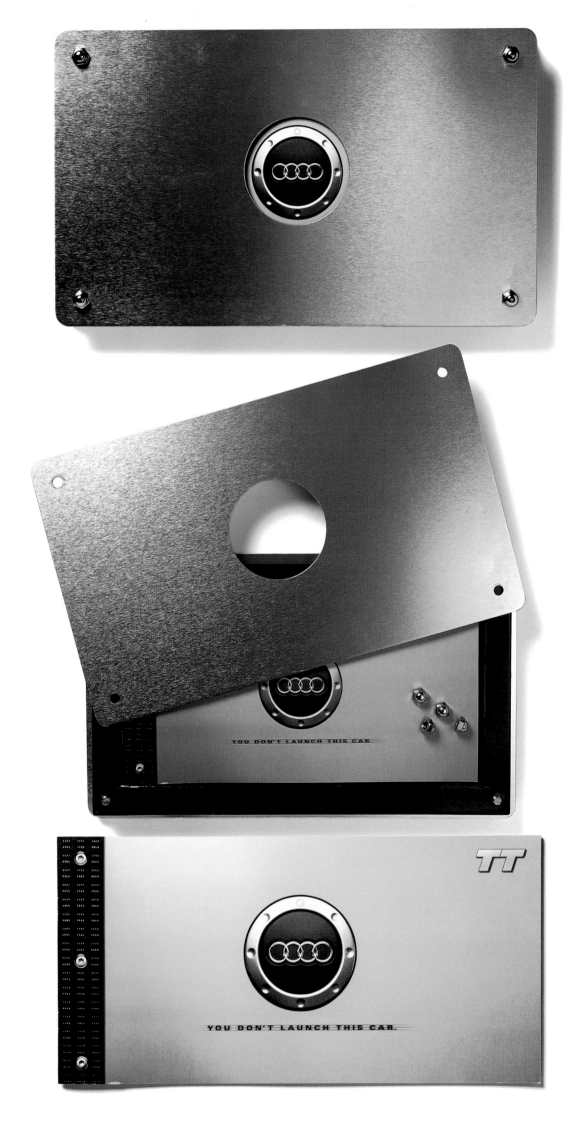

YOU DON'T LAUNCH THIS CAR

TT

YOU DON'T LAUNCH THIS CAR.

Design Firm: **McKinney & Silver** Creative Directors: **David Baldwin** and **Bob Ranew** Art Director: **Bob Ranew** Client: **Audi North America** Automotive 48, 49

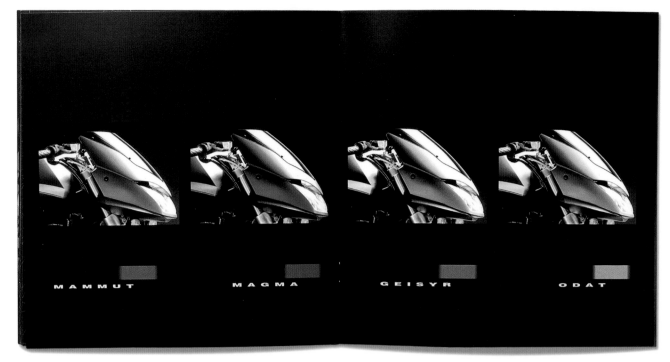

MAMMUT MAGMA GEISYR ODAT

MAMMUT 2000

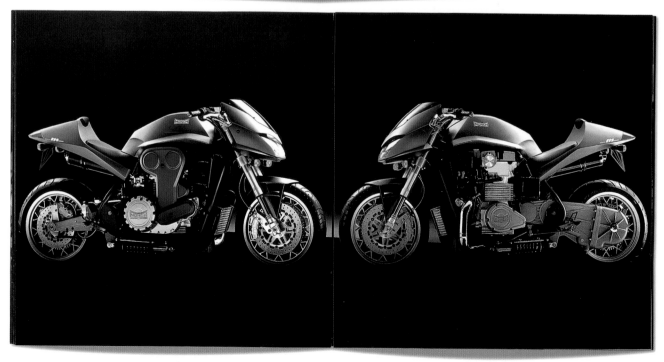

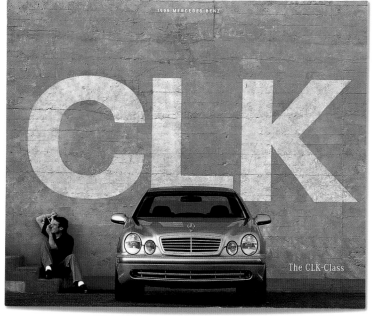

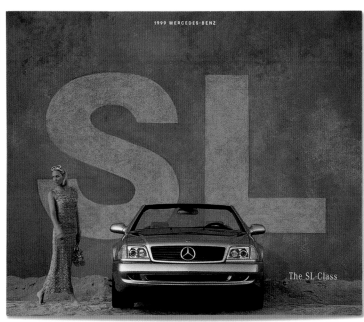

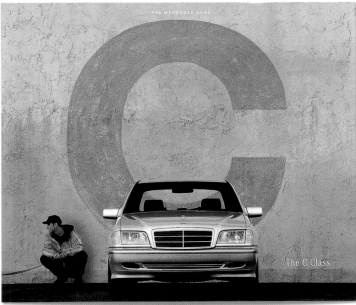

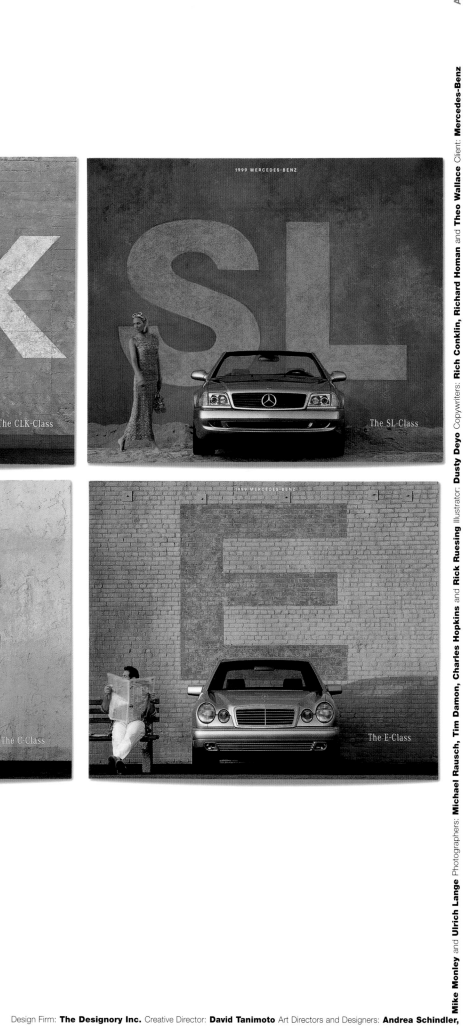

Automotive 50,51

Client: **Mercedes-Benz** and Theo Wallace Illustrator: **Rick Ruesing** Copywriters: **Dusty Deyo** Photographers: **Michael Rausch, Tim Damon, Charles Hopkins** and **Ulrich Lange** Rich Conklin, Richard Homan **Mike Monley**

Design Firm: **The Designory Inc.** Creative Director: **David Tanimoto** Art Directors and Designers: **Andrea Schindler,**

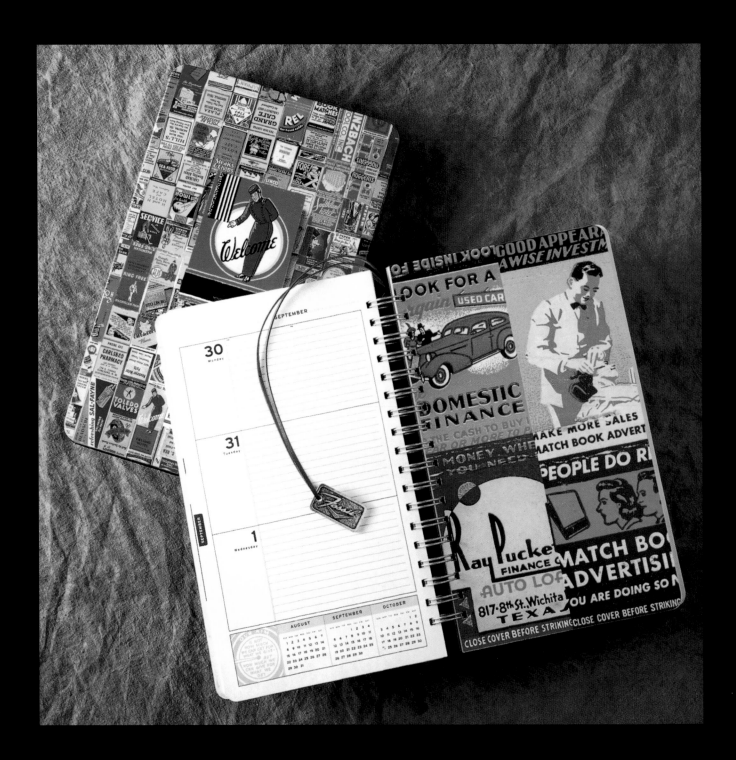

Design Firm: **Bianco & Cucco** Art Directors and Designers: **Giovanni Bianco** and **Susanna Cucco** Photographer: **Marco Pietracupa** Client: **Triton Industria e Comércio de Modas Ltda.**

Design Firm: **Johnson Design Group** Creative Director: **Len Johnson** Art Director: **Norasack Pathammavong** Designers: **Daniel Conlan** and **Norasack Pathammavong** Photographer: **Bill Dempsey** Client: **Chroma Graphics**

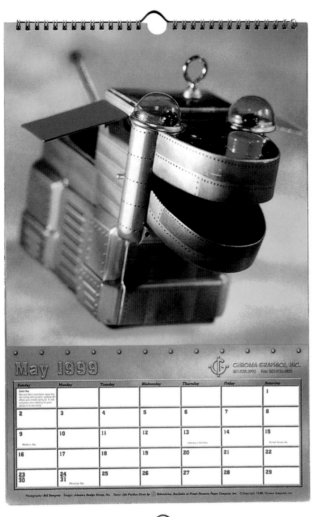

May 1999

CHROMA GRAPHICS, INC.

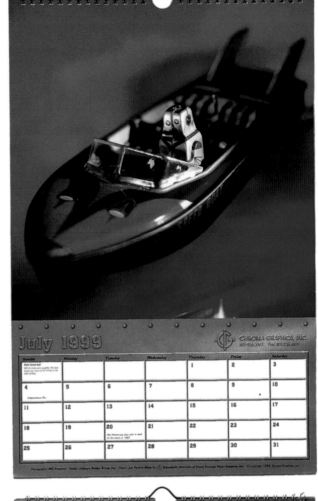

July 1999

CHROMA GRAPHICS, INC.

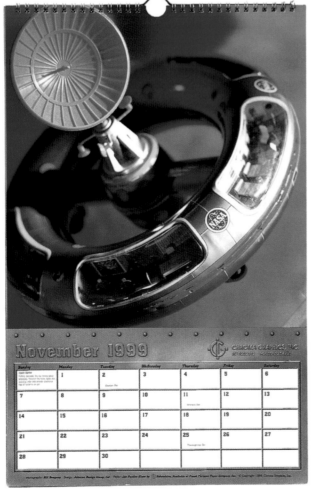

November 1999

CHROMA GRAPHICS, INC.

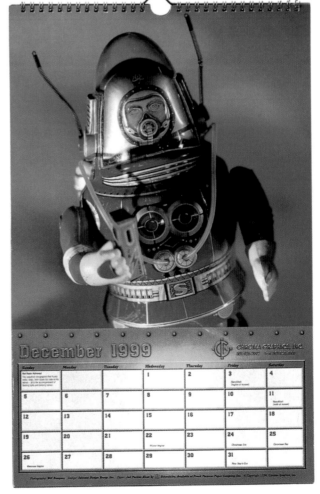

December 1999

CHROMA GRAPHICS, INC.

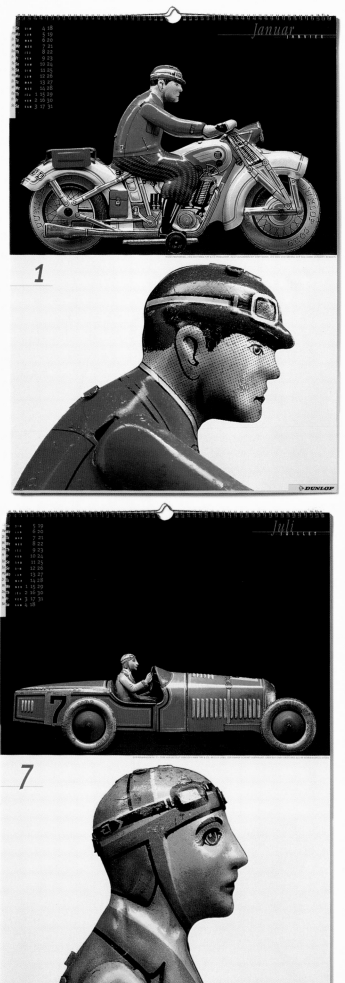

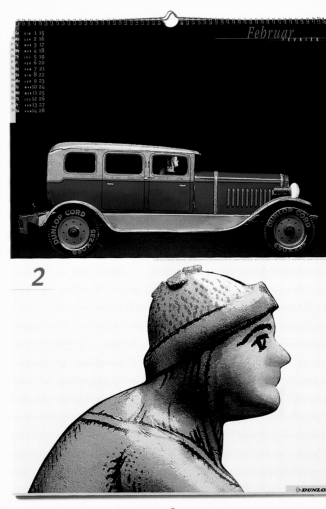

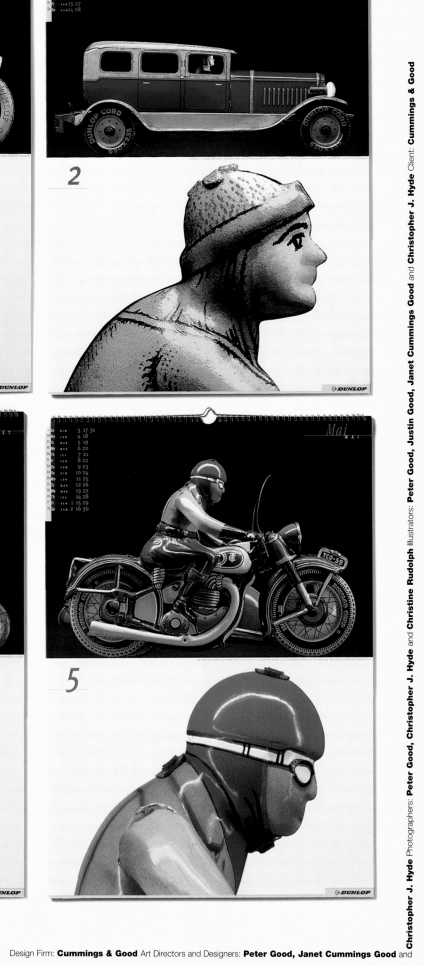

Design Firm: **Cummings & Good** Art Directors and Designers: **Peter Good, Janet Cummings Good** and **Christopher J. Hyde** Photographers: **Peter Good, Christopher J. Hyde** and **Christine Rudolph** Illustrators: **Peter Good, Justin Good, Janet Cummings Good** and **Christopher J. Hyde** Client: **Cummings & Good** Calendars 54, 55

Palakona Split Bamboo Rods

MARVEL

Known as President Eisenhower's favorite rod, the Marvel reigned as the most prized Hardy Palakona from 1925 to 1970. With its traditional slow action and built-in reserve power, the Marvel can punch through the most frustrating headwinds and precisely present the smallest dries. It's the lightest practical rod to trick highly selective trout on spooky spring creeks. And the fluid feel is enough to make any bamboo enthusiast grin with delight.

C.C. de FRANCE

In the early part of the century, if you were a serious fly caster, you attended the European casting tournaments held by the Casting Club of France. It was here in 1911 that John James Hardy cast a world record 81' with his 7' Palakona. The rod revolutionized bamboo design with its unique taper and smooth line turnover. After the tournament Mr. Hardy's rod was christened the C. C. de France and its production spanned 50 years until 1961. Wrapped with deep rub thread, the C.C. de France is an exquisite masterpiece.

PHANTOM

During the middle 60's the Phantom was the rod to own. Designed by Jim Hardy, the Phantom's firm butt section matched with a slightly stiffer tip was all the rage. It gave anglers the ability to roll cast long distances and drop dry flies with pinpoint accuracy. The Phantom balances well in the hand and becomes a true extension of the anglers' forearm. Wrapped in black rings, the Phantom is a welcomed addition to any serious collection.

LIGHTWEIGHTS

In 1997 Hardy introduced three Lightweight Palakonas exclusively for the American market. The Lightweight tapers are medium-fast with a sweet progressive action. Lightweights turnover tight loops with a lower middle to tip flexing profile. The Blue Ridge, Catskill and Yellowstone are excellent choices for your first Palakona.

MODELS	LENGTH	SECTIONS	TIPS	WEIGHT	ROD / BLANK
Marvel	7'	3	2	2 7/8 oz.	$1800 / 1260
Marvel	7'6"	3	2	3 1/8 oz.	$1850 / 1295
C.C. de France	7'	2	2	3 3/8 oz.	$1575 / 1102
Phantom	6'10"	2	2	3 1/8 oz.	$1545 / 1082
Blue Ridge	6'	2	2	2 3/4 oz.	$1465 / 1025
Catskill	6'8"	2	2	3 1/8 oz.	$1475 / 1032
Yellowstone	7'2"	2	2	3 3/8 oz.	$1495 / 1046

All Palakonas are supplied with original polished aluminum hardware, two tips, hand-fitted rosewood ferrule plugs, deluxe rod bag and the best English bridle leather case.

L to R: 7' Marvel, 6'8" Catskill, 7'6" Marvel and 7' C.C. de France

—5—

ESTABLISHED 1872

IN THE TRADITION
OF SPORTSMEN

HARDY USA

ANGLING SPECIALTIES.

FOR THE FLY FISHER

CATALOGUE

1999

Fly Lines

Hardy has produced fly lines for the last 100 years. Our lines are made for us by the world's premier manufacturers to our specifications, taper and density. They are the highest quality for your casting, and promises to make these the best available.

ULTRALITE FLOATING Designed for the Ultralite and Ultralite Plus range of rods, these lines maximize casting efficiency in fast action rods. A specialized coating makes the super soft, straight and buoyant Ultralite our best selling line. Chartreuse Green and HiVis White in 83'. WF3 to WF9 and DT3 to DT6. $40

ULTRALITE SALMON Performing flawlessly when matched to our Salmon/Spey rods, the Ultralite Salmon's unique taper gives excellent loop control, line turnover and wind penetration. Low specific gravity allows better floatation and less surface disturbances. Chartreuse Green and HiVis White in 90' DT9 and DT10. $60

DRY FLY FLOATING The economically priced Dry Fly Floating line has been a part of our range for more than 15 years. Its blue coating has proven to be the most durable coating on the market. The line has excellent shooting properties and floatability. Great for our Featherlite, Smuggler and Perfection Glass rods. Ice Blue in 83'. WF4 to WF6. $38

CLEAR SINKING Designed for saltwater, deep nymphing and saltwater anglers, our Clear Sinking line is virtually undetectable under water. Its has a uniform soak rate of 1.5 to 2.0 inches per second. Clear in 81'. WF5 to WF9. $52

LEATHER FLY WALLETS Made by our leather rod tube craftsman, these wallets make the perfect gifts for die-hard fly tyers. Ideal for nymphs, streamers and steelhead patterns. Smooth Leather $62. Pigskin Embossed Leather $66.

PRIESTS Two sizes for trout and salmon. This handsome accessory has a polished brass head, a hardwood handle and leather wrist thong. Trout $32 Salmon $38

BRASS BALANCE Each brass balance has a large hook and micrometer adjustment. Finished in polished brass, these quality balances have dual markings in ounces and grams. 11 lbs. x 2 ozs. $44

LAPEL PIN The Hardy Corporate logo in brass with enamel appliqué. $15

NEOPRENE REEL POUCH Standard neoprene reel pouch embossed with Hardy logo. Size fits up to 3 3/4" reels or spools. $15

NEOPRENE FLY LINE RETAINER Simple and inexpensive method to keep fly lines in place on spare spools. One size fits all. $10

VINYL REEL POUCH Our standard reel case for the last 50 years with standard zip fastener and foam padded insert. Small $16 Large $16.50 Extra Large $17

PIN-ON RETRACTOR High quality zinger made in our factory. Molded plastic with nylon cord. $20

—21—

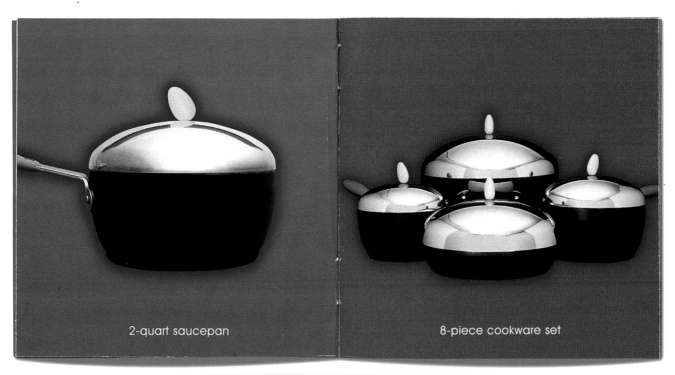

2-quart saucepan

8-piece cookware set

finding the fun
in functional.

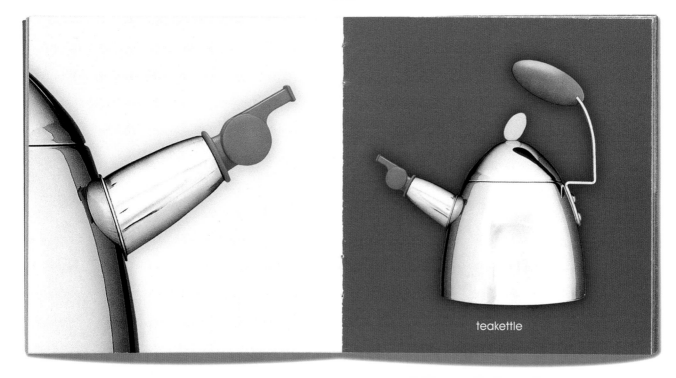

teakettle

Design Firm: **Design Guys** Creative Director and Art Director: **Steven Sikora** Designer: **Dawn Selg** Photographers: **Lars Hansen** and **Darrell Eager** Copywriters: **Jay Kaskel** and **Steven Sikora** Client: **Target Stores**

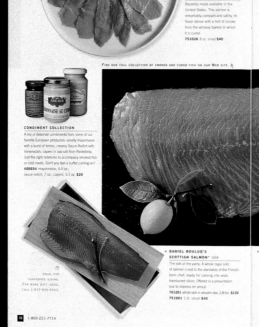

WILD SCOTTISH SALMON* SCOTLAND

SELECTION OF THREE SALMONS USA

CONDIMENT COLLECTION

BALIK OF SALMON* ENGLAND

DANIEL BOULUD'S SCOTTISH SALMON* USA

ATLANTIC SMOKED SALMON* USA

DEAN & DELUCA
PURVEYORS OF FINE FOOD, WINE AND KITCHENWARE

Autumn 2000

WWW.DEANDELUCA.COM

DEAN & DELUCA
PURVEYORS OF FINE FOOD, WINE AND KITCHENWARE

Holiday 2000

WWW.DEANDELUCA.COM

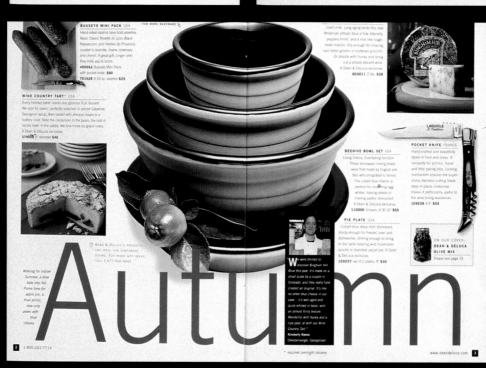

BUSSETO MINI PACK USA

WINE COUNTRY TART* USA

BEEHIVE BOWL SET USA

PIE PLATE USA

POCKET KNIFE FRANCE

ON OUR COVER:
DEAN & DELUCA
OLIVE MIX

Autumn

VOLUME ONE

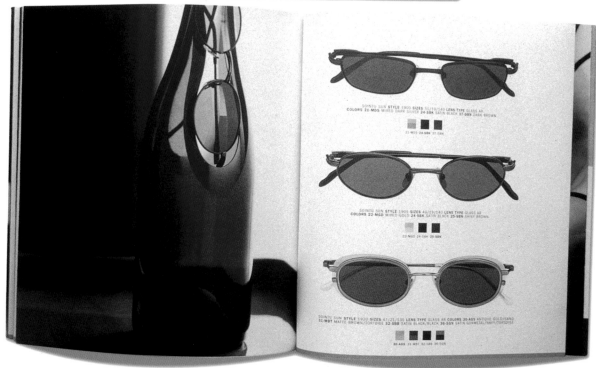

Design Firm: **The Valentine Group** Creative Director: **Robert Valentine** Designers: **David Meredith** and **Robert Valentine** Photographer: **Martyn Thompson** Copywriter: **Walter Thomas** Client: **Marchon Eyewear**

(this spread) Design Firm: **Fossil, Inc.** Creative Director: **Tim Hale** Art Directors: **Hasn Dorsinville** and **Brad Bollinger** Designers: **Brad Bollinger, Courtney Poremski** and **Eric Veneg** Photographer: **David McCormick** Copywriter: **Kathleen Boyles** Client: **DKNY**

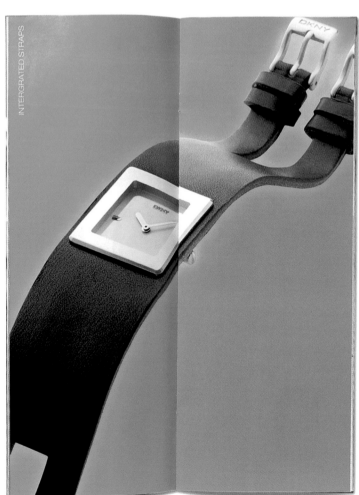

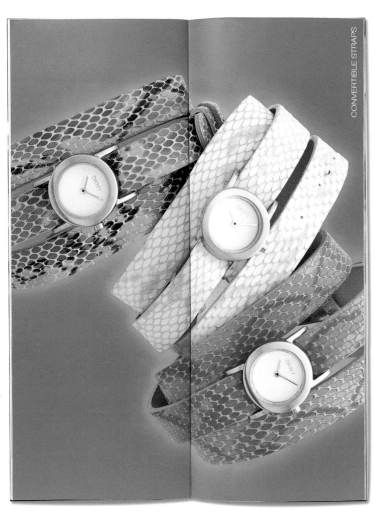

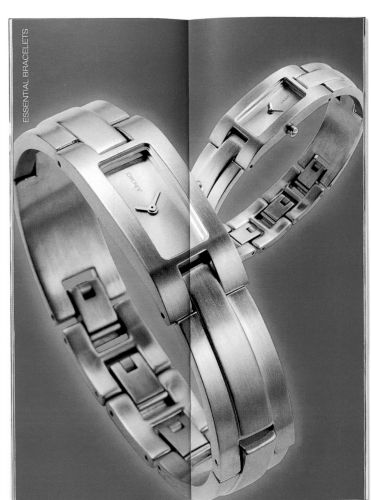

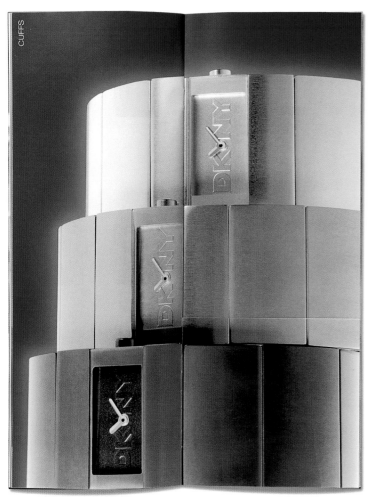

NY-8000

NY-8001

NY-8002

NY-8003

NY-8004

NY-8005

NY-8006

NY-8007

Design Firm: **Fossil, Inc.** Creative Director: **Tim Hale** Art Directors: **Hasn Dorsinville** and **Brad Bollinger** Designers: **Brad Bollinger, Courtney Poremski** and **Eric Veneg** Photographer: **David McCormick** Copywriter: **Kathleen Boyles** Client: **DKNY**

DKNY TIME

UPDATE
05.2000

INTEGRATED STRAPS

DKNY ACTIVE

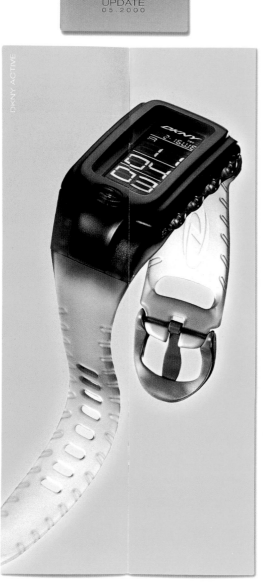

DKNYWATCHES

NY-7000
$ 115

NY-7001
$ 115

NY-7002
$ 115

NY-7003
$ 115

NY-7004
$ 115

NY-7005

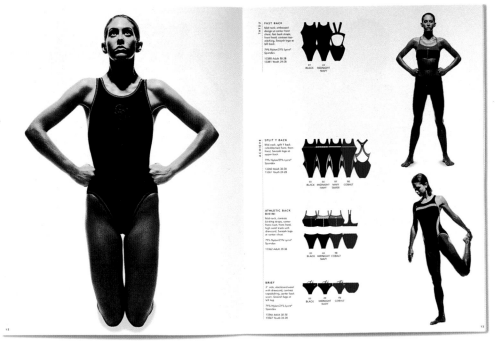

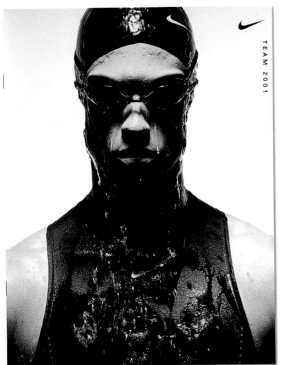

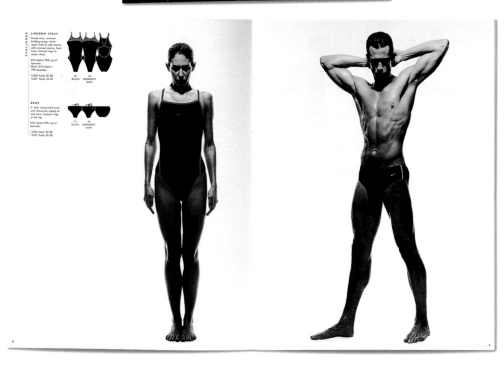

Design Firm: **Todd Eckelman Photography** Creative Director: **Brian Murphy** Art Directors: **Renee Renfrow** and **Brian Murphy** Designer and Photograper: **Renee Renfrow** Client: **Nike**

FOCUS:

AMID THE UNIVERSE OF TEXTILE PROVIDERS LIES THE INTEGRATED SPECIALTY COMPANIES OF THE DIXIE GROUP. THEIR COMBINED FOCUS: HIGH QUALITY SYNTHETIC AND NATURAL YARNS AS INTEGRAL COMPONENTS OF FINE FABRICS, WHICH IN TURN, IMPART THE UNDERLYING VALUE TO A HOST OF FINISHED APPAREL PRODUCTS.

SPECIALTY TEXTILES INCLUDE PREMIUM COTTON KNIT FABRIC DEVELOPED FOR HIGH PERFORMANCE ACTIVE ENTERWEAR, AND YARNS FOR UPHOLSTERY AND DECORATIVE FABRICS FOR HOME AND BUSINESS. DIXIE'S NEWLY FORMED FINISHED APPAREL BUSINESS DESIGNS AND MANUFACTURES SPORTSWEAR, ACTIVEWEAR, AND GOLFWEAR FOR MAJOR NAME-BRAND RETAILERS.

THE DIXIE GROUP. LEADERSHIP IN PREMIUM QUALITY FABRIC AND AN EXPANDING RANGE OF FINISHED APPAREL FOR THE HIGH-GROWTH MARKETS OF ATHLETIC, ACTIVITY, AND LEISURE RETAILERS WORLDWIDE.

LEADERSHIP: SOUND & DETERMINED

TEXTILE/APPAREL: NATURAL AND SYNTHETIC YARNS FOR THE GARMENT AND HOME FURNISHING INDUSTRIES. EXCLUSIVE COTTON KNIT FABRIC FOR NAME-BRAND ACTIVEWEAR AND SPORTSWEAR MANUFACTURERS. FINISHED KNIT GARMENTS FOR LEADING SPORTS APPAREL RETAILERS.

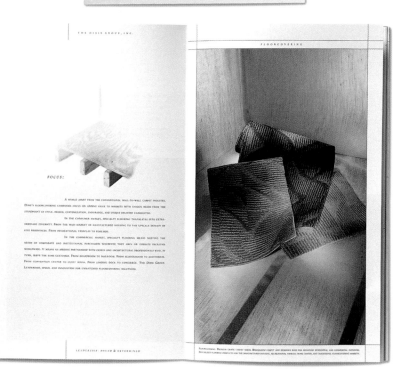

FOCUS:

A WORLD APART FROM THE CONVENTIONAL WALL-TO-WALL CARPET INDUSTRY, DIXIE'S FLOORCOVERING COMPANIES FOCUS ON ADDING VALUE TO MARKETS WITH UNIQUE NEEDS FROM THE STANDPOINT OF STYLE, DESIGN, CUSTOMIZATION, ENDURANCE, AND UNIQUE DELIVERY CAPABILITIES.

IN THE CONSUMER MARKET, SPECIALTY FLOORING TRANSLATES INTO EXTRA-ORDINARY DIVERSITY. FROM THE MASS MARKET OF MANUFACTURED HOUSING TO THE UPSCALE DOMAIN OF FINE RESIDENCES. FROM RECREATIONAL VEHICLES TO POOLSIDE.

IN THE COMMERCIAL MARKET, SPECIALTY FLOORING MEANS MEETING THE NEEDS OF CORPORATE AND INSTITUTIONAL PURCHASERS WHEREVER THEY OWN OR OPERATE FACILITIES WORLDWIDE. IT MEANS AN ABIDING PARTNERSHIP WITH DESIGN AND ARCHITECTURAL PROFESSIONALS WHO, IN TURN, SERVE THE SAME CUSTOMER. FROM BOARDROOM TO MAILROOM. FROM SCHOOLROOM TO AUDITORIUM. FROM CONVENTION CENTER TO GUEST ROOM. FROM LOADING DOCK TO CONCIERGE. THE DIXIE GROUP. LEADERSHIP, SPEED, AND INNOVATION FOR UNMATCHED FLOORCOVERING SOLUTIONS.

LEADERSHIP: SOUND & DETERMINED

FLOORCOVERING: PREMIUM GRADE CARPET YARNS. BROADLOOM CARPET AND DESIGNER RUGS FOR INDUSTRIAL, RESIDENTIAL, AND COMMERCIAL INTERIORS. SPECIALIZED FLOORING PRODUCTS FOR THE MANUFACTURED HOUSING, RECREATIONAL VEHICLE, HOME CENTER, AND TRADITIONAL FLOORCOVERING MARKETS.

Design Firm: **Access Group** Creative Director: **Brent McMahon** Art Directors: **Brent McMahon** and **Rory Meyers** Designer: **Rory Meyers** Photographer: **Jay Hicks (Hicks Photography)** Client: **The Dixie Group, Inc.**

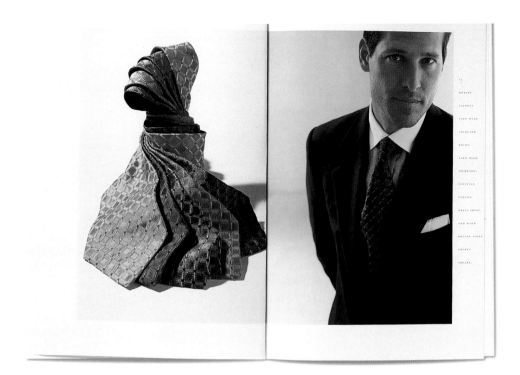

[*ritual*]

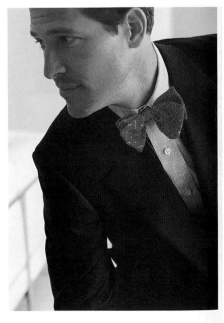

Design Firm: **Vanderbyl Design** Creative Director: **Michael Vanderbyl** Client: **Robert Talbott** Catalogues 64, 65

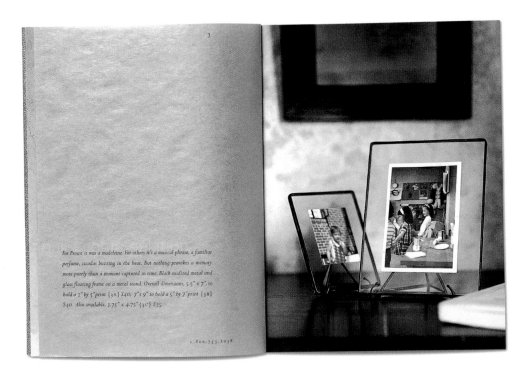

For Proust it was a madeleine. For others it's a musical phrase, a familiar perfume, cicadas buzzing in the heat. But nothing provokes a memory more purely than a moment captured in time. Black oxidized metal and glass floating frame on a metal stand. Overall dimensions, 5.5" x 7", to hold a 3" by 5" print {3A} $40; 7" x 9" to hold a 5" by 7" print {3B} $40. Also available, 3.75" x 4.75" {3C} $35.

1.800.753.2038

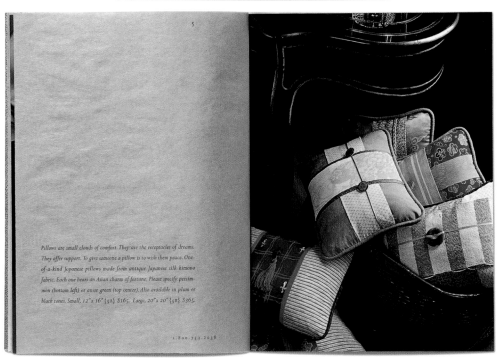

Pillows are small clouds of comfort. They are the receptacles of dreams. They offer support. To give someone a pillow is to wish them peace. One-of-a-kind Japanese pillows made from antique Japanese silk kimono fabric. Each one bears an Asian charm of fortune. Please specify persimmon (bottom left) or anise green (top center). Also available in plum or black tones. Small, 12" x 16" {5A} $165. Large, 20" x 20" {5B} $365.

1.800.753.2038

(this spread) Design Firm: **M/W Design** Client: **Takashimaya**

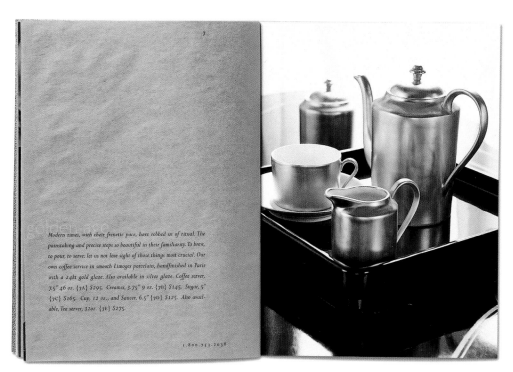

7

Modern times, with their frenetic pace, have robbed us of ritual. The painstaking and precise steps so beautiful in their familiarity. To brew, to pour, to serve: let us not lose sight of those things most crucial. Our own coffee service in smooth Limoges porcelain, handfinished in Paris with a 24kt gold glaze. Also available in silver glaze. Coffee server, 7.5" 46 oz. {7A} $295. Creamer, 3.75" 9 oz. {7B} $145. Sugar, 5" {7C} $165. Cup, 12 oz., and Saucer, 6.5" {7D} $125. Also available, Tea server, 32oz. {7E} $275.

1.800.753.2038

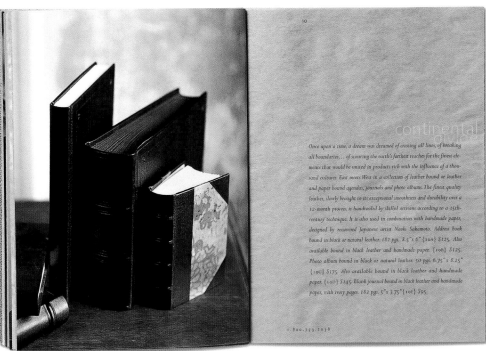

10

Once upon a time, a dream was dreamed of crossing all lines, of breaking all boundaries.... of scouring the earth's farthest reaches for the finest elements that would be united in products rich with the influence of a thousand cultures. East meets West in a collection of leather bound or leather and paper bound agendas, journals and photo albums. The finest quality leather, slowly brought to its exceptional smoothness and durability over a 12-month process, is handtooled by skilled artisans according to a 15th-century technique. It is also used in combination with handmade paper, designed by renowned Japanese artist Naoki Sakamoto. Address book bound in black or natural leather. 132 pgs. 8.5" x 6". {10A} $125. Also available bound in black leather and handmade paper. {10B} $125. Photo album bound in black or natural leather. 50 pgs. 6.75" x 8.25" {10C} $175. Also available bound in black leather and handmade paper. {10D} $145. Blank journal bound in black leather and handmade paper, with ivory pages. 132 pgs. 5"x 3.75"{10E} $95.

1.800.753.2038

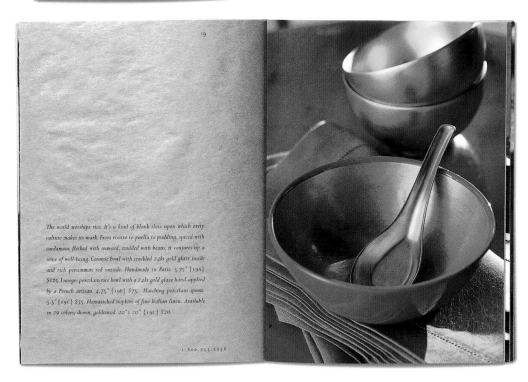

19

The world worships rice. It's a kind of blank slate upon which every culture makes its mark. From risotto to paella to pudding, spiced with cardamom, flecked with seaweed, studded with beans, it conjures up a sense of well-being. Ceramic bowl with crackled 24kt gold glaze inside and rich persimmon red outside. Handmade in Paris. 5.75" {19A} $125. Limoges porcelain rice bowl with a 24kt gold glaze hand-applied by a French artisan. 4.75" {19B} $75. Matching porcelain spoon. 5.5"{19C} $35. Hemstitched napkin of fine Italian linen. Available in 29 colors; shown, goldenrod. 20"x 20" {19C} $20.

1.800.753.2038

Design Firm: **Jennifer Sterling Design** Creative Director, Art Director, Designer and Illustrator: **Jennifer Sterling** Client: **Pina Zangaro**

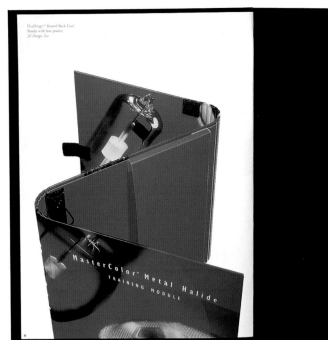

FlexHinge™ Round Back Easel
Binder with box pockets
JE Design, Inc.

MasterColor™ Metal Halide
TRAINING MODULE

Video Mailer with lock tab closure
MJB Associates

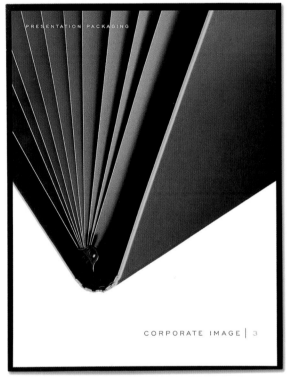

PRESENTATION PACKAGING

CORPORATE IMAGE | 3

WHAT IS A FLEXBOX™? IT'S AN EXCITING NEW CONCEPT FROM CORPORATE IMAGE THAT FEATURES THE BEST OF SEVERAL PRODUCTS. AT FIRST GLANCE, IT LOOKS LIKE A FLEXHINGE™ BINDER, MINUS THE RINGS. THE SPINE CAN BE EITHER ROUND OR SQUARE. BOTH COVER AND LINER CAN BE PRINTED, OFFERING UNLIMITED GRAPHIC DESIGN OPPORTUNITIES. OPEN A FLEXBOX™ AND INSIDE YOU'LL FIND A BOX POCKET THAT CAN

2 | FLEXBOXES™

RANGE IN CAPACITY FROM FOLDER SIZE TO SALES BOX DEPTH. THE POCKET ITSELF CAN BE PRINTED. LARGE OR SMALL, THE FLEXBOX™ IS TRULY AN INNOVATIVE PRESENTATION PACKAGE OFFERING THE APPEARANCE AND DURABILITY OF A FINELY BOUND BOOK. AND SINCE THERE IS NO RING MECHANISM, IT'S THE PERFECT WAY TO PRESENT TRADITIONAL OR SPIRAL BOUND MATERIALS.

FlexBox™ with box pocket
The Dax Ritenbaul Co., Inc

Design Firm: **Pattee Design Inc.** Art Director: **Kelly Stiles** Designers: **Trenton Bured** and **Kelly Stiles** Client: **Corporate Image**

Catalogues 68,69

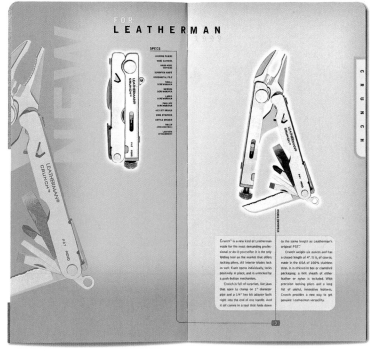

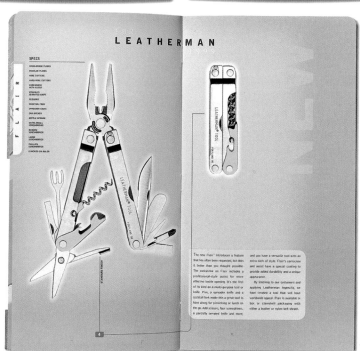

Design Firm: **Hornall Anderson Design Works** Art Directors: **Jack Anderson** and **Lisa Cerveny** Designers: **Lisa Cerveny, Alan Florsheim** and **Don Stayner** Photographer: **Jeff Condit, Studio 3** Illustrator: **Jack Unruh** Copywriter and Client: **Leatherman Tool Group**

Design Firm: **Sandstrom Design** Creative Director and Art Director: **Steve Sandstrom** Designer: **Andrew Randall** Copywriter: **Steve Sandoz** Client: **Tazo**

Catalogues 70, 71

AT VARIOUS TIMES throughout history Tazo has surfaced among the more advanced cultures of the day as a solution to the angst of daily life. Although the origins of Tazo are disputed, evidence of it has been found in most regions of the globe with artifacts dating back nearly 5,000 years. The formulas for these ancient beverages were rediscovered by a team of archeologists and tea scholars when low tides caused by a solar eclipse revealed a previously unknown cave on the edge of the Red Sea. Inside they discovered the Tazo stone. Once the arcane language of the stone was translated, it was a simple task to recreate the formulas for these mystically delicious beverages.

The Tazo you drink today is made with only the finest teas and other ingredients to be found on the planet without regard to cost. The only factors we consider when blending a flavor of Tazo are taste, aroma and appearance. It has been this way for centuries.

Note: This symbol ⊕ indicates a Tazo exclusive product.

TAZO ICED TEA: Recent findings have provided conclusive proof that iced Tazo is just as delicious and refreshing in the winter as it is in the summer. In fact, there is new evidence that some cultures use it as a base for their so-called "holiday" punch. Each box contains 12 oversized iced tea bags, each one large enough to make one quart of the extraordinary beverage. Available in the following flavors: [153] Basic Black, [154] Zen, [155] Passion. $4.95 ⊕

[095] BOOK OF TAZO: Most books are written with words, but this book, in keeping with the ancient traditions of the tea shaman, is written with tastes. It's an elegant and stylish way to offer your guests an extraordinary tea experience. This beautiful black linen book holds 8 filterbags each of: Calm, Earl Grey, Om, Refresh, Awake, Wild Sweet Orange, Zen and Passion. $48.00 ⊕

3

[014] ORGANIC TAZO CHAI: When Chai, the spicy, sweet tea drink of the Himalayas first appeared, it, and everything else on the planet, was organic. But in the several thousand years since its introduction many people have chosen faster, cheaper ways to make this ancient beverage. Tazo Chai is still as organic as it was the day the first chai wallah set up his stall on the path to Muktinath. It contains rich black teas from North India and Sri Lanka blended with ginger, cinnamon, star anise, cloves and cardamom. It is sweetened only with organic honey and agave cactus nectar. Mixed with milk or dairy alternatives, it makes a refreshing and tasty beverage which may be served either hot or cold. Available in a 32 fluid oz. carton. Makes one half gallon. $8.00 ⊕

TAZO No: 1(800)299-9445

014

015

[015] TAZO CHAI FULL LEAF TEA: In parts of Tibet it used to be a custom for the father of the bride to give the groom a dowry of Tazo Chai Full Leaf teas to compensate for the expense of supporting his daughter. Perspective mates judged each other on how much Tazo they could be expected to command. The full leaf Tazo Chai contained in these particular tins enables you to have the full Chai experience at home, brewing it as rich and strong as you like before adding sweetener like honey or agave nectar and milk. $7.50 ⊕

[113] ORGANIC TAZO CHAI FILTERBAGS: In parts of India and Nepal the Chai Wallah is so revered and loved as a guru for his ability to brew robust cups of fresh, sweet, spicy chai. This is a talent you can cultivate at home with no more than a pot of hot water, a carton of milk and this box of magic bags. Not only are these Tazo Chai filterbags certifiably organic, but because you add the sweetener and milk, you can make the brew just as strong and rich as you like. $4.75 ⊕

113

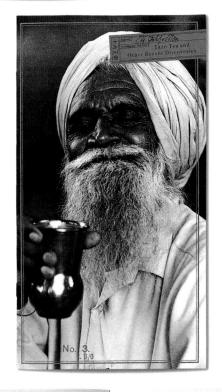

Tazo Tea and Other Recent Discoveries

No. 3.

14

ORDERING INSTRUCTIONS

To order Tazo tea products or teaware is not difficult. Follow the simple instructions and we'll have your Tazo at your door before you know it.

1. TO ORDER: Simply fill in the description of the product in the space provided. Enter the price of the product and multiply it by the number you want of each item. Continue this process for each item ordered. Total the cost of all items then enter the delivery charge (see chart below) in space provided. Finally, add it all up and tell us how you intend to pay.

2. METHOD OF PAYMENT: Payment in the currency of bankrupt nations, or any foreign currency for that matter, is not allowed, nor will we accept payment in ancient talismans, sacred stones or magic beans. We will however accept checks, Visa, Mastercard or American Express. Sorry no C.O.D. orders.

3. Please enclose additional sheets for more items or for special shipping instructions.

4. SEND, CALL, FAX or EMAIL your order to:
 TAZO, P.O. Box 66
 Portland, OR 97207
 Toll free: 1-800-299-9445
 Tel: 503-231-9234
 Fax: 503-231-8801
 Email: tea@tazo.com

5. Please allow approximately 2 weeks of this lifetime for delivery.

TAZO No: 1(800)299-9445

DELIVERY CHARGE PER ADDRESS	
Orders Totaling	Include
$0.00 and under	3.95
10.01-25.00	4.95
25.01-50.00	5.95
50.01-80.00	7.95
80.01-100.00	9.95
100.01-150.00	11.95
150.01 and over	13.95

Endless Tazo. Endless Bliss.

FOR CENTURIES, in many parts of the globe, a tea shaman would ride through villages and small communities once every couple of months to replenish the local supplies of teas. It's your good fortune that this service is once again available.

Enroll in the INFINITE TAZO program, and once every eight weeks (or schedule you determine) a tea shaman (disguised as a UPS delivery person) will bring your favorite form of Tazo right to your door. We'll even toss in a FREE $30 stainless steel Tazo canister to hold your previous teas.

To enroll, call the INFINITE TAZO line, 1-800-299-9445, or use the order form below. Just tell us what you would like to receive (specific flavors, either filterbags or full leaf teas), the quantity you would like (must be at least 3 filterbags cartons or 3 full leaf tea tins), and the frequency of delivery you want and we'll begin your automatic shipments. To change your flavor selection or delivery schedule, call the INFINITE TAZO line 1-800-299-9445.

I would like to receive the following teas as an Infinite Tazo member:

Item Code Item Description Unit Price x Qty. = Total

Please bill shipments to: ☐ Visa ☐ Mastercard ☐ American Express
Credit Card No: Expiration Date:
Your Name X

DETACH AND MAIL TO:
TAZO, P.O. Box 66, Portland, OR 97207

Name: Phone:
Street Address: Code:
City: State: Zip:

15

ORDER FORM TAZO No: 1(800)299-9445

Name:
Street Address:
City: State: Zip:
Phone:

Item Code	Item Description	Unit Price	x Qty.	= Total

Shipping Charge
Total

SEND GIFT TO:

Name:
Street Address:
City: State: Zip:

Item Code	Item Description	Unit Price	x Qty.	= Total

☐ Gift message:

Shipping Charge
Total

ORDER SUMMARY

Customer Total: + Gift(s) Total = Total Payment
Payment Method: ☐ Visa ☐ Mastercard ☐ American Express ☐ Check or M/O
Cardholder's Name:
Card Number:
Expiration Date: Phone:

Thank you for your order. Tazo!

DAS FEUER WAR AUSGANGSPUNKT DER ZIVILISATION. HIER WURDE DIE BEUTE ZERTEILT UND GEGART, HIER WURDEN DIE ERLEBNISSE DES TAGES AUSGETAUSCHT

Am Feuer wurde das erste Werkzeug gebraucht, um die Hände vor der Glut zu schützen und die Hitze des Feuers zu nutzen. Um das Feuer wurden Kenntnisse beschrieben und weitergegeben, um das beste Brennmaterial, die besten Sammelplätze für Früchte und Beeren oder Jagdgründe zu finden. Um das lodernde Feuer herum entstanden Spiele und Rituale, die von den Alten an die Jungen weitergegeben wurden und der Horde ein erstes Selbstverständnis gaben. So wundert es nicht, daß sich die ältesten Zeugnisse menschlicher Geschichte oft um Feuerstellen herum finden, dieser Heimat unserer Kulturen. In der Asche erloschener Feuerstellen finden die Forscher Details, hier können sie anhand von Knochensplittern, Material- und Werkzeugresten den Alltag unserer Vorfahren rekonstruieren. Haben sie schon Erze geschmolzen, Keramik gebrannt?

Viele Errungenschaften unserer Kultur gehen auf die Nutzung des Feuers zurück, sind ohne sie nicht denkbar. Wichtiger für unsere Geschichte scheint aber, daß unsere Vorfahren erst um das Feuer herum die bis heute wirkenden Grundlagen unserer Zivilisation gelernt haben. Ist auch das Geschehen dieser Vorzeiten fast ganz im Dunkel der Frühgeschichte verlorengegangen, findet es immer noch seinen Widerhall, wenn wir gemütlich um ein Lagerfeuer sitzen oder im großen Kreis ehrfürchtig um ein riesiges Osterfeuer stehen – aber auch, wenn wir nur ein prasselndes Feuer im Kamin betrachten oder hungrig um die zischende Glut eines Grills auf das fertig gegarte Mahl warten: im Spiel der Flammen und Glut werden die Erinnerungen an das Ursprüngliche lebendig.

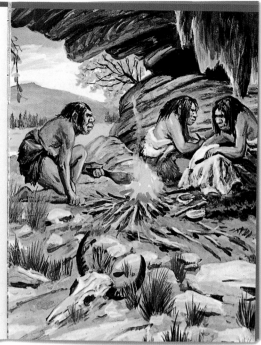

Feuer der Leidenschaft

Ein heißes Lodern ergriff ihr Herz, als er den Aufzug betrat. So oft hatte Bianca diesen Moment herbeigesehnt, doch jetzt wünschte sie nichts sehnlicher, als aus der Hitze dieses Moments in eine einsame Eiswüste fliehen zu können. Zu spät – er grüßte sie nur mit einem flüchtigen Blick, sah auf die Uhr, und öffnete lässig sein maßgeschneidertes Sakko und drehte einen Schlüssel auf der Schalttafel des Aufzugs.

Ein Mann wie im Bilderbuch, dachte sie, als er Atem holte und das frisch gestärkte Hemd sich für einen Moment über seiner Brust spannte. Noch gestern hatte sie ihrer engsten Freundin ihre geheimsten Fantasien anvertraut: wie sie, die charmante Telefonistin des Kunden-Callcenters, durch einen Zufall den Juniorchef des Weltkonzerns in der Leitung hatte – ein Testanruf? Oder ein Fehler in der Telefonanlage? Und wie sie, Bianca, ihn am Telefon zum Lachen brachte, er spontan nach ihrem Namen fragte, sich an sie erinnerte und fragte, ob sie heute abend schon etwas vorhabe ... Kathy lachte nur, sagte irgendetwas von Realität und Alltag, ihr aber war klar, das hier nur ihr Herz gesprochen hatte.

Bis ihr Traum wahr werden sollte, hatte sie beschlossen, jede Mittagspause den Aufzug zur Chefetage zu nutzen. Wie zufällig sollte es aussehen, und daher verbrachte sie die 45 Minuten zwischen den 60 Stockwerken der Systemzentrale, und kommandierte den mahagonivertäfelten Aufzug mit der Schließanlage für das 61. Stockwerk zwischen Himmel und Erde hin und her. Abwärts schien es schneller zu gehen als

HOT 'N

SPICY

Eine flammende Liebeserklärung an die feurige Küche: „Das Essen schuf Gott, die Köche der Teufel" wußte schon James Joyce die bloße Nahrungsaufnahme von den kulinarischen Künsten zu unterscheiden.

Und seit jeher wird dem leidenschaftlichem Genuss eher teuflische Schärfe zugemessen, die nicht nur auf der Zunge und im Gaumen, sondern im Gemüt als Ganzen Wirkung zeigt. Die teuren Gewürze treiben Blutdruck, Herzschlag und Transpiration, sie öffnen Pupille und Seele für die schönsten Seiten des Lebens.

Aber wer soll das glauben, der noch nicht nachgemessen hat: in Scoville-Einheiten bewertet man die Schärfe von Chilis, und wen eine ordentliche Arrabiata mit italienischen Peperoncinos von 5000 Scoville ins Schwitzen bringt, der sei vor einem üblichen Thai-Chili mit rund 100.000 Scoville gewarnt.

Wer wagt, gewinnt. So sei deshalb der schonenden Küche kühler Breiten ein Feuerwerk scharfer Exotik entgegengesetzt. Denn erst mit dem Curry wurde aus der Wurst ein Kult, wissen wir selbst im kalten Norden, und freuen uns mit Heißhunger auf die scharfen Sachen:

Archetyp

Sieger Design

Reminiszenz an den Kanonenofen und seine vielfältigen Formen. Sieger Design entwickelte ein Modulsystem aus archetypischen Formen, die daherkommen wie altbekannt, trotzdem kompromißlos modern sind: flexibel, individuell und eigenständig. In schlichtem Schwarz mit kontrastierenden Beschlägen in Edelstahl.

$XH + O_2 \Rightarrow XO + H_2O + Wärme$

Feuer – eine seit jeher gelernte Selbstverständlichkeit. Doch was ist Feuer eigentlich?

Das Prinzip Feuer ist die Oxidation reduzierter Moleküle – meistens Kohlenwasserstoffe mit verschiedenen anderen gebundenen Molekülen. Sie werden mit Sauerstoff versetzt, die Elektronenbindung zwischen den Molekülen wird auf ein niedrigeres Energieniveau herabgesetzt, die Ursprungsmoleküle werden dabei aufgelöst. Dieser

Prozeß kann unterschiedlich schnell ablaufen – vom langsamen Glimmen feuchten Torfes bis hin zur explosionsartigen Verpuffung von Gasen.

Die Brennstoffe Im Prinzip sind fast alle Materialien oxydierbar. Im Normalfall brennen Kohlenwasserstoffe – große Molekülverbände, die wie Holz in der Natur durch die Photosynthese unter Nutzung der im Sonnenlicht gebundenen Energie entstehen oder wie Kohle, Öl und Erdgas in erdgeschichtlichen Prozessen aus diesen Grundstoffen hervorgegangen sind.

Die Hitze Feuer ist Freisetzung von Energie. Die Überführung großer geordneter Molekülverbände in kleinere Partikel setzt die in den Brennstoffen

gebundene Energie frei – je nach Brennstoff unterschiedlich viel, wie auch jeder Brennstoff unterschiedlich viele Endprodukte und nicht brennbare Reststoffe bedingt, d. h. mehr oder weniger sauber verbrennt.

Die Asche Feuer ist ein irreversibler Prozeß. Durch Zerlegung der molekularen Strukturen der Brennstoffe wird das Ausgangsmaterial mehr oder weniger vollständig zu neuen Endprodukten verändert, die zum Teil flüchtig sind. Übrig bleiben ausgebrannte Schlacken, die nicht brennbaren Reste. Sie können durchaus wertvoll sein, da sie entweder im Brennstoff enthaltene Materialien konzentrieren oder für andere Prozesse nützlich sind – z. B. als Kalk oder Dünger.

Die Flamme Der Umwandlungsprozeß findet an der Oberfläche der Brennstoffe in einer Gasblase statt, die vom für die Verbrennung notwendigen Sauerstoff und Partikeln der Brennstoffe gespeist wird. Durch die freiwerdende Energie und die Verflüchtigung der freigesetzten Gase entstehen die charakteristischen Flammenformen, deren Größe und Farbe von den beteiligten Brennstoffen und Katalysatoren abhängt.

ARCHITECTURAL
INTERIOR
DECORATIVE GLASS
LAMINATE
CASTING
SANDBLASTING
KILNFORM

FUSION GLASS DESIGNS LTD.

THERE IS NO ARCHITECTURAL MATERI-
AL MORE VERSATILE AND BEAUTIFUL
THAN GLASS. WE AT FUSION ARE ESPE-
CIALLY WELL EQUIPPED TO REALISE
ITS POSSIBILITIES. WIDE EXPERIENCE,
DEEP TECHNICAL KNOWLEDGE AND,
PERHAPS MOST IMPORTANT, A BROAD
AND ORIGINAL CREATIVE APPROACH,
HAVE BROUGHT US COMMISSIONS ON A
FASCINATING RANGE OF PROJECTS
LARGE AND SMALL. COMBINING NEW
AND TRADITIONAL METHODS, WE HAVE
BEEN ABLE TO RISE TO ALL MANNER OF
TECHNICAL CHALLENGES AND AT THE
SAME TIME PRODUCE WORK WIDELY
ADMIRED FOR ITS ORIGINALITY.

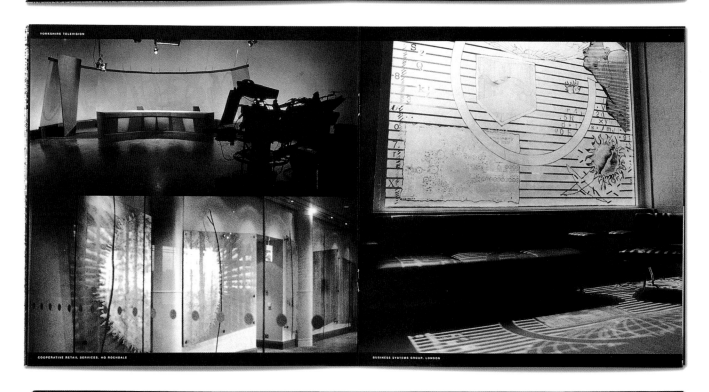

COOPERATIVE RETAIL SERVICES. HQ ROCHDALE

BUSINESS SYSTEMS GROUP, LONDON

SIGNAGE
INTERIOR FEATURES
FURNITURE
EXHIBITION DISPLAY
SCULPTURE
AWARDS
LIGHTING

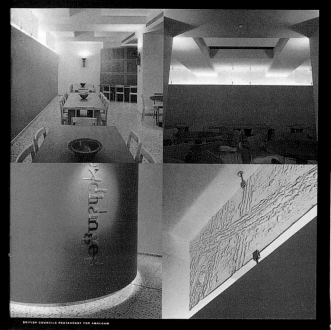

BRITISH COUNCILS RESTAURANT FOR AMALGAM

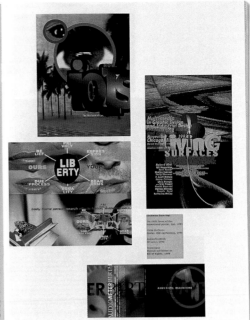

P. SCOTT MAKELA
1960-1999

VISCERAL/VIRTUAL BY KATHERINE MCCOY

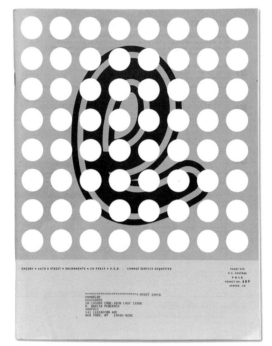

DEAD HISTORY ROMAN 14 and 18 pt

abcdefghijklmnopqrstuvwxyzABCDEFGHIJKLMNOPQRSTUVWXYZ
1234567890 > the quick brown fox jumps over a lazy dog

DEAD HISTORY BOLD 14 and 18 pt

abcdefghijklmnopqrstuvwxyzABCDEFGHIJKLMNOPQRSTUVWXYZ
1234567890 > the quick brown fox jumps over a lazy dog

DEAD HISTORY BOLD 100 pt

MTejkrx

DEAD HISTORY BY PHILIP MEGGS

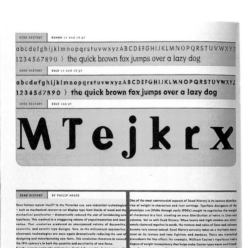

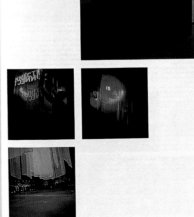

(this spread) Design Firm: **Charles S. Anderson Design** Client: **French Paper Company**

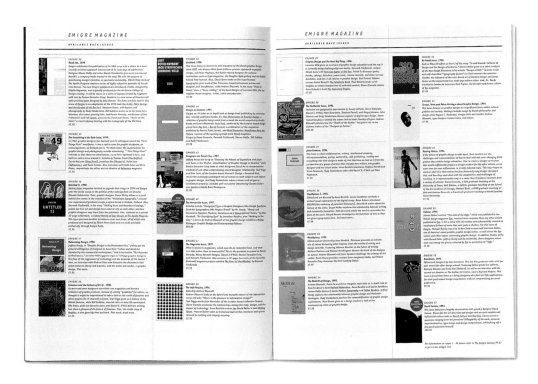

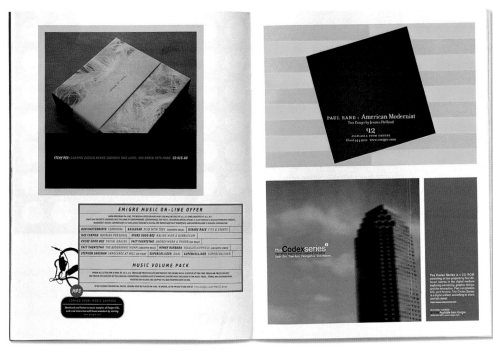

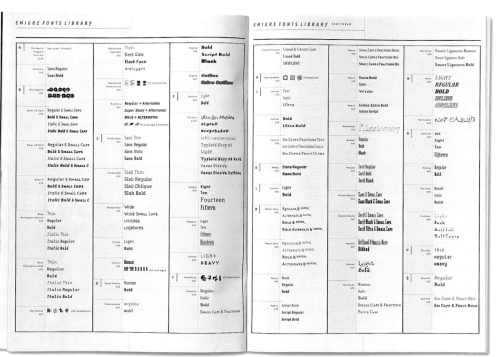

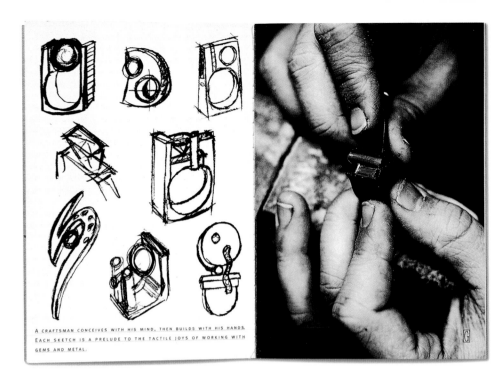

A CRAFTSMAN CONCEIVES WITH HIS MIND, THEN BUILDS WITH HIS HANDS. EACH SKETCH IS A PRELUDE TO THE TACTILE JOYS OF WORKING WITH GEMS AND METAL.

SCOTT A. GAUTHIER

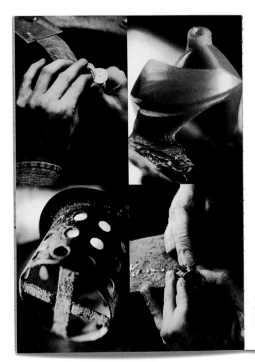

SHOULD BEAUTIFUL THINGS BE MADE ONE AT A TIME? FOR SCOTT GAUTHIER, IT'S THE ONLY CONCEIVABLE WAY. AND SO, HE CHOOSES THE LOST WAX PROCESS, AN ANCIENT METHOD THAT DEMANDS TIME AND SKILL. EACH STEP IS A RITE OF PASSAGE FOR THE FINISHED PIECE, WHICH WILL BE AS SINGULAR AS THE STONE IT HOLDS.

Design Firm: **CFO Design** Creative Director, Art Director and Designer: **Steve Ditko** Photographer: **Bruce Racine** Copywriter: **Jill Spear** Client: **Jewelry By Gauthier**

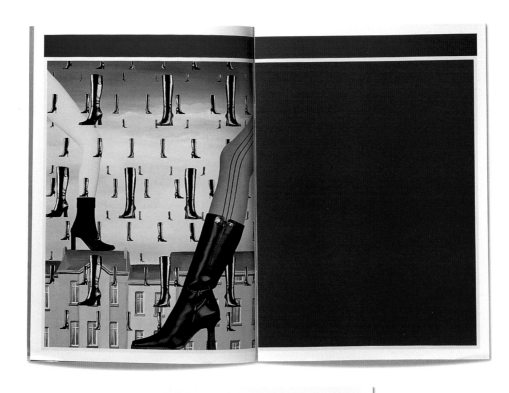

ALBA
ОСЕНЬ - ЗИМА 2000 - 2001

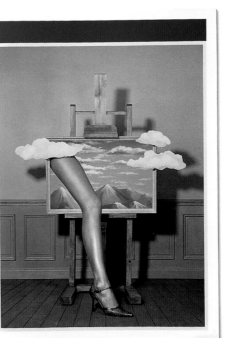

Design Firm: **Likin & Raytses** Art Directors: **Eugeny Raytses** and **Ekaterina Melni** Designer: **Eugeny Raytses** Photographers: **Vladimir Fridkes** and **Boris Antonov** Illustrator: **Michail Shishlannikov** Client: **Alba**

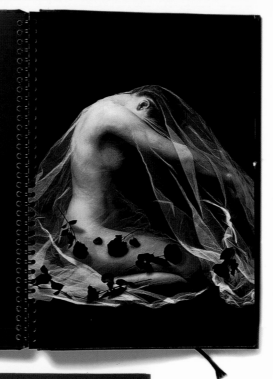

LIEBE.
BEGEHRTHEIT.
ERFOLG
UND
E W I G E
JUGEND.

COME
B A C K
EINER GROSSEN
LIEBE.

BEI EINER GUTEN
FEE
HABEN SIE NUR
3 WÜNSCHE
F R E I.
IM
NEUEN
EXQUISIT
T A U S E N D E.

Design Firm: **Michael Osborne Design** Art Director: **Michael Osborne** Designer: **Paul Kagiwada** Client: **Tayland Cellars**

Amphibious monoplane model

Alphonse Pénaud (1850–1880) was an aviation visionary whose aeronautical inventions were years ahead of his time. In 1876 he designed an amphibious monoplane. Though Pénaud's aerial conception never left the drawing board, it incorporated several brilliant concepts: two counter-rotating propellers, double elevators, a rudder connected to a fixed vertical fin, a glassed-in cockpit, retractable landing gear and a control system for the pilot.

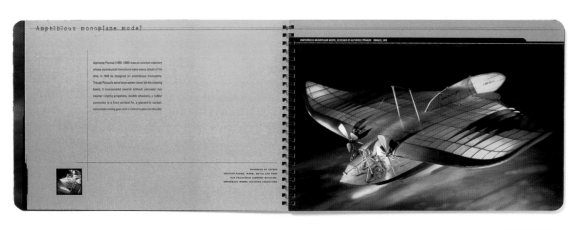

AMPHIBIOUS MONOPLANE MODEL, DESIGNED BY ALPHONSE PÉNAUD FRANCE, 1876

WINGSPAN 20 INCHES
TWISTED PAPER, WOOD, METAL AND WIRE
SAN FRANCISCO AIRPORT MUSEUM,
HUBBARD MODEL AVIATION COLLECTION

Curtiss Condor
T-32 model

The Curtiss Condor had the dual distinction of being the world's first sleeper airliner and the United States aviation industry's last biplane airliner. When originally introduced in December of 1933, the Condor could carry eighteen passengers, but in 1933 the T-32 model was modified to carry twelve passengers in sleeping berths. With the introduction of the Douglas DC-2 in 1934, the Condor became obsolete.

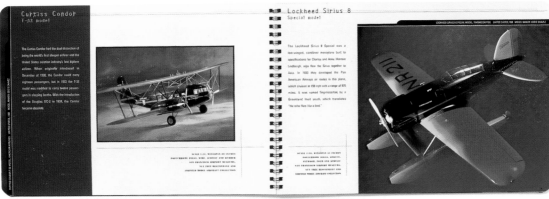

SCALE 1:32, WINGSPAN 32 INCHES
POLYURETHANE RESIN, WOOD, STRING AND RUBBER
SAN FRANCISCO AIRPORT MUSEUM,
LOU FREE DEVELOPMENT AND
AIRFIELD MODEL AIRCRAFT COLLECTION

Lockheed Sirius 8
Special model

The Lockheed Sirius 8 Special was a low-winged, cantilever monoplane built to specifications for Charles and Anne Morrow Lindbergh, who flew the Sirius together to Asia. In 1933 they developed the Pan American Airways air routes in this plane, which cruised at 150 mph with a range of 525 miles. It was named Tingmissartoq by a Greenland Inuit youth, which translates "he who flies like a bird."

LOCKHEED SIRIUS 8 SPECIAL MODEL, TINGMISSARTOQ UNITED STATES, 1930 MODEL MAKER EDDIE CHAVEZ

SCALE 1:30, WINGSPAN 15 INCHES
POLYURETHANE RESIN, WOOD, PLYWOOD, IRON AND STRING
SAN FRANCISCO AIRPORT MUSEUM,
LOU FREE DEVELOPMENT AND
AIRFIELD MODEL AIRCRAFT COLLECTION

THE AVIATION HISTORY
COLLECTION AT SAN FRANCISCO
INTERNATIONAL AIRPORT

San Francisco Airport Museums

DIRIGIBLE LZ-127 MODEL, GRAF ZEPPELIN GERMANY, 1928 MODEL MAKER EDDIE CHAVEZ

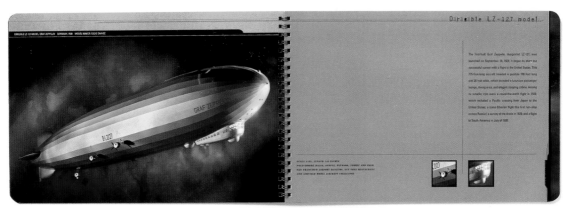

Dirigible LZ-127 model

The first-built Graf Zeppelin, designated LZ-127, was launched on September 18, 1928. It began its short but successful career with a flight to the United States. This 775-foot-long aircraft boasted a gondola 100 feet long and 30 feet wide, which included a luxurious passenger lounge, dining area, and elegant sleeping cabins. Among its notable trips were a round-the-world flight in 1929, which included a Pacific crossing from Japan to the United States; a trans-Siberian flight the first non-stop across Russia; a survey of the Arctic in 1931; and a flight to South America in July of 1930.

SCALE 1:50, LENGTH 145 INCHES
POLYURETHANE RESIN, STEEL, PLYWOOD, FABRIC AND FOAM
SAN FRANCISCO AIRPORT MUSEUM, LOU FREE DEVELOPMENT
AND AIRFIELD MODEL AIRCRAFT COLLECTION

THE PAN AM HISTORICAL FOUNDATION

The Pan Am Historical Foundation was established in February 1992 to preserve the historic archives and memorabilia of the company, and to perpetuate Pan Am's place in early international aviation history.

Martin M-130 model

The Martin M-130 flying boat was introduced in 1935 to meet Pan American Airways' specifications for an aircraft to fly the transpacific route to the Philippines: San Francisco-Honolulu-Midway Island-Wake Island-Guam-Manila. Only three were produced: the Hawaii Clipper, the Philippine Clipper, and the China Clipper. While built to carry forty-one passengers, the M-130 could accommodate only twelve on its transpacific service. These passengers were free to move about this glorious expanse of the hull, enjoying a degree of comfort never before achieved in the history of air transportation.

MARTIN M-130 MODEL, CHINA CLIPPER UNITED STATES, 1935 MODEL MAKER EDWIN PAQUARD

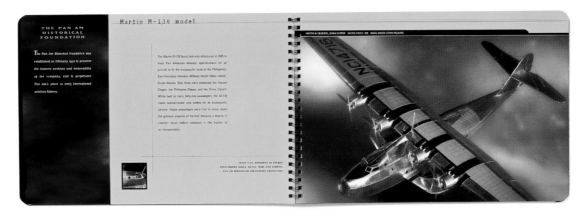

SCALE 1:36, WINGSPAN 42 INCHES
POLYURETHANE RESIN, METAL, WIRE AND STRING
PAN AM HISTORICAL FOUNDATION COLLECTION

Design Firm: **Sackett Design Associates** Art Director: **Mark Sackett** Designers: **James Sakamoto, Wendy Wood** and **George White** Photographers: **Michal Venera** and **Catherine Buchanan** Client: **San Francisco International Airport**

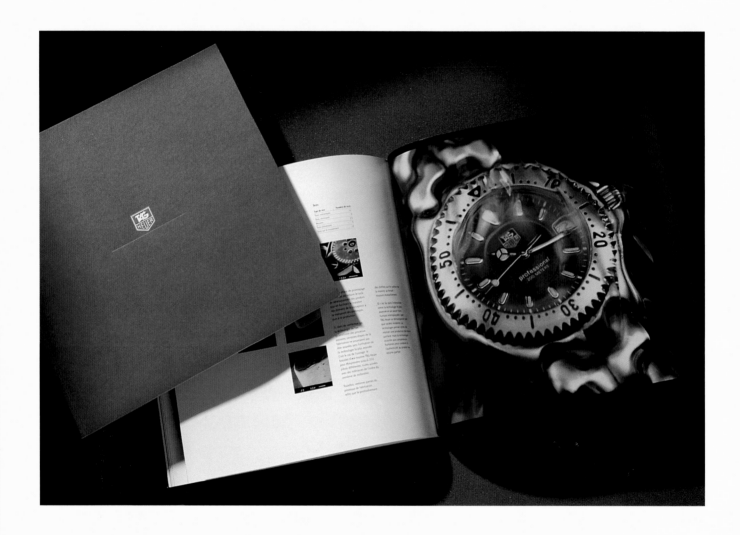

New York Marriott Marquis

Georgia-Pacific Corporation

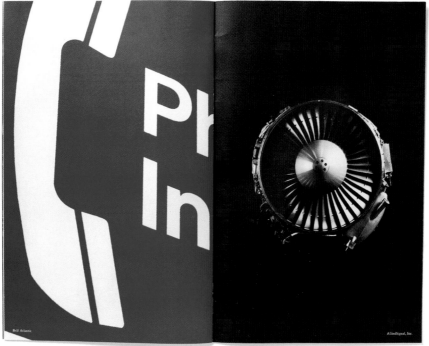

Bell Atlantic

AlliedSignal, Inc.

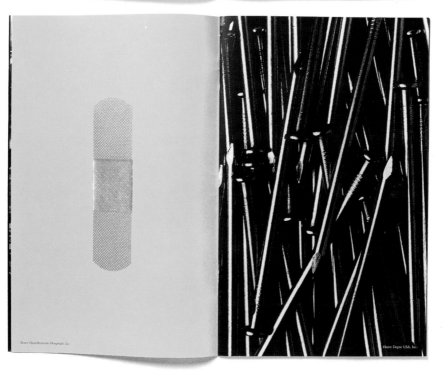

Texas Healthsystem Hospitals, Inc.

Home Depot USA, Inc.

Design Firm: **Cahan & Associates** Creative and Art Director: **Bill Cahan** Designer: **Michael Braley** Photographers: **Robert Schlatter** and **William Mercer** Illustrator: **Nanette Biers** Copywriter: **Maria Peevey** Client: **New Energy**

Corporate 82,83

(this spread) Design Firm: **Digitas** Creative Directors: **Toshi Ide** and **David Haskell** Art Director: **Toshi Ide** Designers: **Toshi Ide, Nancy Glazer, Susan Pearson** and **Segal Orit** Photographer: **John Midgley** Copywriter: **David Haskell** Client: **Aquent**

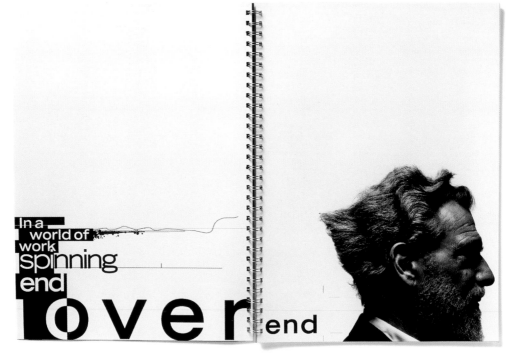

In a
world of
work
spinning
end

over end

Work.
version
2.0.

We work in a workplace while mind
manpower "freelance" is no ser a
your c tin competitiv dge.
re a ne fe t kind of c any
uent is rewriting th ules i ur favor.

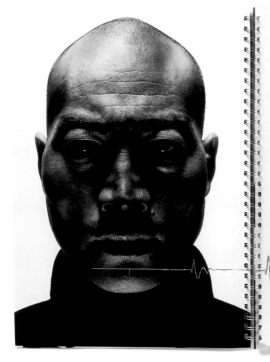

We live and work in extraordinary times.
The entire concept of the company is being
challenged and transformed. The old rules of
how companies work, how work gets done,
and who does the work are out the window.
At the same time, talented people by the
millions have gone out on their own. They
are creating a completely new kind of
work force—independent, uniquely skilled,
intensely motivated. It is a time of tumultuous
change. And for those willing to seize the
moment, it is a time of phenomenal opportunity.

Introducing Aquent. We've turned the whole idea of staffing on its ear. We're not here just to fill positions. We're here to help the working world work better. That starts with providing talented people everything they need to work the way they want to work—from training to marketing to health benefits. Not surprisingly, this attracts an astonishing array of great talent. The kind of talent you need to move your entire organization forward.

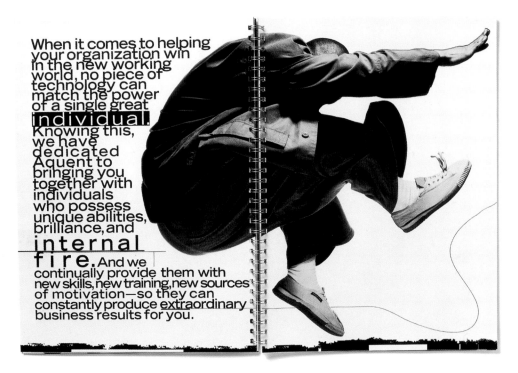

When it comes to helping your organization win in the new working world, no piece of technology can match the power of a single great **individual.** Knowing this, we have dedicated Aquent to bringing you together with individuals who possess unique abilities, brilliance, and **internal fire.** And we continually provide them with new skills, new training, new sources of motivation—so they can constantly produce extraordinary business results for you.

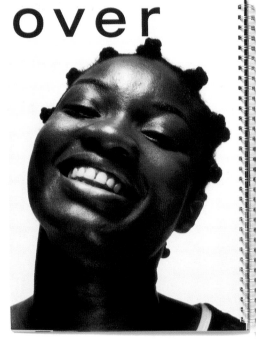

over

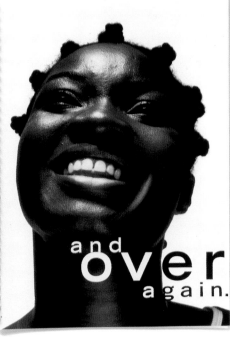

and **over** again.

Knowledge is power. The power to surge ahead of the competition. And in today's business environment, it's the key to making crucial decisions.
Here's where Strategic Intelligence can help.

Strategic Intelligence
Nurture business growth with Asia's leading intellectual force

The Club of Asia

At the heart of Strategic Intelligence is a network comprising Asia's best economic, political and business minds. All of whom are active participants in the development of socio-economic and political policies throughout the region. Members of the Club of Asia comprise former cabinet ministers in the region's governments, leading policy advisors, senior academics, active as well as retired business executives, directors of prestigious think tanks and heads of highly respected research institutions. This unique and valuable wellspring of talents can offer you exclusive insights into Asian markets, and provide you with information critical in developing business strategies.

The knowledge base of our network members covers all major markets in Asia, including:

• China
• Hong Kong SAR
• Taiwan
• South Korea
• Japan
• Thailand
• Malaysia
• The Philippines
• Indonesia
• Singapore
• India
• Australia
• New Zealand

Design Firm: **Design Asylum Pte. Ltd.** Creative Director: **Christoper Lee** Art Directors: **Christoper Lee** and **Cara Ang** Designer and Illustrator: **Cara Ang** Photographer: **Ken Seet** Client: **Strategic Intelligence**

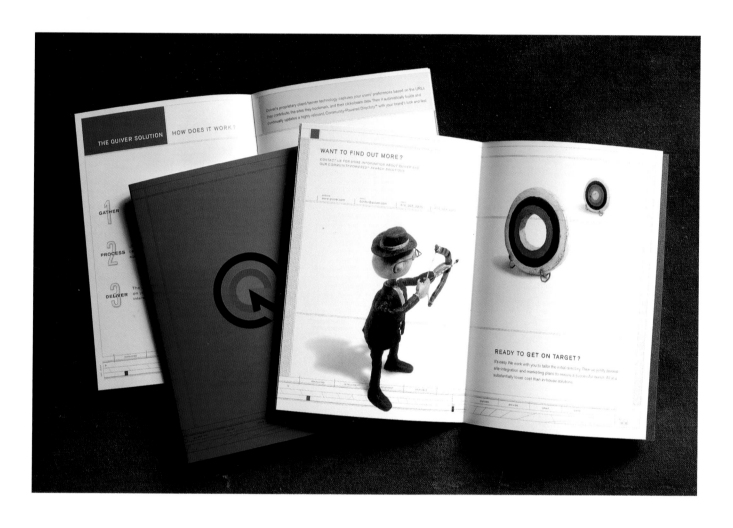

Design Firm: **Templin Brink Design** Creative Director: **Gaby Brink** Designer: **Kris Delaney** Client: **Quiver Inc.**

create the
technology
that could shape
the way people
live for decades
from the city
that embraces
living here
and now
Atlanta_Live
in the current.

AtlantaSmartCity.com

06

07

Our mission is to improve the efficiency of markets. Our object
We will provide access to the most attractive securities and de

Being the only fully integrated exchange organization world-wid
custody, information and infrastructure services at lowest costs.

We will organize new markets and thereby improve their liquid
intermediaries and vendors, investors and issuers world-wide.
framework and are open for valuable partnerships.

To achieve these goals we build on our uniquely skilled profess
electronic systems. **Thus, we create superior shareholder value.**

10

11

Design Firm: **Claus Koch Corporate Communications** Creative Director: **Claus Koch** Art Directors and Designers: **Patrick Koch** and **Jochen Theurer** Copywriter: **Felix Hoepfner** Client: **Deutsche Borse AG**

Corporate 88, 89

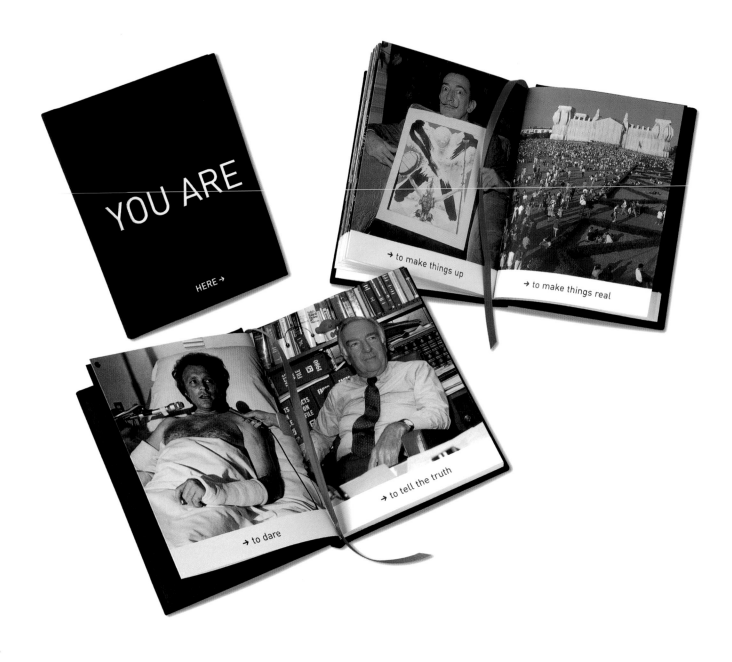

YOU ARE

HERE →

→ to make things up

→ to make things real

→ to tell the truth

→ to dare

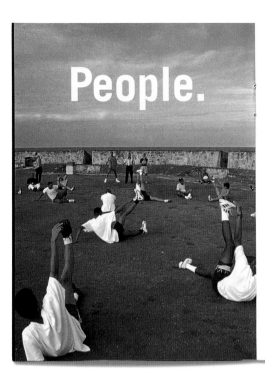

People.

Population:
3.8 million
1002 people
per square mile
71% urban
29% rural
Largest City:
San Juan (426,832)
Languages:
Spanish, English
Ethnicity:
99% Spanish

Some Famous Puerto Ricans José Campeche (18th century artist), Roberto Clemente (baseball player for the Pittsburgh Pirates, 1955 to 1972), José de Diego (father of the modern Puerto Rican poetry & independence movement), Rosario Ferré (writer), Raul Julia (actor, Adam's Family movies), Juan Morel Campos (19th century composer), Tito Puente (defined Latin Jazz), "Chi Chi" Rodríguez (golfer)

Local Flavor.

Climate.

Puerto Rico has one of the most pleasant and unvarying climates in the world, with daily highs almost invariably at 70 to 85°. The island is at its wettest in August, with over 7 inches average rainfall in one month. Weather is the coolest in the north, in the higher altitudes of the Cordillera Range, where the lowest temperature in the history of the island was recorded at 39°.

INSURING THE
EXTRAORDINARY
INSURANCE MARKETPLACE
CRITERION INTERNATIONAL
PREMIUM ACCEPTANCE

PROFESSIONAL LIABILITY

Our services are like music to your ears. Whether
your clients are officers in the board room or
doctors in the operating room. People who consult
on cold computers or those who counsel on hot
crises. We can underwrite an association of
homeowners or a single engineer. Even eccentric
musicians. Insurance Marketplace protects your
clients, so you don't miss a note.

GENERAL LIABILITY

We know the territory, so your clients will feel
confident and sure-footed. Our coverage includes
everything from restaurants to radio towers to
rattlesnake races. Insuring special events like
concerts, and special places like your hometown.
Whether it is a bluegrass festival, a builder or a
bar. Fairgrounds to campgrounds. We cover day
care centers for grandkids to grandparents. Private
health club facilities, home healthcare operations
and public healthcare agencies. If you need it,
chances are Insurance Marketplace can cover it.
We're right in step with what your clients require.

FINANCING

You can call it. We offer more than insurance, so
if needed you can offer to help your clients finance
the coverage we arrange. We provide financing for
any business written by our Insurance Marketplace
and Criterion International groups. And we do
it with our special team of finance specialists. At
Premium Acceptance we are here to help, so your
clients are never left up in the air.

Design Firm: **Sibley Peteet Design** Art Director: **Rex Peteet** Designers: **Julie Berand** and **Rex Peteet** Illustrators: **Rex Peteet** and **Mark Brinkman** Copywriters: **Ann Finamore** and **Rex Peteet** Client: **Insurance Marketplace**

Every language has its street vocabulary and Puerto Rico's is especially rich. Like all, it reflects its geography, native foods, derogatory terms, taboos and culture. So enjoy some of these words you always wanted to know but were afraid to ask. →

Oye, 'mano, que pasa?

Averiguao

A nosey person.

Awards are for the
cream-of-the-crop.
Being ordinary just won't do.
To be a winner, you must
work hard, persevere,
and above all, be the best.
On the following pages,
you will meet some winners
from all walks of life.
Top performers just like you.→

And the winner is...

Spot
Stockton Dog Show ~ Retrievers Division
(1982)

Buddy Rodgers
Western Sales Summer Picnic ~ 3-Legged Race
(1979)

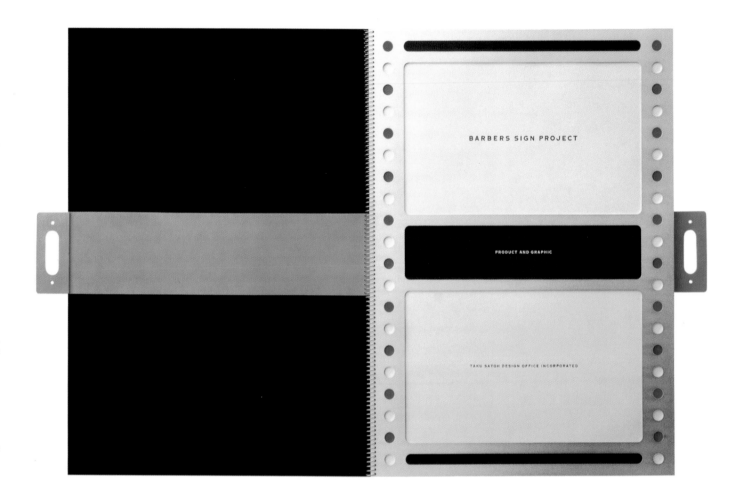

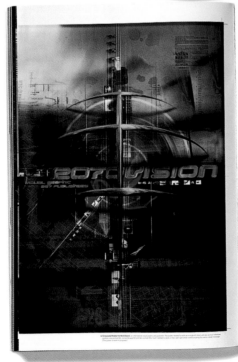

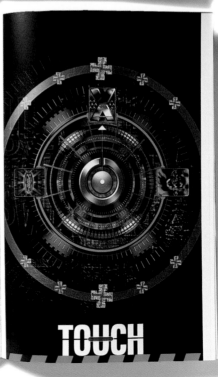

ESIC

DESIGN NOW.AUSTRI

ARGENED APPROACH TO PURPOSES AND APPLICATIONS OF C

S

AY

ES

RESOURCES

INOLOGIES

ION

SHOWS

AWARDS

IC

TO

CO

NE

TE

FA

SL

ST

DESIGN EXHIBITION

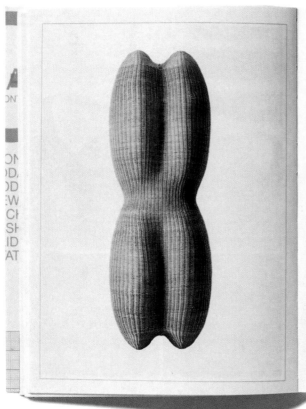

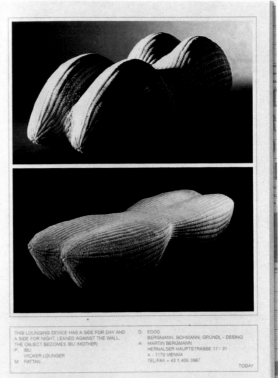

THIS LOUNGING DEVICE HAS A SIDE FOR DAY AND
A SIDE FOR NIGHT. LEANED AGAINST THE WALL,
THE OBJECT BECOMES IBU (MOTHER)
P: IBU
 WICKER LOUNGER
M: RATTAN

D: EOOS
 BERGMANN, BÖHMANN, GRÜNDL - DESING
A: MARTIN BERGMANN
 HERNALSER HAUPTSTRASSE 17 / 31
 A - 1170 VIENNA
 TEL/FAX + 43 1 406 3987

TODAY

P: A 109 GALEFORCE
M: SPX
D: JOHANN SCHMIDTHALER

P: A 121 SPROCKET
M: SPX
P: A 252 STRIKER
M: SPX
D: GERHARD FUCHS

TODAY

1. What is the difference between a dog and a flea?

Riddle Dogs.

ENTER THE
RIDDLE DOGS
CONTEST!
See Inside Back
Cover For
Details

DESIGNED BY
The Pushpin Group
NEW YORK

PRINTED BY
Berman Printing Co.
CINCINNATI

Riddle Dogs.

Corny
Conundrums
with Cute
Illustrations
by Seymour
Chwast

A Pushpin Pamphlet

9. What is the difference
between a greyhound
and a locomotive?

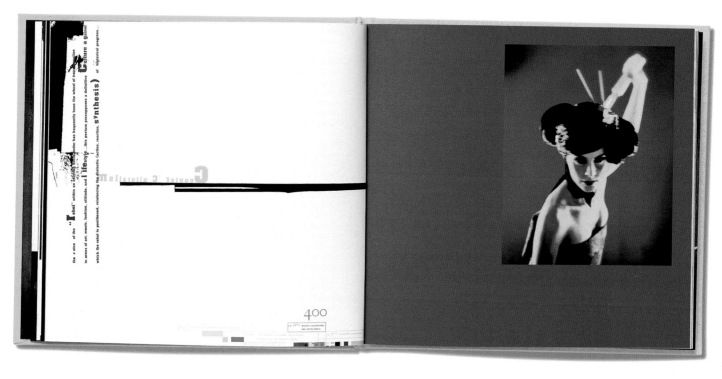

Design Firm: **Louey/Rubino Design Group** Designers: **Robert Louey** and **Alex Chao** Copywriter: **Elizabeth Charney** Client: **Louey/Rubino Design Group**

Creative and Art Director: **Robert Louey** Designers: **Robert Louey/Rubino Design Group**

Designers 104, 105

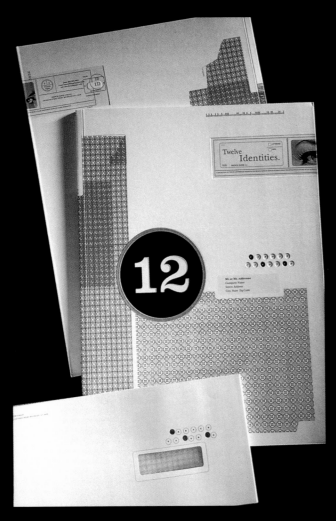

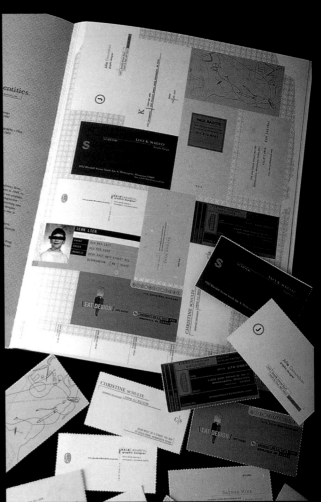

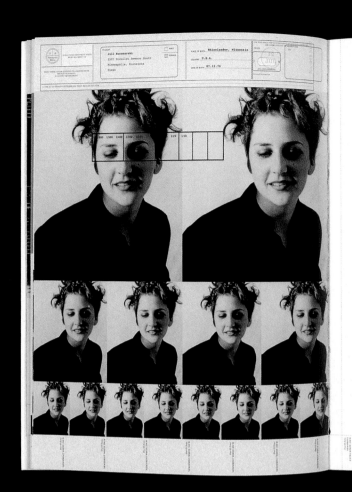

Date/Month/Year

Mr. or Ms. Addressee
Company Name
Street Address
City, State Zip Code

Dear Name of Addressee,

I was born in Rhinelander, Wisconsin. The world I grew up in was small but the energy was high. We lived on a farm, and aside from all the broken bones and emergency room visits, life was pretty quiet. Naturally, this has had an effect. In my case it has made me a risk taker, and has given me an understanding of how the beautiful can be useful, and vice versa.

The first time I remember noticing graphic design was helping my dad shop for tractor parts at Mill's Fleet Farm. I love all the images and objects at Fleet Farm, with its simple signage, packaging and layout. It really fertilizes the imagination (no pun intended). However, I actually made the decision to go into design as a career when I realized that design is one of the only professions where being strange is acceptable and I could talk about the aesthetic value of a beat-up Buick without the threat of being locked up in a padded room. Right now, my style tends toward the (underline one): conservative/exotic/classical/funky/irreverent/other: delinquent Catholic schoolgirl.

This stationery system represents layers. On one hand it shows my passion for literature and old printed matter; on the other it represents my love for the eclectic. The only thing that was a given in this project was using French Paper. I chose Dur-O-Tone Newsprint Extra White because it is reminiscent of the vintage encyclopedias I used to ravish as a kid. Everything else was fill in the blank.

Since I am a little hard to follow at times, I would like to bring a certain clarity to my designs. I want to make people experience design, not just look at it. As for the future, I never want to grow up and I hope I can still be awed by at least two things a day until I die.

Sincerely,

Jill Kuczmarski
Design Student

Phone

715 369 5127

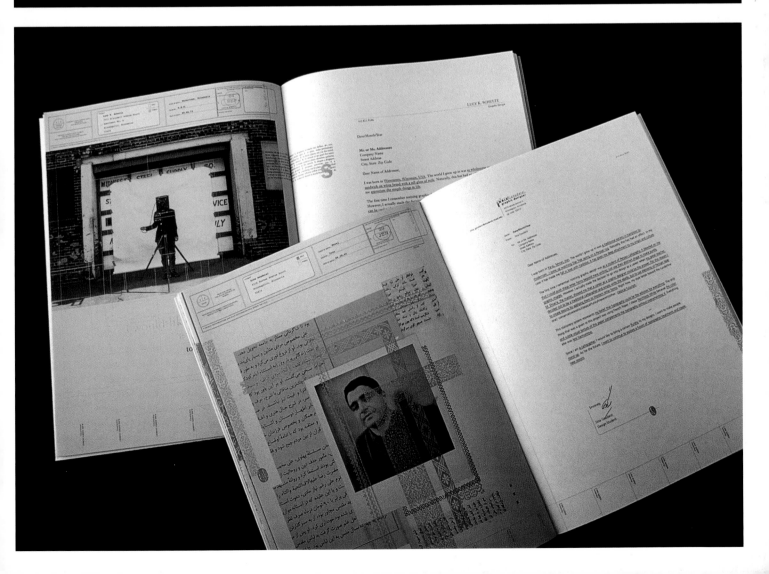

(this spread) Design Firm: **Human Design Group** Creative Director: **No Jae Kimz**

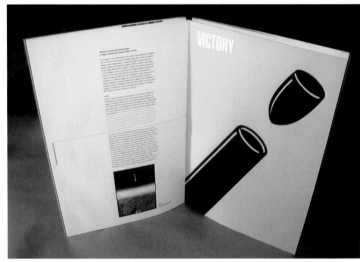

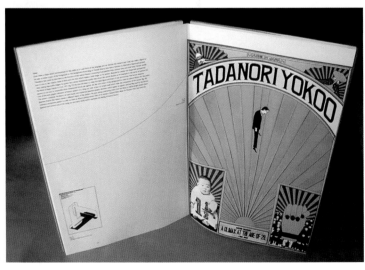

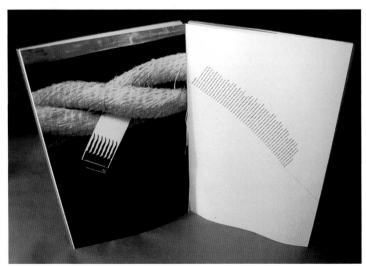

celebrated ccac alumii and faculty include
erik adigard, opal pamer adisa, lynn kirby
kit hinrichs, robert aneson, patrick coyne
john mc cracken, sydney carson, robert
bechtle, richard mc lian, barry katz, leslie
becker, gigi biederman, steven skov holt
linda fleming, kathar brown, john mattos
aaron betsky, squeal carnwath, tomie de
paola, michael cronar, dennis crowe, david
karam, stephanie seyer coyne, judith
foosaner, lucille tenazas, marilyn da silva
jeanne finley, ralphgoings, gary hutton

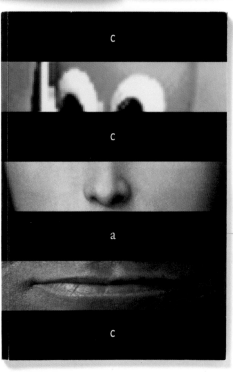

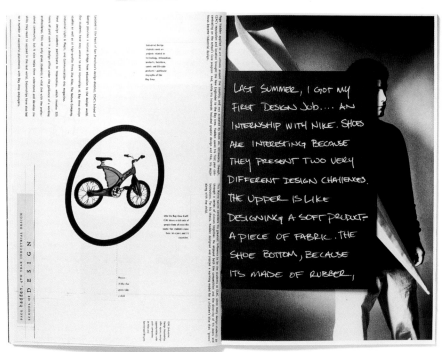

LAST SUMMER, I GOT MY FIRST DESIGN JOB.... AN INTERNSHIP WITH NIKE. SHOES ARE INTERESTING BECAUSE THEY PRESENT TWO VERY DIFFERENT DESIGN CHALLENGES. THE UPPER IS LIKE DESIGNING A SOFT PRODUCT- A PIECE OF FABRIC. THE SHOE BOTTOM, BECAUSE ITS MADE OF RUBBER,

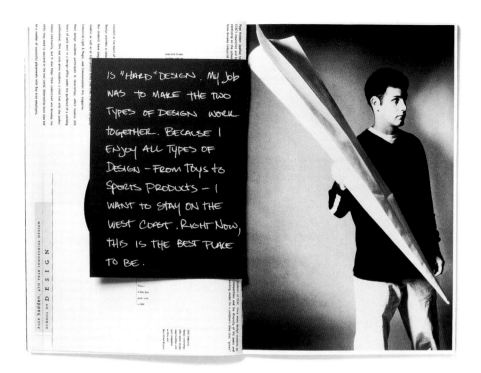

IS "HARD" DESIGN. MY JOB WAS TO MAKE THE TWO TYPES OF DESIGN WORK TOGETHER. BECAUSE I ENJOY ALL TYPES OF DESIGN – FROM TOYS TO SPORTS PRODUCTS – I WANT TO STAY ON THE WEST COAST. RIGHT NOW, THIS IS THE BEST PLACE TO BE.

PAGE hadden, 4TH YEAR INDUSTRIAL DESIGN
SCHOOL OF DESIGN

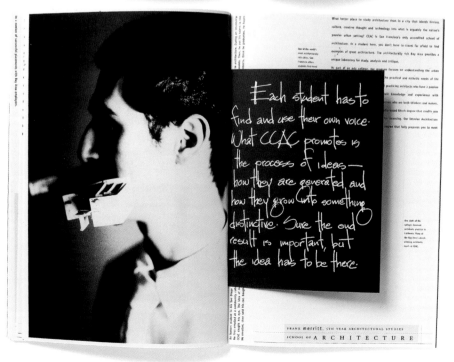

What better place to study architecture than in a city that blends history, culture, creative thought and technology into what is arguably the nation's premier urban setting? CCAC is San Francisco's only accredited school of architecture. As a student here, you don't have to travel far afield to find examples of great architecture. The architecturally rich Bay Area provides a unique laboratory for study, analysis and critique.

As part of an arts college, the program focuses on understanding the urban environment and the practical and esthetic needs of the client. We bring in practicing architects who have a passion for sharing their knowledge and experience with students — mentors who are both thinkers and makers. Our studio-based BArch degree that credits you toward early licensing. Our Interior Architecture degree that fully prepares you to meet

Some of the world's most architecturally rich cities, San Francisco offers students first-hand

Each student has to find and use their own voice. What CCAC promotes is the process of ideas — how they are generated and how they grow into something distinctive. Sure the end result is important, but the idea has to be there.

One-sixth of the nation's licensed architects practice in California. Many of the Bay Area's award-winning architects teach at CCAC.

FRANK merritt, 5TH YEAR ARCHITECTURAL STUDIES
SCHOOL OF ARCHITECTURE

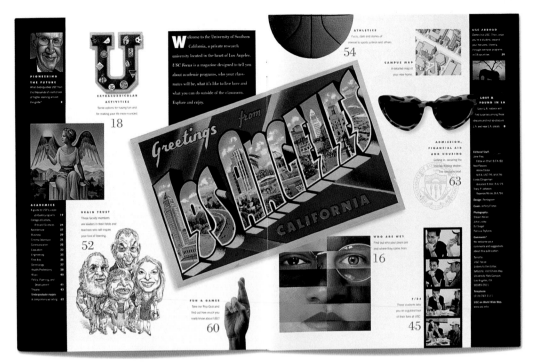

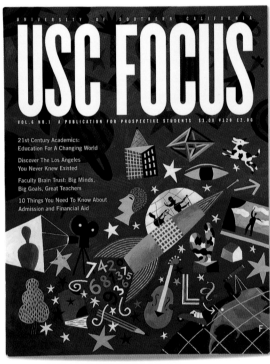

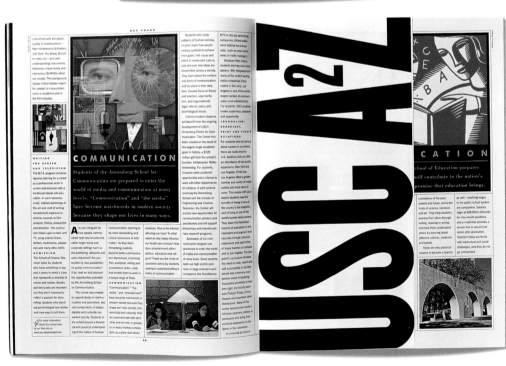

(this spread) Design Firm: **Pentagram Design** Creative Director: **Kit Hinrichs** Art Director: **Karen Berndt** Designers: **Karen Berndt** and **Anita Luu** Client: **University of Southern California**

University of Southern California Undergraduate Programs

There's a lot of talk these days about what it will mean to live, work, and prosper in the 21st century. In fact, this century is being hailed as a kind of renaissance. Not the rebirth of classical art and culture, as in the 15th century, but a rebirth of what we understand to be knowledge, how to acquire it, and how to use it productively. ◆ At USC, our mission is the development of graduates who will be leaders in this environment, and we have what it takes to enable our students to learn and grow in ways that will prepare them uniquely for the future. ◆ Perhaps what distinguishes us most is this: at USC undergraduates can pursue degrees not only in the Liberal Arts College, but also at any one of our 17 professional schools. ◆ Nowhere else in the country—probably in the world—can you:

- Major in Anthropology and minor in Interactive Multimedia • Major in Business and minor in Bioethics • Double major in Biomedical Engineering and Russian • Major in Cinema-Television and minor in Music Industry • Major in Political Science and minor in International Urban Development • Double major in Psychology and Urban Planning. • Major in Art History and minor in Business • Major in International Relations and minor in Urban Planning. • Tomorrow's leaders will have broad backgrounds in diverse fields. They will be life-long learners with the ability and passion to continuously acquire and synthesize knowledge. In short, they will have both breadth and depth of knowledge. ◆ USC's undergraduate programs offer a constellation of opportunity, outlined in the following pages. For those who accept them, there are challenges here to be seized and shaped for a lifetime of leadership, intelligent citizenship, and enlightened living. —*Joseph Hellige, Vice Provost, Academic Programs*

COLLEGE OF LETTERS, ARTS AND SCIENCES

The College, home to more than 30 academic departments, is where you will find the heart of USC's liberal arts education.

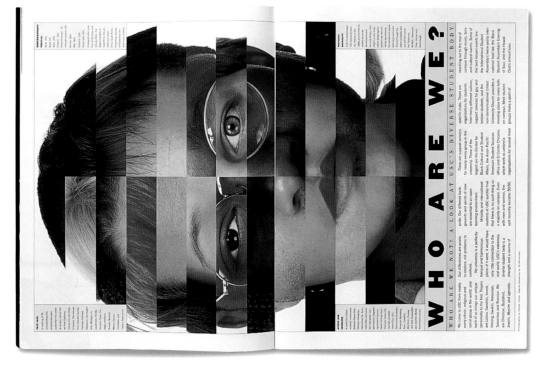

WHO ARE WE?

WHO ARE WE NOT? A LOOK AT USC'S DIVERSE STUDENT BODY

Scholarship and Education and was the 1998 recipient of the Francis Rawle Award for outstanding contributions to the field of post-admission legal education from the American Law Institute-American Bar Association Committee on Continuing Professional Education.

We are one of a select few law schools able to boast of having two American Law Institute reporters on its faculty at the same time: Aaron Twerski, Francis Newell DeValpine Professor of Law, who co-authored the Restatement of Products Liability, and Professor Neil Cohen, who authored the new Restatement of Suretyship.

Professor Stacy Caplow serves as president of the Clinical Legal Education Association; Professors William Hellerstein, Ursula Bentele and Robert Pitler have been honored by the New York State Bar Association for their "Outstanding Contribution in the Field of Criminal Law Education"; Professor Maryellen Fullerton has been a Fulbright Scholar, Marshall Fund Fellow, and Reporter for Human Rights Watch/Helsinki; Professor Roberta Karmel has been a Fulbright-Hays Grantee; Professor Paul Schwartz is the recipient of a Humboldt Scholar Grant, Guggenheim Fellowship, and Fulbright Fellowship; Professor Anthony Sebok was awarded a Berlin Prize Fellowship by the American Academy in Berlin; and Professor

Professor Kumar Meranha, formerly on the faculty of Monash University Law School in Melbourne, Australia, specializes in international human rights and intellectual property law.

Richard Allan is the American Scholar-in-Residence at the Institute for East West Studies.

They are prolific authors of law review articles, casebooks and treatises, including the most widely used legal writing textbook for first-year law students, the leading casebook on sexuality and the law, the leading treatises on evidence and bankruptcy law, and books on labor law, jurisprudence, and psychology and the law. In a study asserting the academic distinction of the nation's top law faculties that was recently published in the *Journal of Legal Studies*, Brooklyn Law School ranked 32nd for the scholarly impact of our faculty's books and articles, as measured by citations, and 38th for faculty-authored books published with leading law publishers. Professors Margaret Berger, Aaron Twerski, Elizabeth Schneider, and Steven Winter were mentioned as "scholars who are among the most cited figures in legal academia."

Because they write books and articles, because they are actively involved in legislative reform, because they are called upon by elected officials to draft new laws and by courts to help resolve complex cases, Brooklyn Law School faculty members are able to bring to the classroom—and impart to their students—something much more special than mere textbook knowledge. They bring the outside in. As dedicated as they are to shaping law in the outside world, they are even more dedicated

In a recent year, students came to BLS from over 350 colleges, 30 states and D.C., and 17 foreign countries. Shown here, a student from Minneapolis, Minnesota.

Twenty-two

Twenty-three

THE PLACE BROOKLYN LAW SCHOOL

Lawyer magazine surveyed the nation's 100 highest grossing law firms to find out where they recruited their first-year associates. Brooklyn Law School was ranked one of the top four choices in New York City (together with Columbia, New York University, and Fordham) and 49th nationwide. During that period, another 17% of our graduates chose positions in business, nearly 18% obtained jobs in government, 5% were selected for judicial clerkships, and about 4% went into public interest practice.

OUR ALUMNI: ACCOMPLISHED AND ACCESSIBLE
One of the great and growing strengths of Brooklyn

Leon Black '73 has served the Merrill Barnes Group as Chief Operating Officer of the New York fashion.

Law School is the size, stature, and loyalty of our more than 15,000 alumni, one of the largest alumni groups of any law school.

Generous with their time and their financial support, they actively participate in mentoring, career planning, and other programs sponsored by the School. One such program is the Dean's Roundtable Luncheons, which bring distinguished graduates back to the Law School to meet with small groups of students in a congenial setting. Through these gatherings, students have gained practical advice from alumni who have had successful careers in criminal defense, health care practice, bankruptcy

Twenty-nine

GALLERY

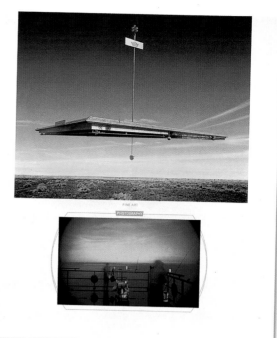

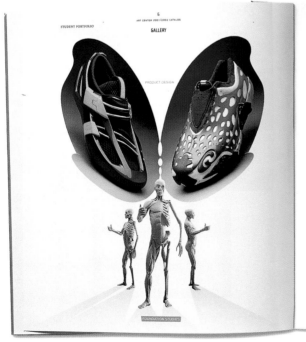

GALLERY

(welcome)

foxcroft has become a national model for the education of young women because we have created a learning and living environment that addresses in a comprehensive way the specific strengths and needs of girls. Everything at Foxcroft is curriculum, and everything contributes to our girls' growth. Our cutting-edge academic program combined with high moral standards and expectations for community service produces confident, lifelong learners, participants, and leaders. We hope you will visit our School and speak with our girls. They will help you understand most clearly what sets Foxcroft apart.

MARY LOUISE LEIPHEIMER, HEAD OF SCHOOL

FOXCROFT
SCHOOL

foxcroft transforms girls. They are transformed because they are in a community singularly designed to ensure their growth. Girls become known here. It is through this experience of being known by wise and caring adults and by friends they will keep for the rest of their lives that girls form the bonds that not only shape their joy here, but ignite the intellectual passion that is the goal of our demanding academic program.

(academics)

The academic program is designed to help girls reach beyond their expectations of themselves. Our traditional college-preparatory program meets students where they are, gives them a strong foundation in fundamentals, and then presents them with increasing levels of challenge and responsibility as they progress through the School. ‡ A six-to-one student-faculty ratio and maximum class size of 15 enhance individual attention, promote open discussion, and encourage collaborative learning that helps young women find their own voices. ‡ Exceptionally broad academic offerings for a small school, extensive academic enrichment outside of the classroom, and a broad array of Advanced Placement courses lead Foxcroft students to discover new potential within themselves.

Design Firm: **Studio d Design** Art Director: **Laurie Demartino** Designers: **Laurie Demartino** and **Paulina Reyes** Client: **Minneapolis College of Art & Design**

05
MICHELLE SERVAIS

07

08
MICHAEL BRASEL

il faut cult
ver notre jardin

06

05 TITLE: "TENDING OUR GARDEN" STUDENT: MICHAEL LECHNER, SENIOR 07 TITLE: "MAN BALANCING REGISTER" STUDENT: MICHAEL LECHNER, SENIOR

MCAD MINNEAPOLIS COLLEGE OF ART AND DESIGN MCAD MINNEAPOLIS COLLEGE OF ART AND DESIGN MCAD MINNEAPOLIS COLLEGE OF ART AND DESIGN
DICKERSON A COLLECTION OF STUDENT WORK FROM MINNEAPOLIS COLLEGE OF ART AND DESIGN HONORED BY THE SOCIETY OF ILLUSTRATORS OF LOS ANGELES

MCAD

13/9

THIRTEEN WORKS BY NINE STUDENTS

07
PETER LOCHNER

09

08 TITLE: "ENGINE WITH FLAMES" STUDENT: MICHAEL BRASEL, SENIOR 09 TITLE: "SECRETS" STUDENT: PETER LOCHNER, SENIOR
 10 TITLE: "CRASH" STUDENT: GLORIE FILLAH, BFA 1999

08

10

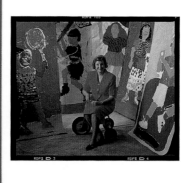

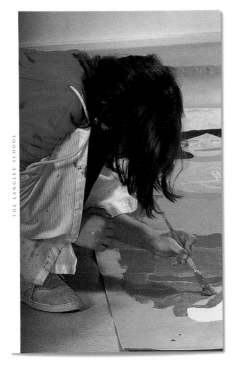

Design Firm: **Michael Gunselman Inc.** Creative Director, Art Director and Designer: **Michael Gunselman** Photographers: **Bill Denison, Kevin Fleming** and **Michael Gunselman** Illustrator: **Al Lorenz** Copywriter: **Joe Robino** Client: **Foxcroft School** Education 120, 121

(this spread) Design Firm: **Oh Boy, A Design Company** Art Director: **David Salanitro** Designers: **Ryan Mahar** and **Ted Bluey** Photographers: **Ryan Mahar, Hunter Wimmer, FPG International, Photonica** and **The Stock Market** Copywriter: **Carol Baxter** Client: **Mercury**

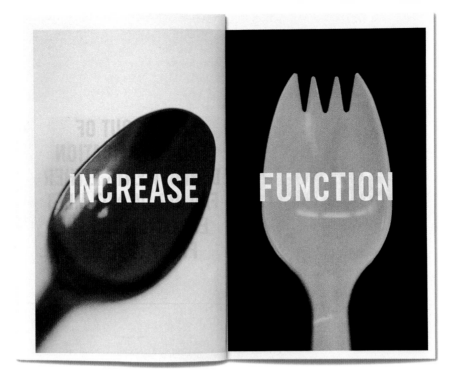

A BUSINESS LOSES
UP TO $600,000
FOR EVERY HOUR A
MISSION-CRITICAL
E-COMMERCE
APPLICATION
IS DOWN.

E BUSINESS

ERP Application Testing Tuesday, October 19		
10:15 a.m.–11:15 a.m.	Session R05	Automated Testing of SAP R/3— 18 Times Faster Than Manual Testing!
11:15 a.m.–12:15 p.m.	Session R06	TestDirector in a Validated Environment and Over a WAN
1:15 p.m.–2:15 p.m.	Session R07	Reusable Test Plans—How to Integrate into an SAP Environment
2:15 p.m.–3:15 p.m.	Session R08	Stress Test Performance Analysis Methodologies
3:15 p.m.–4:15 p.m.	Session R09	Implementing the Oracle Applications Test Kit for Real-world Testing

ERP Application Testing Wednesday, October 20		
9:00 a.m.–10:00 a.m.	Session R10	Network Capacity and Stress Testing
10:00 a.m.–11:00 a.m.	Session R11	Performance as a Critical Success Factor in Implementing SAP Projects
11:00 a.m.–12:00 p.m.	Session R12	SAP Testing Process

ADVANCED TESTING

Think *Gladiator* meets *Pillow Talk.*

EVERY
GOOD FILM
BEGINS WITH
ONE
GOOD IDEA

It's a love story.

Each character speaks his or her lines in a
different language. Intriguing, no?

TRADITIONAL
CHANNELS
MAY NOT
LEAD TO THE
NEXT
GREAT FILM

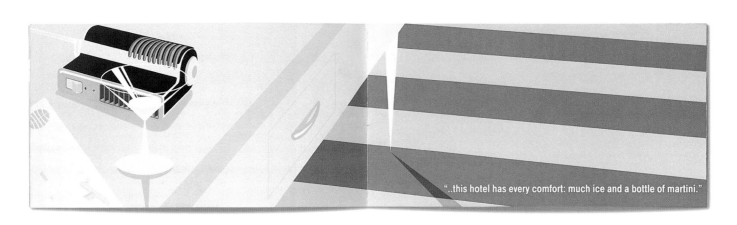

"..this hotel has every comfort: much ice and a bottle of martini."

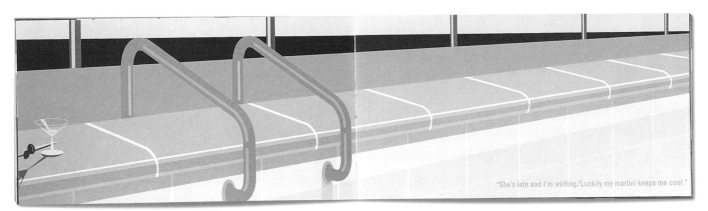

"She's late and I'm waiting/Luckily my martini keeps me cool."

martini/perfect parties

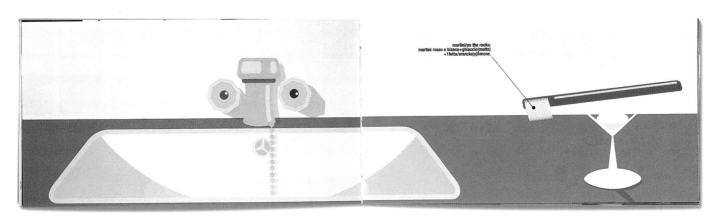

martini/on the rocks:
bicchiere conico ghiacciato
martini rosso o bianco+ghiaccio(molto)
+1fetta/arancio(o)limone.

martini cocktail:
bicchiere conico ghiacciato
1parte di martini dry+4(o)5di gin
mescolare/agitare+1oliva e 1scorza di limone.

Design Firm: **McCann Erickson S.P.A.** Creative Directors: **Dario Neglia** and **Milka Pogliani** Art Director, Designer and Copywriter: **Federico Pepe** Illustrators: **Federico Pepe** and **Luca Cantoni** Client: **Martini**

BALLY

(this spread) Design Firm: **Columbus/Italia** Photgrapher: **C. Paggiarino** Client: **Bally**

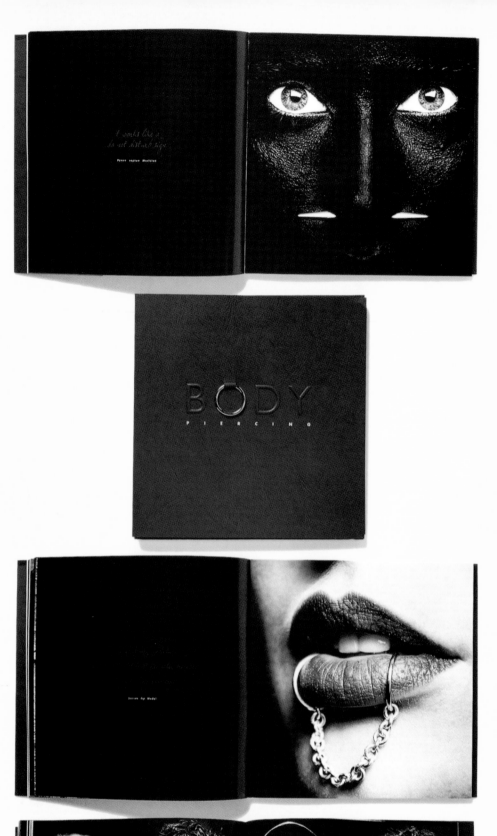

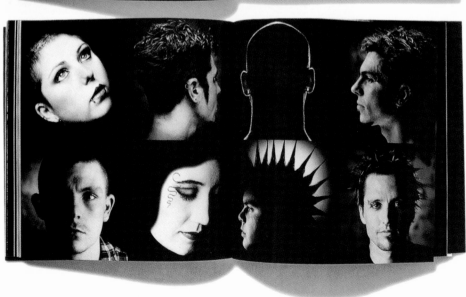

Design Firm: **Lahn Stafford Design** Art Director and Designer: **Dean Lahn** Copywriters: **Dean Lahn** and **Andrew Dunbar** Client: **Wakefield Press**

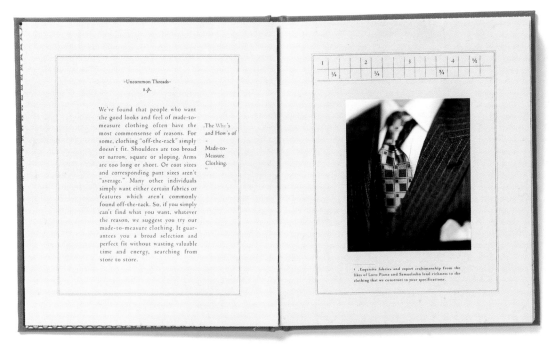

-Uncommon Threads-
2.p.

We've found that people who want the good looks and feel of made-to-measure clothing often have the most commonsense of reasons. For some, clothing "off-the-rack" simply doesn't fit. Shoulders are too broad or narrow, square or sloping. Arms are too long or short. Or coat sizes and corresponding pant sizes aren't "average." Many other individuals simply want either certain fabrics or features which aren't commonly found off-the-rack. So, if you simply can't find what you want, whatever the reason, we suggest you try our made-to-measure clothing. It guarantees you a broad selection and perfect fit without wasting valuable time and energy, searching from store to store.

.The Why's and How's of - Made-to-Measure Clothing.

1 .Exquisite fabrics and expert craftsmanship from the likes of Loro Piana and Samuelsohn lend richness to the clothing that we construct to your specifications.

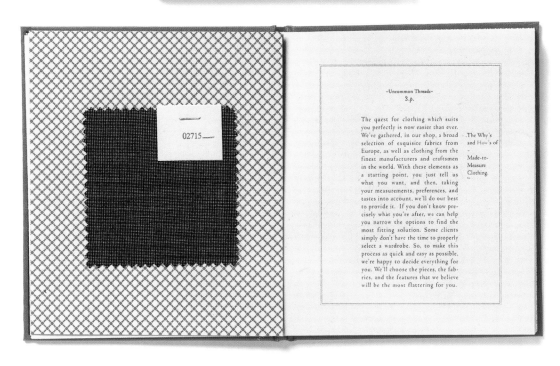

02715

-Uncommon Threads-
3.p.

The quest for clothing which suits you perfectly is now easier than ever. We've gathered, in our shop, a broad selection of exquisite fabrics from Europe, as well as clothing from the finest manufacturers and craftsmen in the world. With these elements as a starting point, you just tell us what you want, and then, taking your measurements, preferences, and tastes into account, we'll do our best to provide it. If you don't know precisely what you're after, we can help you narrow the options to find the most fitting solution. Some clients simply don't have the time to properly select a wardrobe. So, to make this process as quick and easy as possible, we're happy to decide everything for you. We'll choose the pieces, the fabrics, and the features that we believe will be the most flattering for you.

.The Why's and How's of - Made-to-Measure Clothing.

Design Firm: **Slaughter Hanson** Art Director and Designer: **Marion English** Photographer: **Don Harbor** Illustrator: **David Webb** Copywriter: **Cathy Oldham** Client: **Plains Clothes**

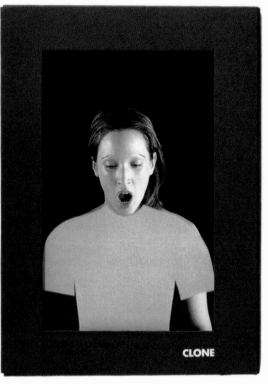

CLONE

(this spread) Design Firm: **Bianco & Cucco** Creative and Art Directors: **Giovanni Bianco** and **Susanna Cucco** Photographer: **Bettina Komenda** Client: **Clone—Bruno Bordese**

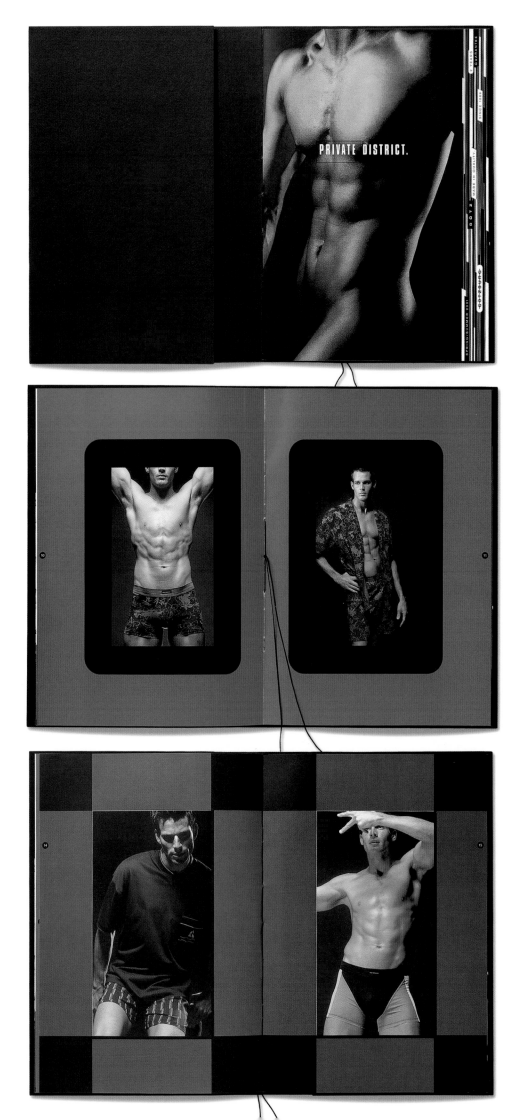

(this spread) Design Firm: **ISSA D/A** Creative Director and Art Director: **Claudia Issa** Designers: **Claudia Issa** and **Flavia Lafor** Photographer: **Paulo Vainer** Client: **NK Store**

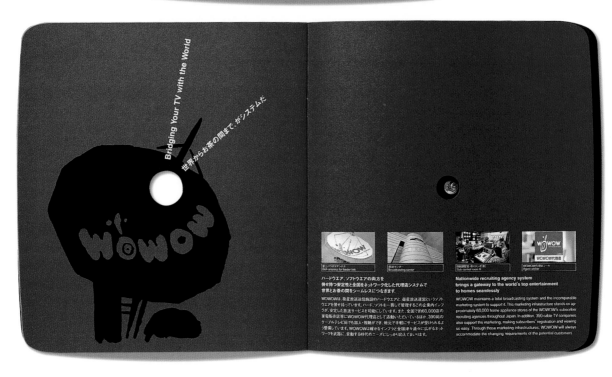

Design Firm: **BBI Studio Inc.** Creative Director: **Akira Kagami** Art Directors: **Zempaku Suzuki** and **Toru Shikiya** Designers: **Zempaku Suzuki** and **Mashairo Naito** Illustrator: **Masahiro Naito** Copywriter: **Naoya Hosokawa** Client: **WOWOW**

Design Firm: **CMg Design Inc.** Creative Directors: **Julie Amrkfield** and **Greg Crawford** Art Director: **Julie Amrkfield** Designer: **Jean De Angelis** Copywriter: **Marty Kaplan** Client: **The Norman Lear Center at the Annenberg School at USC** Film & TV 136, 137

Design Firm: **Pentagram Design** Creative and Art Director: **Kit Hinrichs** Designer: **Leslie Stitzlein** Photographer: **John Blaustein** Copywriters: **Betsy Brown** and **Peterson, Skolnick & Dodge** Client: **KQED**

KQED Campaign for the Future

FUTURE

Imagine...gaining access to the Bay Area's rich cultural resources and diverse communities through television, radio, the Internet, and educational outreach.

Share

From the Asian Art Museum and the Stanford Business School to Berkeley's Black Repertory Group Theater and the San Francisco Ballet, the Bay Area offers a vast array of cultural, academic, and entertainment treasures. KQED wants public broadcasting to support creative partnerships that connect ever more people with these resources. Teamed with community groups and organizations in the arts and sciences, KQED will become a virtual classroom for lifelong learners...a catalyst for informed citizenship...a gateway to the Bay Area's cultural wealth and history.

BY CAMERON
CROWE
1972-1979

Design Firm: **Matsuno Design Group** Creative Director: **Mike Vollman** Art Director and Designer: **Laura Debole** Photographer: **Neal Preston** Copywriters: **Cameron Crowe** and **Sharon Black** Client: **DreamWorks SKG**

quickly

caper comes in

⊌HermanMiller

caper comes in

⊌HermanMiller

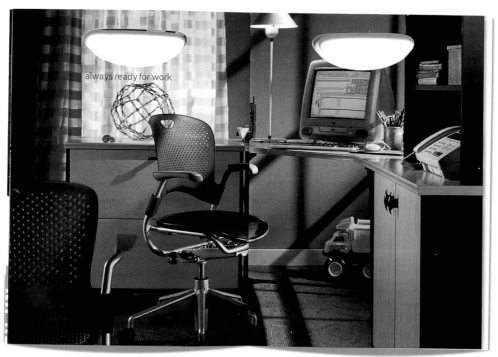

always ready for work

Design Firm: **Herman Miller Inc.** Creative Director and Designer: **Brian Edlefson** Art Director: **Kathy Stanton** Photographer: **Nick Merrick** Copywriter: **John Catlin** Client: **Herman Miller Inc.**

Food & Beverage, Furniture 140, 141

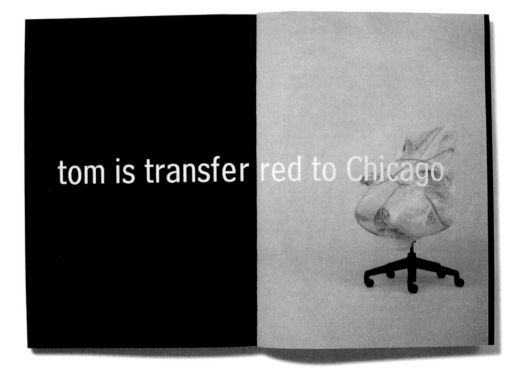

tom is transfer red to Chicago

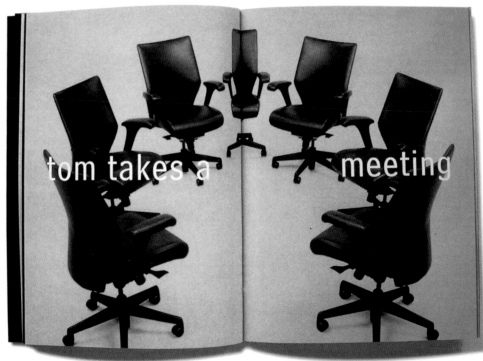

tom takes a meeting

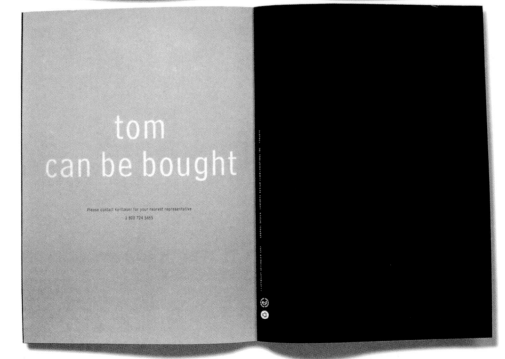

tom
can be bought

Please contact Keilhauer for your nearest representative
1 800 724 5665

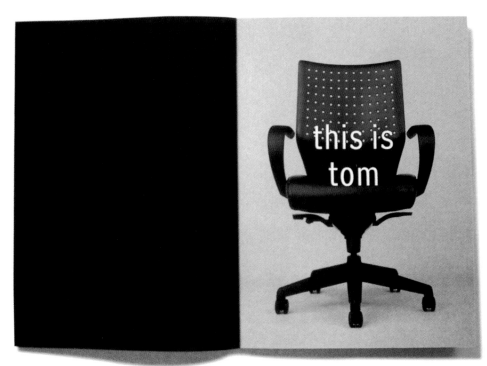

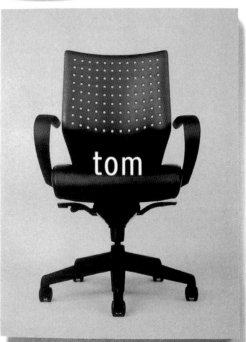

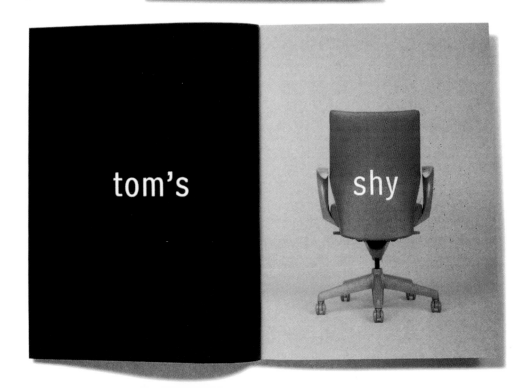

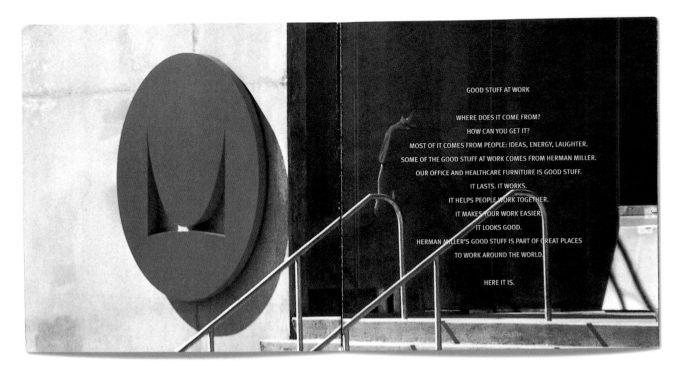

GOOD STUFF AT WORK

WHERE DOES IT COME FROM?
HOW CAN YOU GET IT?
MOST OF IT COMES FROM PEOPLE: IDEAS, ENERGY, LAUGHTER.
SOME OF THE GOOD STUFF AT WORK COMES FROM HERMAN MILLER.
OUR OFFICE AND HEALTHCARE FURNITURE IS GOOD STUFF.
IT LASTS. IT WORKS.
IT HELPS PEOPLE WORK TOGETHER.
IT MAKES YOUR WORK EASIER.
IT LOOKS GOOD.
HERMAN MILLER'S GOOD STUFF IS PART OF GREAT PLACES
TO WORK AROUND THE WORLD.

HERE IT IS.

HermanMiller

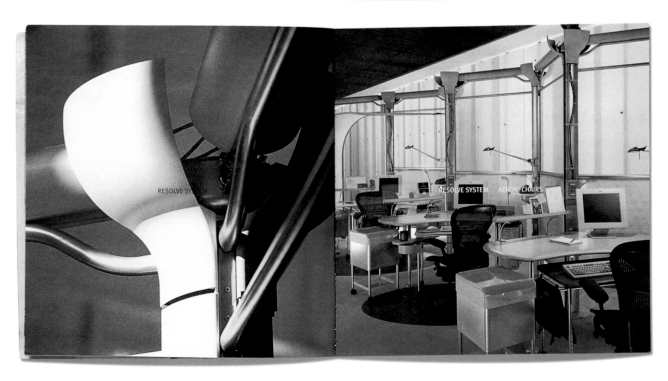

RESOLVE SYSTEM RESOLVE SYSTEM AERON CHAIRS

(this spread) Design Firm: **Herman Miller Inc.** Creative and Art Director: **Stephen Frykholm** Designer: **Brian Edlefson** Photographers: **Jim Warych** and **Brian Edlefson** Copywriters: **Clark Malcolm** and **Dick Holm** Client: **Herman Miller Inc.**

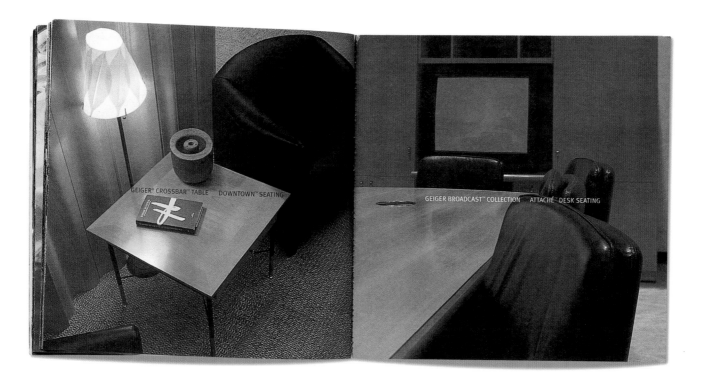

GEIGER® CROSSBAR™ TABLE DOWNTOWN™ SEATING

GEIGER BROADCAST™ COLLECTION ATTACHÉ™ DESK SEATING

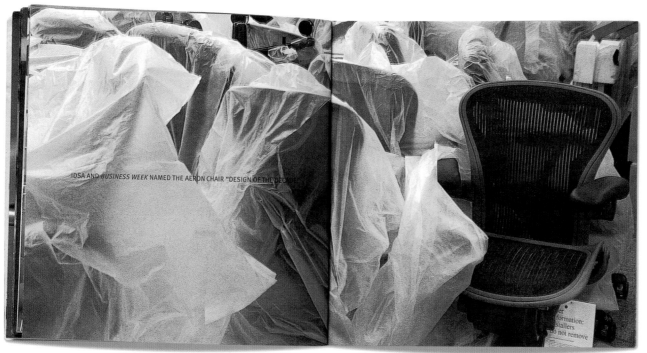

IDSA AND *BUSINESS WEEK* NAMED THE AERON CHAIR "DESIGN OF THE DECADE"

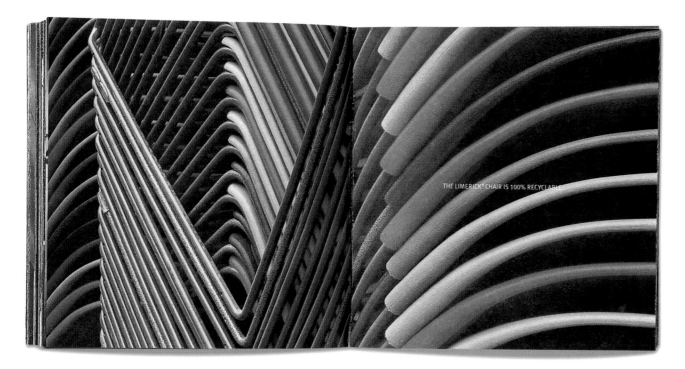

THE LIMERICK® CHAIR IS 100% RECYCLABLE

What is this thing called

Leap?

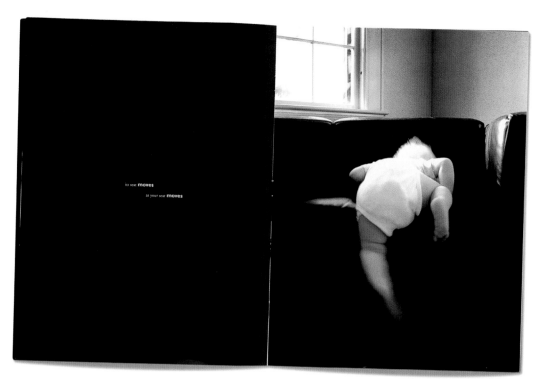

its seat **moves**

as your seat **moves**

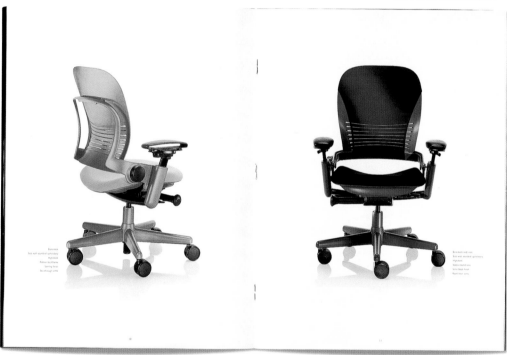

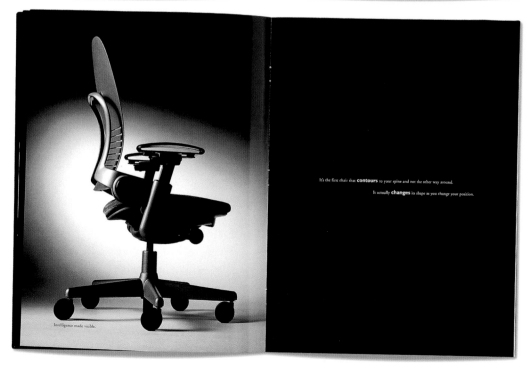

Intelligence made visible.

It's the first chair that **contours** to your spine and not the other way around.

It actually **changes** its shape as you change your position.

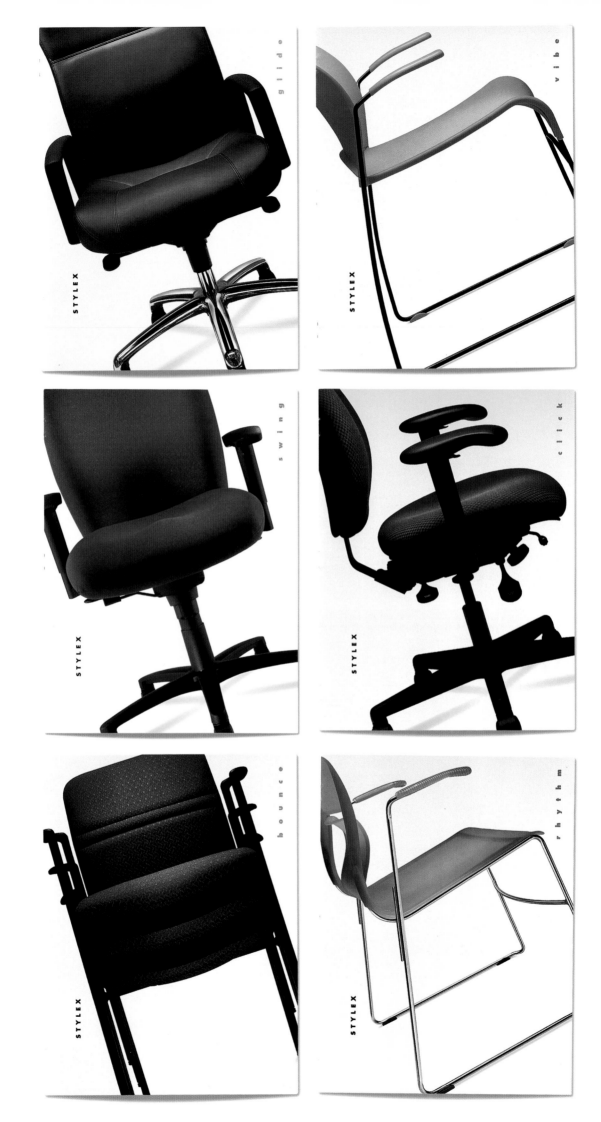

(this spread) Design Firm: **Michael Gunselman Incorporated** Creative Director, Art Director and Designer: **Michael Gunselman** Photographer: **Tom Crane** Copywriter: **Jeff Rasmussen** Client: **Stylex**

glide

vibe

STYLEX

STYLEX

swing

click

STYLEX

STYLEX

bounce

rhythm

STYLEX

STYLEX

BRAWNY, YES.
BUT A SCHOLAR, TOO.

NO TEACHERS' DIRTY LOOKS
FOR THIS STURDY STACKER.

ADD TO ITS PRINCELY CHARM A BOOKISH SIDE. WELL, ACTUALLY, A BOOK
RACK – UNDERNEATH. PLUS, VIBE'S DEEP CONTOURS AND WATERFALL FRONT MAKE
LONG HOURS OF WORK OR STUDY MORE COMFORTABLE.

AND, PEOPLE? PEOPLE? ARE YOU TAKING NOTES? GOOD. BECAUSE WE'VE
PROVIDED A TABLET ARM OPTION, AS WELL. NO, THESE ADDITIONS DON'T
SUBTRACT FROM VIBE'S ERGONOMIC SUPPORT SYSTEM. HEALTHY SEATING IS
CONDUCIVE TO HEALTHY LEARNING, AFTER ALL.

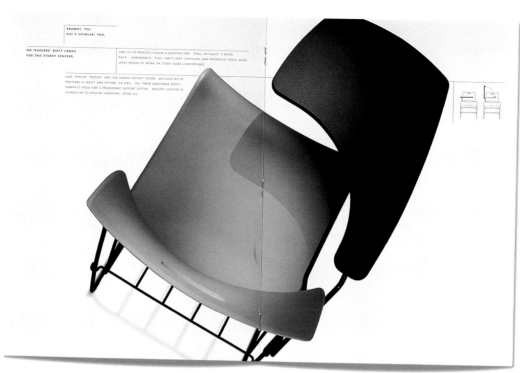

rhythm

WHO COULD ASK FOR ANYTHING MORE? IT'S GOT ERGONOMICS. IT'S GOT OPTIONS. AND STYLE?
SAY NO MORE. NO WONDER A STACKER THIS INNO-
VATIVE, THIS LOADED, THIS FUN LOVING IS DESTINED FOR
IMMENSE POPULARITY.

DESIGNER SAVA CVEK INFUSED RHYTHM WITH COMFORT, VERSATILITY
AND A SUNNY PERSONALITY, PLUS SUPERIOR ERGONOMIC DETAIL.
ALL THIS IN A STACKER? SURE. TO GIVE YOU A SMART SOLUTION
TO SPECIFICATIONS THAT USED TO YIELD LESS FASHION
FORWARD RESULTS.

AND THE BEAT GOES ON. AS IF RHYTHM WEREN'T ALREADY ON YOUR DANCE CARD,
YOU'LL FIND A MYRIAD OF OTHER REASONS PUT IT
IN YOUR LINE-UP. VIBRANT COLOR OPTIONS (INCLUD-
ING TRANSLUCENTS). CONTRASTING ARMS AND
GLIDES. UPHOLSTERY. REAR CASTORS (MORE ABOUT
THAT LATER). AND MORE.

STYLEX

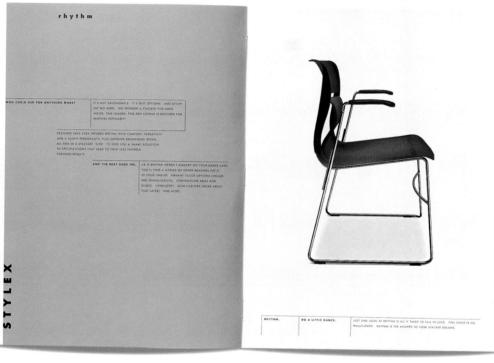

RHYTHM. DO A LITTLE DANCE. JUST ONE LOOK AT RHYTHM IS ALL IT TAKES TO FALL IN LOVE. THIS CHAIR IS NO
WALLFLOWER. RHYTHM IS THE ANSWER TO YOUR STACKER DREAMS.

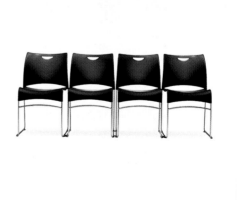

A CHAIR THIS AND IT STILL PLAYS WELL STACK 'EM UP AND MOVE 'EM OUT. OR IN. FIT UP TO 40 VIBE CHAIRS ON THIS
MANLY... WITH ITS DOLLY. STURDY DOLLY FOR QUICK AND EASY TRANSPORT.

HAVE THE GANG THE MORE, THE MERRIER. KEEP YOUR GANG OF VIBES IN LINE WITH OPTIONAL GANGING GUIDES.
OVER. LINE UP FOUR, FIVE OR A WHOLE FLEET. THEY'LL BE A COLORFUL ASSET TO
YOUR TEAM.

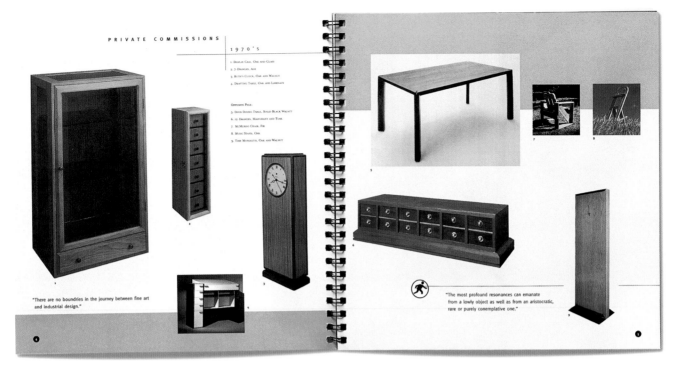

PRIVATE COMMISSIONS 1 9 7 0 ' S

1. DISPLAY CASE, OAK AND GLASS
2. 7 DRAWERS, ASH
3. RUTH'S CLOCK, OAK AND WALNUT
4. DRAFTING TABLE, OAK AND LAMINATE

OPPOSITE PAGE:
5. DAVIS DINING TABLE, SOLID BLACK WALNUT
6. 12 DRAWERS, MAHOGANY AND TEAK
7. McMURDO CHAIR, FIR
8. MUSIC STAND, OAK
9. TIME MONOLITH, OAK AND WALNUT

"There are no boundries in the journey between fine art and industrial design."

"The most profound resonances can emanate from a lowly object as well as from an aristocratic, rare or purely conemplative one."

THE WORK OF MICHAEL WOLK

MAKING DESIGN MATTER

GALLERY PLUS 1 9 7 0 ' S

"Your living room will look great in our new cocktail table."

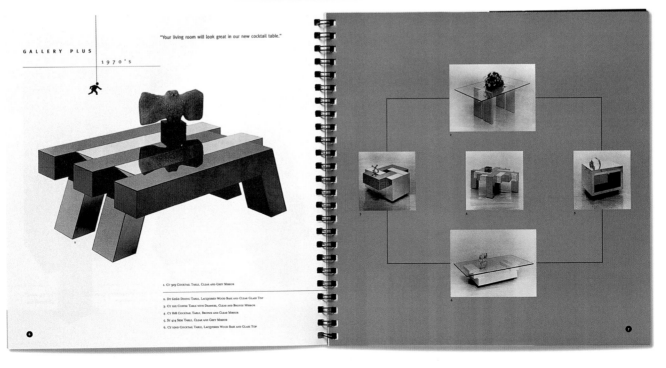

1. CT 919 COCKTAIL TABLE, CLEAR AND GREY MIRROR
2. DT 6060 DINING TABLE, LACQUERED WOOD BASE AND CLEAR GLASS TOP
3. CT 919 COFFEE TABLE WITH DRAWER, CLEAR AND BRONZE MIRROR
4. CT 818 COCKTAIL TABLE, BRONZE AND CLEAR MIRROR
5. ST 414 SIDE TABLE, CLEAR AND GREY MIRROR
6. CT 1010 COCKTAIL TABLE, LACQUERED WOOD BASE AND GLASS TOP

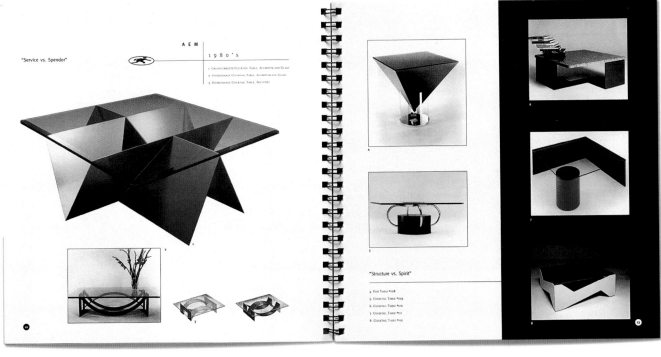

AEM | 1980'S

"Service vs. Spendor"

1. CHODREEMENTS COCKTAIL TABLE, ALUMINUM AND GLASS
2. INTERCHANGE COCKTAIL TABLE, ALUMINUM AND GLASS
3. INTERCHANGE COCKTAIL TABLE, SKETCHES

"Structure vs. Spirit"

4. END TABLE #108
5. COCKTAIL TABLE #109
6. COCKTAIL TABLE #110
7. COCKTAIL TABLE #111
8. COCKTAIL TABLE #112

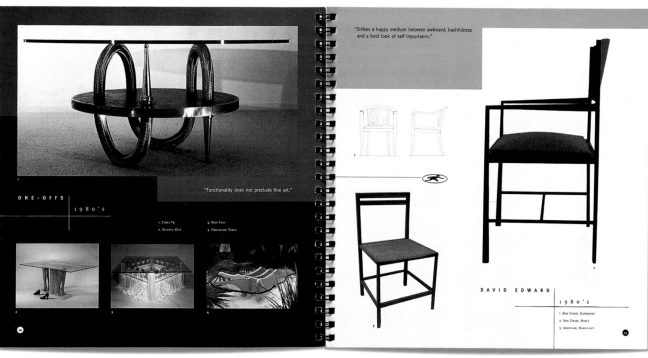

ONE-OFFS | 1980'S

"Functionality does not preclude fine art."

1. TABLE #9 3. MOP TOPS
2. STEPPIN-OUT 4. COCKTAIL TABLE

"Strikes a happy medium between awkward, bashfulness and a bold look of self importance."

DAVID EDWARD | 1980'S

1. SIDE CHAIR, SCHEMATIC
2. SIDE CHAIR, MAPLE
3. ARMCHAIR, MAHOGANY

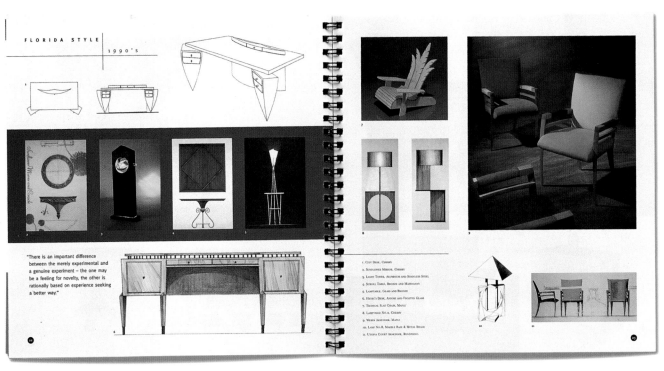

FLORIDA STYLE | 1990'S

"There is an important difference between the merely experimental and a genuine experiment – the one may be a feeling for novelty, the other is rationally based on experience seeking a better way."

1. CITY DESK, CHERRY
2. SUNFLOWER MIRROR, CHERRY
3. LIGHT TOWER, ALUMINUM AND STAINLESS STEEL
4. SCROLL TABLE, BRONZE AND MAHOGANY
5. LAMPTABLE, GLASS AND BRONZE
6. HENRI'S DESK, ANIGRE AND FROSTED GLASS
7. TROPICAL SLAT CHAIR, MAPLE
8. LAMPTABLE NO.2, CHERRY
9. WEBER ARMCHAIR, MAPLE
10. LAMP NO.8, MARBLE BASE & METAL SHADE
11. UTOPIA COURT ARMCHAIR, RENDERING

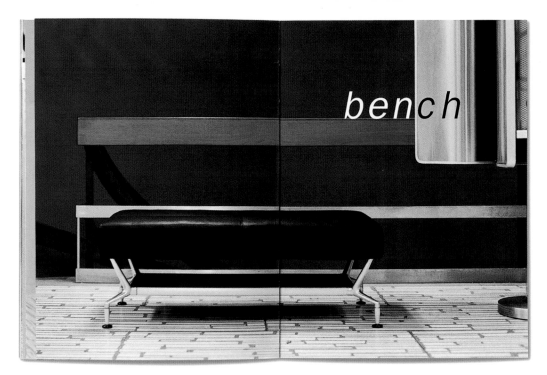

bench

jet

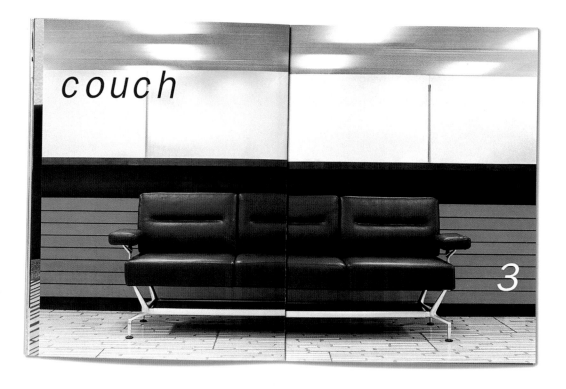

couch

3

Design Firm: **Concrete Design Communications** Art Directors: **Diti Katona** and **John Pylypczak** Designer: **John Pylypczak** Photographer: **Chris Chapman** Client: **Keilhauer**

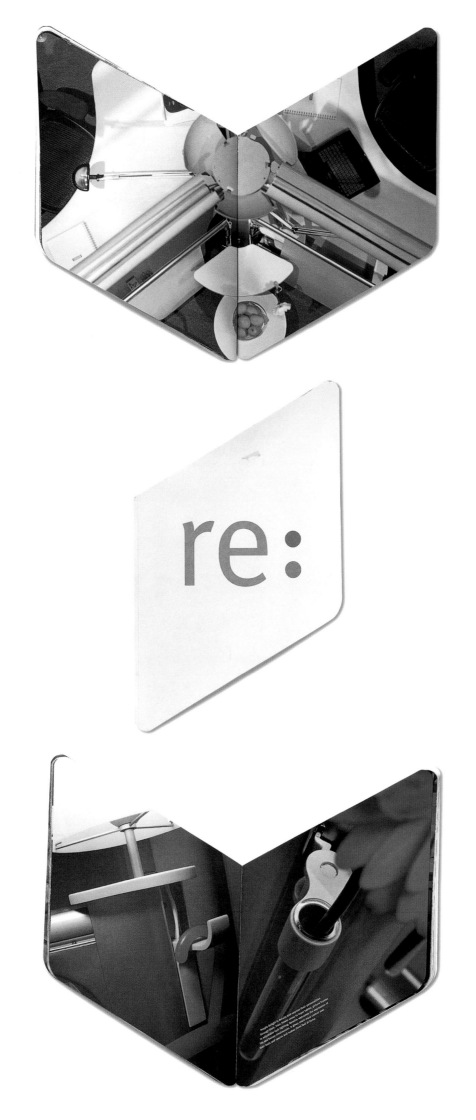

re:

Design Firm: **Pentagram Design** Art Director: **Paula Scher** Designers: **Paula Scher** and **Anke Stohlmann** Photographer: **Francois Robert** Client: **Herman Miller Inc.**

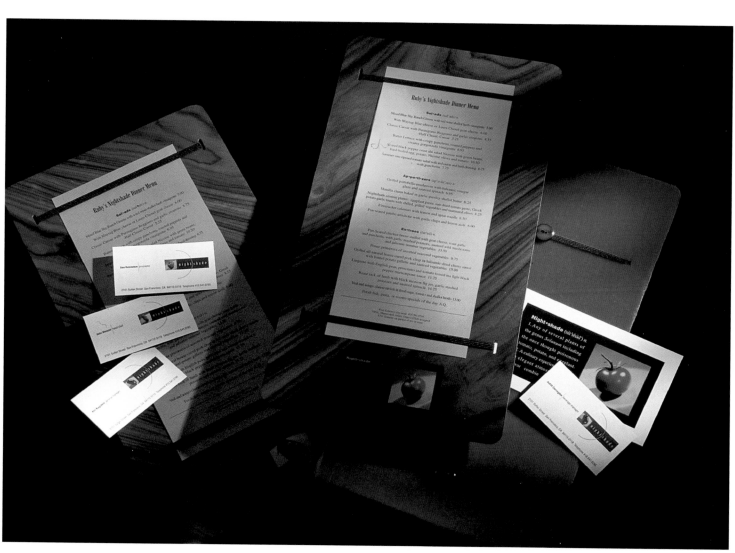

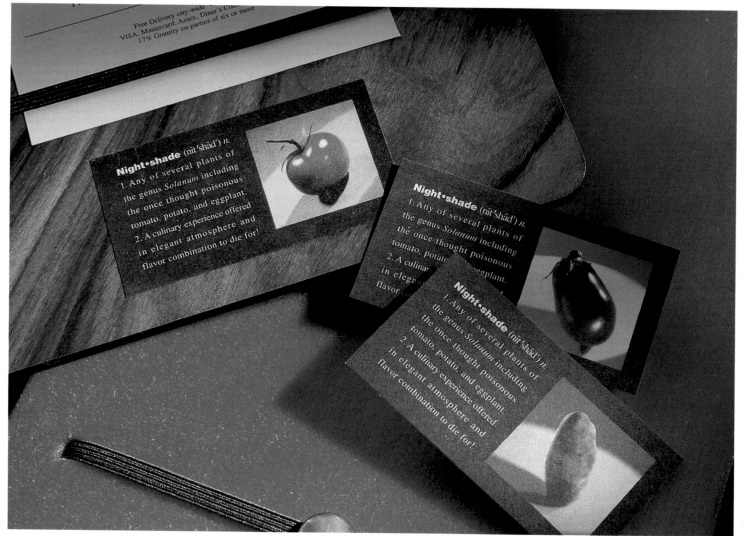

Design Firm: **Sackett Design Associates** Creative and Art Director: **Mark Sackett** Designers: **Wayne Sakamoto** and **James Sakamoto** Photographer: **John Acuro** Client: **Nightshade Restaurant**

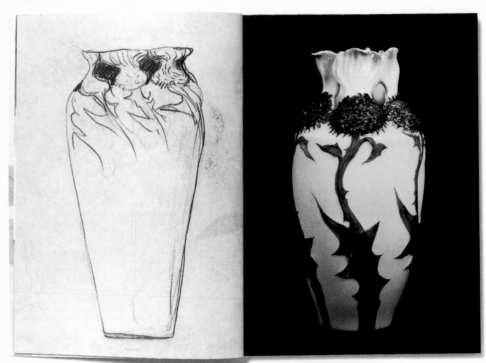

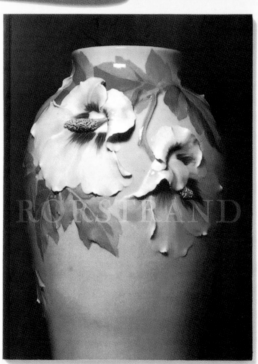

RÖRSTRAND

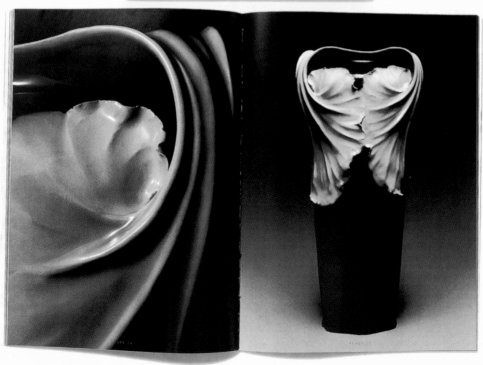

Design Firm: **Socio X** Creative and Art Director: **Bridget de Socio** Designer: **Laura Harris** Photographer: **Noël Allum** Client: **Robert Schreiber**

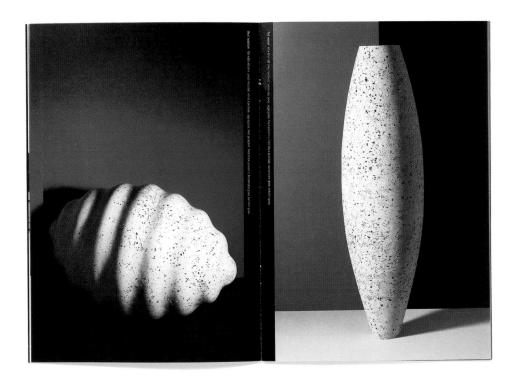

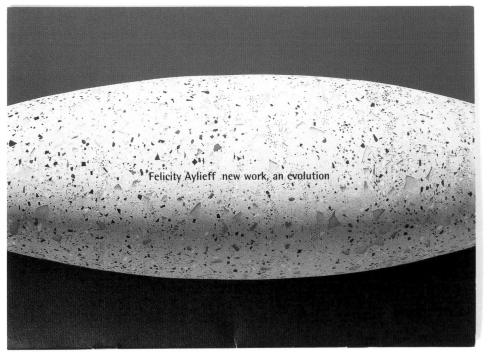

Felicity Aylieff new work, an evolution

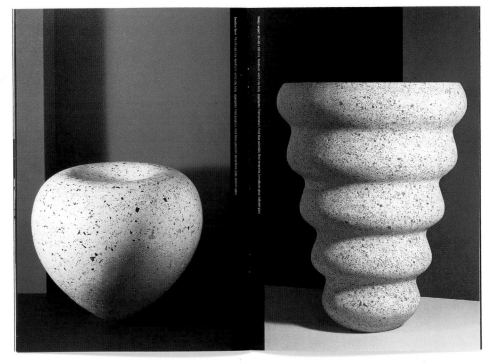

Design Firm: **Mytton Williams** Art Director: **Bob Mytton** Designer: **Danielle Way** Photographer: **Sebastian Mylius** Client: **Felicity Aylieff**

AUTOMATA
Fascinations and Machinations of the Nineteenth Century:
Automata and Mechanical Toys

ANCESTORS
Abelam Figures from Papua New Guinea

Basketry
The Art and Utility of California
Indian Basketry

Parasols
Four Seasons in Japan:
Parasols from the Gifu City Museum of History

Pentagram Design Creative Director: Belle How Art Director: Kit Hinrichs Photographers: M. Fatheree, G. Branbury and C. Ranier Client: San Francisco Airport Commission

made as design experiments or in response to the commands of royalty. Large fortunes were offered for these unique pieces, and the animated art objects bearing ornaments and jewels were greatly esteemed at the time as centerpieces or music boxes.

A significant change in the world of automata occurred in the second half of the

Automata keys
"LB" stands for the names "Lambert" and "Bourgeois" and symbolizes the close collaboration between Léopold Lambert and his wife Eugénie Bourgeois

nineteenth century, a period of industrialization that allowed for improvement of techniques of the first half of the century and the establishment of a capitalist economy. A large middle class appeared who had a taste for leisure. They developed an infatuation for art, performance, and decorative, extravagant objects. They constituted a clientele important for the makers of automata who were for the most part located in the Marais quarter of Paris.

The collection of automata at the Musée de Neuilly-sur-Seine includes sixty-nine pieces. It offers a nearly complete range of automaton production in the second half of the nineteenth century and the first half of the twentieth century. The majority of these pieces date from the period 1880 to 1914. Most are set in motion by a mechanical spring

motor and generally possess a music box. The best makers of the era are represented: Bontems, Lambert, Vichy and Triboulet, Roullet and Decamps, and Phalibois.

The sources of inspiration for the creators of these automata accurately reflect the preoccupations and interests of French society at the end of the last century, including a pronounced attraction for travel and the exoticism stimulated by the colonies in Africa

6 7

The song of a bird has been reproduced artificially since antiquity. Songbirds, such as canaries, have always been appreciated both in the West and in the Far East. The fabrication of this bird in a cage is attributed to Bontems, a family specializing in this type of automaton at the end of the last century. A spring in the motor allows it to move the wings, head, and tail in a realistic manner. A whistle joined to a piston produces a perfect imitation of a birdsong.

Cage with Singing Bird
late 19th century
Bontems
France
wood, feathers, metal
Collection of Musée des automates de Neuilly-sur-Seine, France
978.1.2
L9906.01.001

Bontems

Blaise Bontems was born in 1814. An apprenticeship with a clockmaker in Vosges, France, and an early interest in taxidermy were to set him on the path of a long and successful career as maker of singing, life-sized birds that he placed under domes, in cages, and in clocks. Subjects varied from tiny plumed solitary singing birds to complicated scenes containing several birds moving realistically. It was the quality of the birdsong, most often the nightingale and canary, that made them lasting favorites.

Bontems reproduced the extraordinary rapidity and continuous succession of notes and trills that make up the various birdsongs by means of bellows and a slide whistle. As there was no available recording machine, the stories of hours spent listening in the woods at dawn cannot be doubted.

10 11

The hand-cranked barrel organ plays a German folk tune for a clown and a donkey, a popular German subject for toys. The unusual case is decorated with carvings in a folk art style.

Clown and Donkey
probably
mid 19th century
Germany
porcelain, wood, composition, applied fur, fabric
Private collection
L9906.03.008

Punch and Judy on Drum Manivelle
c. 1875
probably Germany
papier-mâché, fabric, paint
Collection of San Francisco Airport Museums
C1997.016.8
L9906.05.012

The composition-headed duo fight atop the paper drum lithographed with children and magicians; the drum beats as the handle is turned to one side.

14 15

the tao of painting:
principles in monochrome

(this spread) Design Firm: **Sullivan Perkins** Art Director: **Rob Wilson** Designers: **Rob Wilson, Robert Eford** and **Sandy White** Copywriters: **Marina Zakarian, Johannes Meinhardt** and **Chris Greissinger** Client: **The McKinney Avenue Contemporary**

the tao of painting: principles in monochrome
BY MARINA ZAKARIAN

the origins of monochromatic painting lie early in the century, when Kazimir Malevich painted a white square on a white field in 1918. As an expression of a pure state of feeling, Malevich's painting offered a beacon of hope for abstract painting's spiritual potential. Three years later, Alexandr Rodchenko exhibited a red, a yellow, and a blue painting, declaring that together they represented the final statement that could be made in the medium and thus signified the death of easel painting, turning his attention to production, regarding this as a necessary and inevitable choice. When Malevich's Black Square was displayed at the 0-10 exhibition in Petrograd from December 1915 to January 1916, hung diagonally in a corner of a room and near the ceiling in the traditional position of the Russian icon, the association with death was irresistible to critics, one of whom wrote, "The corpse of the Art of Painting, the art of nature with make up added, has been placed in its coffin and marked with the Black Square."[1]

For the first time in the history of art, painters, through a conscious rejection of their specific field and a shift of orientation, became highly sensitive seismographs of the tendencies for the future. These dual perceptions of experimentation with monochromatic painting, as a vehicle for spiritual redemption and as the absolute end of painting, have ebbed and flowed throughout the century.

Monochromatic painting is a key concept of radical modern art and avant-garde's non-objective painting. In the course of the liberation of painting from imagery, during the avant-gardist abstraction period from 1922 through 1940, and again in the second Neo-Avantgarde period from 1948 through 1960, monochromatic painting was a final point, and also a turning point, in a consistent trend towards reduction: the reduction of everything recalling object-related perception; the reduction of all external references, as well as the reduction of all random, sensual and contingent forms and associations within a picture. Progressing to the total absence of inner articulation and relations, the analytical movement of purification and reduction of abstraction led, however, to aporia[1] in monochromatic works. By reducing to the point of non-existence, the inner articulation of a picture-area and its inherent autonomous pictorial quality, painting reached a stage at which monochromes were nothing more than simple planes, visible only as the monochromatic surface of a material body or as a color shape within the contingent color shape of the wall. The trend reversal, as monochromatic paintings reached point Zero[2], occurred between 1918 and 1921—exemplified by the transition from Malevich to Rodchenko—and again between 1958 and 1960 in the transition from Ad Reinhardt to Frank Stella.

Monochromatic painting can therefore mean the most reduced form of ideality and immateriality of autonomous abstraction, as well as its greatest contrast: a homogeneous material surface, devoid of any immateriality and autonomy. The pseudo-category of "monochromism" became highly regarded work due to its evident ability to unite contradictory forms of perception. A monochromatic painting is perceived in totally different, sometimes contradictory ways. Color is perceived either, firstly, as an optical value within an immaterial and conceptual color style, as a significant heroic abstraction; or, secondly, as a subjective, emotional value whose seemingly direct, speechless and natural expression is based on a cultural color style, on a significance which is unconscious or not actualized, as in expressionist art; or, thirdly, as a density or spatial effect of color based on the physiology of perception; or, fourthly, as a real, material application of a material color, and thus as an element of the objective world.

Monochromatic painting has been regarded as having a deep relationship with Eastern metaphysics—as suggested by many of the artists that have committed themselves to the process—by embracing the elements of an objective world through non-objective depiction. Throughout the century, interest in myth and the unconscious, coupled with an interest in Native American mysticism[3], encouraged American artists' receptivity to other non-Western ideas, including those of Lao-tzu, Zen[4], Taoism, mandalas[5], and the I Ching[6]. The Singyo[7], or Heart Sutra, embodies the central meaning of Zen thought, according to the theologian and philosopher Alan Watts[8]: "What is form that is emptiness, what is emptiness that is form."[9]

Simplicity of form and color intrinsic in the early works of Malevich, Rodchenko and Yves Klein, does not necessarily reflect an investigation such as that of "minimalist" art.[10] In a meditative sense, these monochromatic paintings open up the way to absolute emptiness and silence. Such art that aims at the transcendence of physical life may be visually harmonious, but, this use of color and geometry is meant to serve as a spiritual principle rather than as aesthetic decorativeness or a formal structure.

With a monochromatic painting, which relies entirely on the inherent value of the structured paint, the work is untrammeled by any illusion or conceptual definition: In place of a legible illustrative image, there exists a perceptible color image. Beyond mimesis, there is a vast source of aesthetics, the sensual and transcendence, perceived as more than a mere noting of factual color. In this way, monochromatic paintings, a canvas of one color, or a hue of one color, constitute visual landscapes in which the memory and presence of the color image are inseparably intertwined. As with Eastern philosophy, specifically Taoism, the pedagogical tradition is distinctive for certain fundamental concepts, and for the manner in which they have long been unified in an order of harmony.

The philosophy of the Tao (the Way) is focused entirely on the premise that all things in the world are ultimately part of this single Tao: All contradictions and opposites are resolved in the Tao. The Tao is the sum total of everything; yet it is still only a single entity.

Joseph Marioni, Yellow Painting, 1999

For the Taoists, anything viewed apart from this unitary principle, that is, anything viewed as having reality in and of itself apart from its place in the entirety of the universe, is fundamentally an illusion. Nothing has any meaning, value, or reality apart from its relation to the Tao. This Tao is unknowable and unspeakable: All human knowledge is knowledge of individual things and their relations, so no human knowledge can encompass the whole of everything as a single thing.

In France during the late 1950's and early 1960's, Yves Klein investigated monochrome as a painting of "nothingness." For Klein, his ultramarine canvases were the representation of the immaterial and the sovereign liberation of the spirit as reflected in his investment of spiritual content of art. Klein's series of monochromatic paintings entitled International Klein Blue (IKB), attempted to imply infinite space and the immateriality of the void. Proceeding logically, he then presented an exhibition entitled The Specialization of Sensibility from the State of Prime Matter to the State of Stabilized Pictorial Sensibility, also known as The Void, at the Paris Galerie Iris Clert on April 28, 1958. For this exhibition, he emptied the space and whitewashed the walls in order to psychically impregnate the space with his aura.[11] Increasingly conceptualizing painting, Klein created Ritual for the Relinquishment of the Immaterial Pictorial Sensitivity Zone from 1957 to 1959. In this series of paintings for "the mind," he enumerates steps for the identification of the cognitive aspect of perception that shapes visual experience and imagination.

It is eminent in Klein's statement regarding "nothingness," and Ad Reinhardt's assertion that "art of color are voids,"[12] that philosophy and spirituality begin to intertwine relative to Taoism. The idea of Nothingness to Taoism comprises notions of "no concern for the affairs of the state, for mundane or quotidian matters of administration, or for elaborate ritual"; rather Taoism encourages avoiding public duty in order to search for a vision of the transcendental world of the spirit. With a monochromatic painting, a distinctive quality is aesthetically conveyed in a spiritual equation.

The relationship between the monochromatic painting and the observer, in terms of an energy current to which the beholder connects himself and which causes him to become fused with the painted surface in experiencing the painting, reveals the energy and transcendence of Eastern philosophy. The rejection of recognizable images, and of the customary avenues of psychological engagement, is accompanied for the viewer by a troubling sense of exposure, of having been divested of the habitual instruments for managing one's environment. With large-scale monochromatic paintings, a discrepancy between the viewer and the painting play a key factor in this disquieting effect. These triggers of emotionality are what the Taoist views as fu or altar, which takes place entirely inside the body, in another world, a new space which is added to the inner and outer spaces we are experiencing.[13]

The artistic processes of the monochromatic painting often ponder "eternal questions" based on a broader philosophy or mysticism, encompassing the general duality between the physical and the reaction; and the harmony, and its orderly environment. The spirituality inherent in monochromatic works reverts to a movement embraced by those artists whose ideals and perceptions were immersed in finding the relationship between the viewer, the participant and the work.

Spiritualism is the devotion to principles relating to religious or moral, rather than to bodily or temporal, matters. Spiritualism is narrowly defined as the belief in an afterlife of the soul and the ability to communicate with spirits. In a broader definition this encompasses a wide range of related beliefs. These may be termed occult, referring to systems of "hidden truths" leading to metaphysical revelations; mystical, or direct experience of God; or non-Western, ranging from Vedanta and Yoga to Taoism and Zoroastrianism.

The spiritual values externalized in monochromatic painting stem from a delicate perception of nature as it actually exists: Spiritual values are obtained from harmony with nature. The naturalism conveyed is reflected in the use of material, processes, and the indescribably delicate atmosphere. Monochromatic painting departs from the Western ideology of dichotomy, which distinguishes subject from object, spirit from nature, and exterior from interior. Monochromatic paintings narrow these seemingly contradicting elements and incorporate them into one.

Since ancient times, "unity between subject and object" has been one of the major points of discussion in theories of Oriental painting. The considerable focus on "incorporated subject and object" has always been on nature rather than on humankind. Chinese painting was never separate from the Tao of living. Its main focus is the Tao, the Way, the Order of Nature or the way nature works, which was alluded to not only in the classics but frequently in discussions of painting as the ideal—the harmony of Heaven and Earth that everything should express. In painting, this aim of the fusion of the spirit, that which pertains to Heaven, and of matter, that which pertain to Earth, relates both to the artist's own development and to the work of art, for successful results require the exercise of insight as well as technical skill, the ability to render the inner character as well as its external form.

Such a nature-oriented attitude could explain why Oriental landscape

Helene Majera, 1950, 1990

Marcia Hafif, Permanent Red Light, 1991

painting preceded its Western counterpart by a millennium; and why landscape painting has always been the mainstay of traditional Oriental painting: The unchangeable view of the world that saw humans as mere 'weak creatures' compared to 'grand mother nature'.

For monochromatic painting, unity between non-narrative and non-object has different causes: Induced harmony with nature through the constant buildup of material, and the effort to portray a purified world by using pure color. Monochromatic painting uses a solid color, excluding artificial composition or contrast for managing space. Neither the material nor the traces of activity claims anything, as if they gave up the very reason for their existence. But such a statement fails to be a complete explanation, as we would still be left with the question of the continued effort for 'naturalization'. Instead of creating an image to be appreciated, the painter strives to show the light, the energy of pure material.[13] It is the power found pumping and breathing in pure material that conveys the intangible embodiment by the simple use of material and color. The world of abyss is the true value of both Chinese painting and the spiritual "void" in monochromatic painting.

1. Zhadova, Larissa A., Malevich: Suprematism and Revolution in Russian Art, 1910-1930, London: Thames and Hudson, 1982, p. 41.
2. Greek term meaning "difficulty."
3. In La page zéro de l'écriture, Naald Barthes theorized that a zero point had been reached in writing after World War II. "Now here is an example of a mode of writing whose function is no longer only communication or expression, but the imposition of something beyond language, which is both History and the stand we take in it."
...
[footnote text continues, partially illegible]
...
11. Klein, Alec, In My Own Way, An Autobiography 1915 - 1965, New York: Vintage, 1973, p. 61f.
12. Ristovation has been insufficiently related to mystical thought, although certain artists, such as Anna Masden, Stein, and Lari Andes have openly admitted urged their interest in alchemy.
...
13. Ad Reinhardt, quoted in Interior Yoga, Yoga Reinhardt: Art as Art," in Selected Writings of Ad Reinhardt, 1975.
...

Callum Innes, Exposed Painting, Violet, 1996

Phil Sims, Blackford Painter, 1999

monochrome as a painting breakdown and breakpoint
BY DR. JOHANNES MEINHARDT

in the history of modern art and postmodern painting, monochrome is the decisive relay, the essential transition point. During this historical turning point, epochal re-evaluations and new interpretations occurred. In this period, fundamental shifts and transitions took place—in painting as well as in other art genres that arose from painting (sculpture, objet d'art) or even in production beyond art (design, production art). Debates around both the '20s and the '60s and beyond concerning monochrome painting saw the modern art of painting struggle for its concept or essence and in an effort to crystallize its expression, rush into an aporia of painting identical with its own concept. Consequently it can no longer exist as a real, contingent, historical, and individual work of art. All the while, Monochrome continues to be an indissoluble and contradictory issue within the categories of modern and postmodern painting. Being the realization of its own idea, the concrete individual painting coincides with the "painting itself," the substance of the painting or the conception of the painting. However, this "painting itself," which encompasses the essence of all individual paintings and delivers the answer to the essentialist issues of modern art, questioning the truth or character of the art of painting, cannot exist as a real and visible painting but rather remains an empty notion, which cannot be visualized or concretized.

The central position that Monochrome holds in modern art, which makes it the somewhat obscured model of the entire epoch, had its primary roots in the fact that it was the inevitably flawed answer to essential theoretical problems of modern art. It thus held a central position because Monochrome represented the time and place of a break or a breakdown. In Monochrome—the monochrome plate, no matter how reduced, is perceived as a painting—the immanent contradictions of modern art were driven to the point of explosion and destruction of the issues and perception orders within modern painting. In other words, a point of implosion was reached due the painting's loss of its inner ambiguity, as articulated in the aesthetic difference, which "imploded" in to nothing more than a mere object or surface. The irreducible tension of modern art existing between the real and sensual visibility of the painting and its immaterial, intellectual, and spiritual content both motivates and justifies the non-representational composition. It led to an extreme reduction in applied visual means for most of the heroes of abstract painting. The painting showed a conceptual, essential necessity only when random, contingent, and variable moments of painting

...it all starts from books.

FREEMAN
LAU 劉小康訊
WORKS 息的
OF 存在与再現
MESSAGE

The first time I saw Lau's work was in the exhibition of the "Contemporary Hong Kong Biennial". The work, entitled "Message Symbol No.1", with books as its theme, remains fresh in my memory. A pile of neatly cut white sheets was bound up like a book, which was at least three to four feet thick and opened. The fact that it was a mixed media work was entered as a sculpture was enough to draw one's attention. This piece, which looks

(this spread) Designer: **Freeman Lau** Photographer: **C.K. Wong** Client: **Freeman Lau**

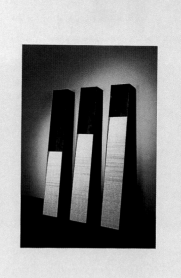

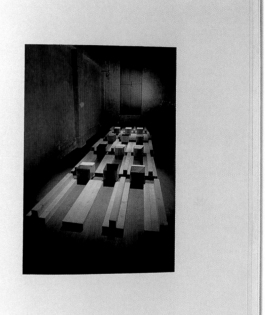

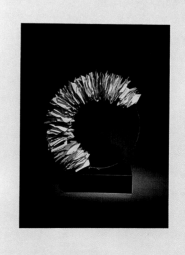

STRIPES & STARS

*

ON JUNE 14, 1777, THE CONTINENTAL CONGRESS
FORMALLY ADOPTED A MODIFIED VERSION OF THE SONS OF
LIBERTY FLAG, RESOLVING THAT "THE FLAG OF THE UNITED STATES
BE 13 STRIPES ALTERNATE RED AND WHITE,
THAT THE UNION BE 13 WHITE STARS IN A BLUE FIELD
REPRESENTING A NEW CONSTELLATION."

*

EARLY FLAG MAKERS LIBERALLY INTERPRETED THESE
GUIDELINES, ARRANGING THE STARS INTO WREATHS, ARCS, OVALS,
STRAIGHT LINES, OR JUST RANDOMLY ACROSS
THE BLUE FIELD. SOME DESIGNED ELABORATE STARBURSTS,
OTHERS CREATED FIVE-POINTED STARS.
EVENTUALLY THE PENTAGRAM PREVAILED.

*

THROUGHOUT THE FIRST 150 YEARS OF FLAG
PRODUCTION, ONLY VAGUE LEGAL GUIDELINES DEFINED
THE GRAPHIC APPLICATION OF THE "STRIPES
AND STARS," THE ORIGINAL VERNACULAR TERM FOR THE
FLAG. AS A RESULT, AMERICANS FREELY AND PROUDLY
DISPLAYED THE STRIPES AND STARS ON A VARIETY
OF COMMON OBJECTS, RANGING FROM EMBROIDERED
BLANKETS TO LAPEL PINS.

*

DESPITE LEGAL RESTRICTIONS ADOPTED BY CONGRESS
IN 1912 AND 1934, THIS EXHIBITION ILLUSTRATES THAT
POPULAR INTERPRETATIONS OF THE FLAG MOTIF HAVE CONTINUED
TO PROLIFERATE, RESULTING IN A RICH VISUAL HISTORY
OF A TRUE AMERICAN ICON.

*

STRIPES & STARS

A GRAPHIC HISTORY OF AN
AMERICAN ICON

*
ARTIST UNKNOWN
NAVAJO "DIAMONDS &
STARS" FLAG WEAVING
CIRCA 1960
ANILINE DYED WOOL
35.5" x 64.2"
*

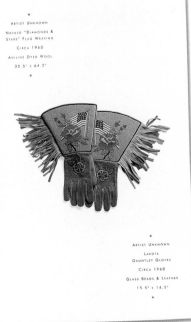

*
ARTIST UNKNOWN
LAKOTA
GAUNTLET GLOVES
CIRCA 1960
GLASS BEADS & LEATHER
15.5" x 14.5"
*

(this spread) Design Firm: **Pentagram Design** Creative Director, Art Director and Designer: **Kit Hinrichs** Photographers: **Bob Esparza** and **Terry Heffernan** Copywriter: **Delphine Hirasuna** Client: **American Institute of Graphic Arts**

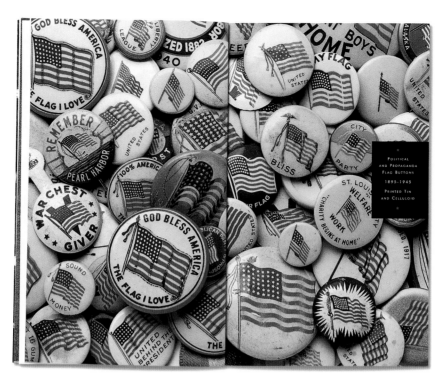

POLITICAL
AND PROPAGANDA
FLAG BUTTONS
1895-1945
PRINTED TIN
AND CELLULOID

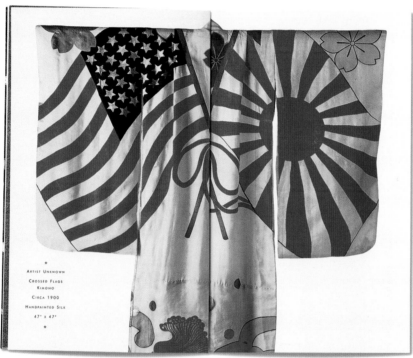

*
ARTIST UNKNOWN

CROSSED FLAGS
KIMONO

CIRCA 1900

HANDPAINTED SILK

47" X 47"
*

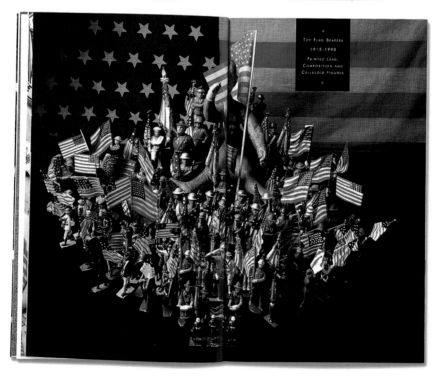

*
TOY FLAG BEARERS

1915-1990

PAINTED LEAD,
COMPOSITION AND
CELLULOID FIGURES
*

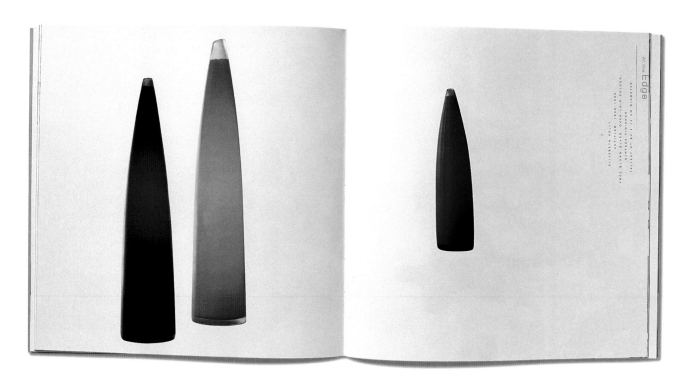

At the Edge

Australische
AUSTRALIAN Glaskunst
GLASS ART

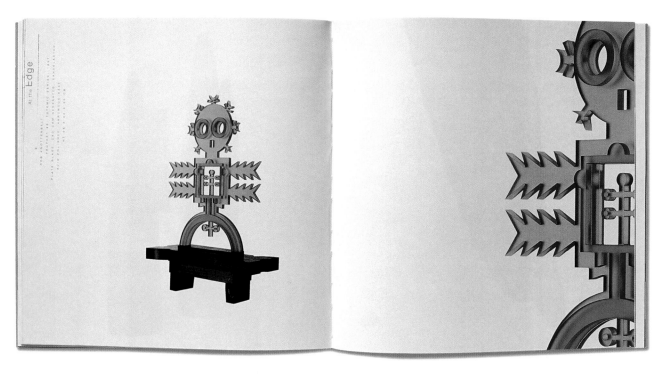

(this spread) Design Firm: **Dot Dash** Creative Director: **Mark Ross** Art Director and Designer: **Paul Nolan** Photographer: **Peter Budd** Client: **Brisbane City Gallery**

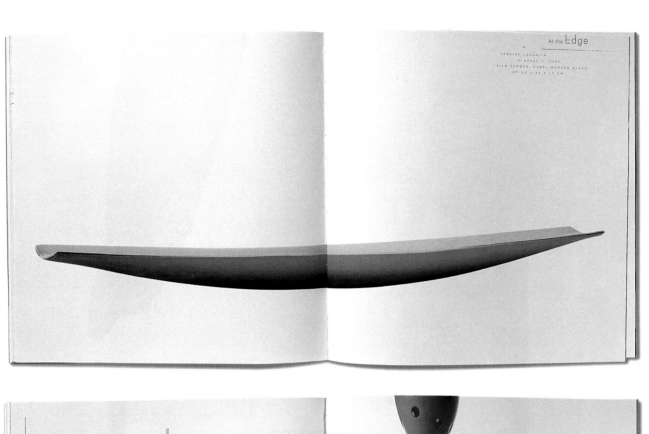

At the Edge

NICK MOUNT
SCENT BOTTLE #11, 2000
BLOWN GLASS FORMED,
CUT, POLISHED AND SAND-BLASTED
HT 94 × 36 CM DIAMETER

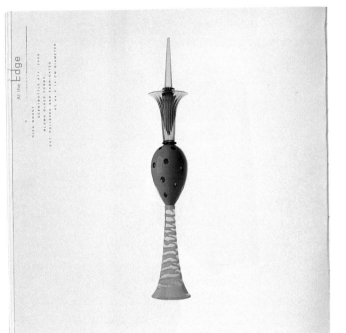

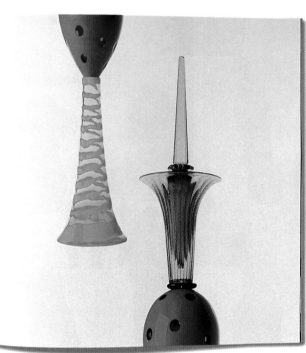

At the Edge

RICHARD WHITELEY
CORRECTION, 1999
CAST LEAD AND SODA-LIME GLASS
GLUED, HAND-CUT AND POLISHED
HT 48 × 23 × 21 CM

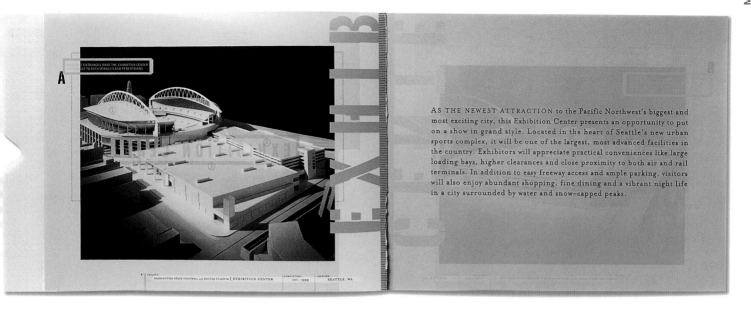

A

B

AS THE NEWEST ATTRACTION to the Pacific Northwest's biggest and most exciting city, this Exhibition Center presents an opportunity to put on a show in grand style. Located in the heart of Seattle's new urban sports complex, it will be one of the largest, most advanced facilities in the country. Exhibitors will appreciate practical conveniences like large loading bays, higher clearances and close proximity to both air and rail terminals. In addition to easy freeway access and ample parking, visitors will also enjoy abundant shopping, fine dining and a vibrant night life in a city surrounded by water and snow-capped peaks.

PROJECT: WASHINGTON STATE FOOTBALL and SOCCER STADIUM (EXHIBITION CENTER COMPLETION: NOV 1999 LOCATION: SEATTLE, WA

EXHIBITION CENTER

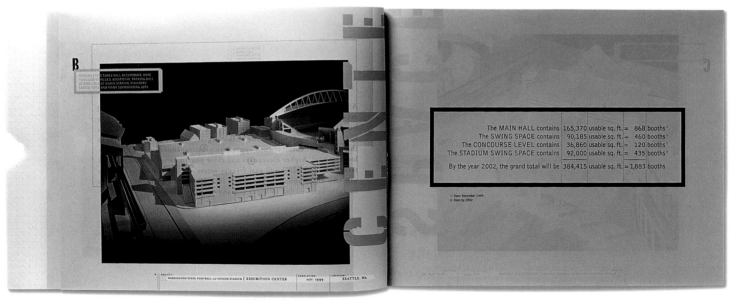

B

PARKING STRUCTURES WILL ACCOMODATE MORE
THAN 2,000 VEHICLES. ADDITIONAL PARKING WILL
BE AVAILABLE AT UNION STATION, MAKINERY
AND MANY SURROUNDING LOTS.

PROJECT: WASHINGTON STATE FOOTBALL and SOCCER STADIUM (EXHIBITION CENTER COMPLETION: NOV 1999 LOCATION: SEATTLE, WA

	usable sq. ft.	=	booths
The MAIN HALL contains	165,370	=	868 booths[1]
The SWING SPACE contains	90,185	=	460 booths[1]
The CONCOURSE LEVEL contains	36,860	=	120 booths[1]
The STADIUM SWING SPACE contains	92,000	=	435 booths[2]
By the year 2002, the grand total will be	384,415	=	1,883 booths

1- Open November 1999
2- Open by 2002

Design Firm: **Sandstrom Design** Creative and Art Director: **Steve Sandstrom** Project Manager: **Kathy Middleton** Client: **Seattle Exhibition Center**

Museums 168, 169

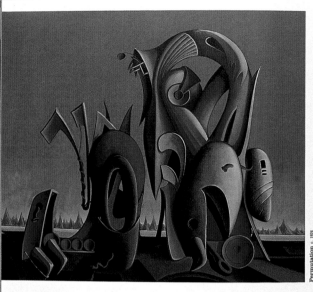

Permutation c. 1974
Oil on canvas, 60 x 70 inches
Collection of Valley House Gallery

Permutation, one of my all-time favorite works by Valton Tyler, is now twenty-six years old and no less magnificent (if somewhat smaller) than the recent *Give Us Sound*, 1999, 78 x 121 inches. *Permutation* was made in 1974 and is 60 x 70 inches. In it, the phosphorescent red sky becomes lighter as the eye travels downwards from the top of the painting, until the gold of a florid sunset back-lights a series of mountains in the very deep space. There is a mysterious band of the same gold light immediately in front of those mountains which modulates to orange as it forms a band across the entire canvas, which varies from ⅛ to 1 inch wide depending on the exact outline of the complex, deep blue sculptural edge/wall which separates the dense, complex foreground from the tiny rear space of this canvas (the tallest mountain is only 2½ inches high).

And, what a spectacular foreground! There are two conglomerates of forms Mr. Tyler invents. They are all folded together and can be curves, ellipses, circles, truncated rectangles, obloids, ovoids, ever-variant triangles, soft forms, hard forms, melting forms, floating forms, swollen forms, wiggling forms, flags, rods, pipes, points, pins, twists, curves, flat planes, curved planes, and they exist in any number of changing perspectives.

There are at least eight shades of blue or purple (apart from the six places where dark blue has crept into red). There are five different greens: one with yellow, one with blue, two with degrees of yellow and white, and one almost pure.

A major frontal organic-type form (it might even have a tusk and an open mouth) is tan. The rhythms that flow like an electrical charge from one form to the other, from one space to another, and from one texture to another provide a continuous challenge to the viewer, while carrying the audience (us) along in its path.

6

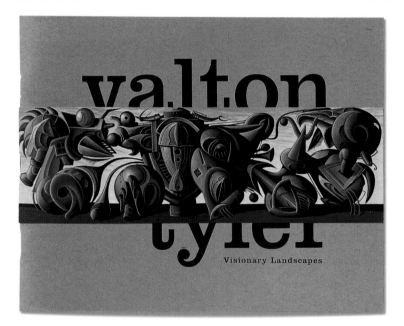

valton
tyler
Visionary Landscapes

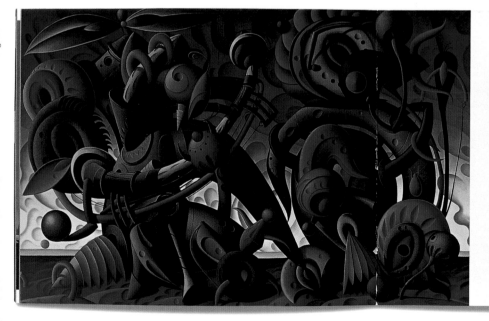

Give Us Sound c. 1999
Oil on canvas, 78 x 121 inches
Private Collection

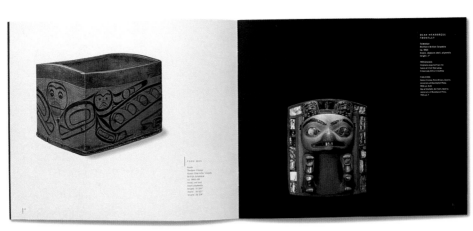

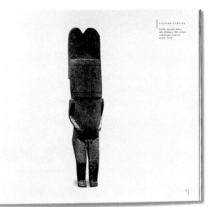

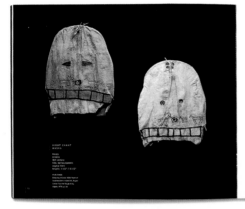

Donald Ellis Gallery

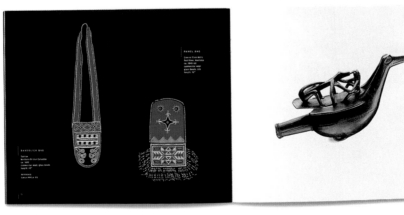

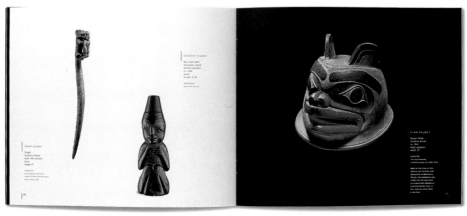

Design Firm: **Hambly & Woolley Inc.** Art Director and Designer: **Barbara Woolley** Client: **Don Ellis Gallery**

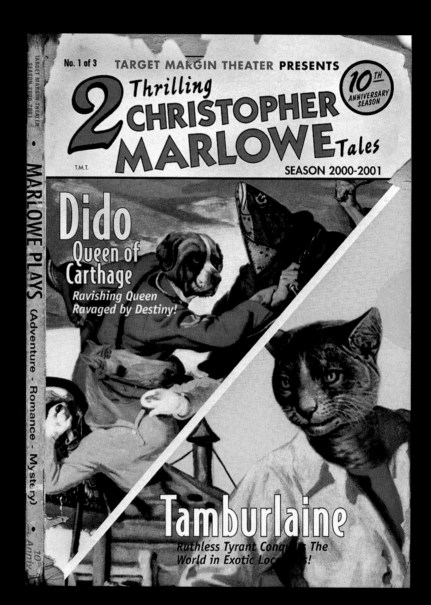

When I sat down to design this 25th Anniversary Limited Edition Series, I knew I couldn't just rehash one of my old designs. That may be enough for a simple collector's item, but these guitars demanded to be much more than that. And with the development of our New Technology design, I knew they could be. I discovered an incredible log of Sapele. A wood I love and a wood worthy to be used to create these guitars. And the designs are my own personal favorites. The New Dreadnought, our evolution of the old classic which offers a powerful response in all registers — and the Grand Auditorium, which yields more treble response and better definition to individual notes. Keep in mind that these guitars are not just reissues. They're not just digging up the past. They are the product of our New Technology — the culmination of 25 years of craftsmanship, ingenuity, art and technology. Play one and I think you'll agree. Guitars this good are worth the wait.

BOB TAYLOR, APRIL NINETEEN NINETY-NINE

Design Firm: **Mires Design** Creative Director: **Scott Mires** Designer: **Deborah Hom** Illustrator: **Chris Wimpey** Client: **Taylor Guitars**

Music & Theater 172, 173

For our fourth and final volume of the American Design Century, we look at some of the objects and images that have become icons of the 20th century. It has been a fascinating exercise contemplating what has endured as meaningful and important to society, and what has ended up being more hype than substance. Some objects have come to symbolize an era, while others have come to define how we lived and played in the 20th century, and what we championed as our greatest achievements. Together these icons are our legacy to future generations – artifacts for them to ponder in amusement or to marvel at the tremendous strides we made. More than any other time in human history, the 20th century witnessed a rapid succession of changes, both technological and social. In America, the century dawned with the introduction of inventions that laid the foundation for everything that followed – the internal combustion engine, the electric motor, the telephone and assembly line production, to name a few. For the first time in history, it became possible to manufacture millions of identical copies of an object and promote them over the airwaves and sell them everywhere. Mass production led to mass marketing, which, in turn, led to mass consumerism. America unabashedly became a consumer society, and business actively pursued

customers by using design to make their products more unique and appealing. Industrial design – a term coined in 1926 – emerged as a vital profession in the 1930s and graphic design – previously lumped under commercial arts – was recognized as a distinct discipline a few decades later. The combined impact resulted in everyday objects that exhibited greater style, physical appeal and functionality. Identical in appearance and cheap enough to own, these objects fostered a shared reality. Say the word "Rolodex" or "McDonald's" or "Weber Grill" and a scene, complete with sound and atmosphere, usually comes to mind. Iconic objects provided a kind of shorthand language for everything from work to leisure. The 20th century is rich with American icons understood not only in the U.S. but all over the world. That has made choosing subjects for this book particularly hard. We surveyed several designers for suggestions, and we narrowed our criteria to "designed" objects, eliminating vast categories such as photojournalism, fine art and typography. Even so, space limitations and an inability to get our hands on certain images forced us to leave out many deserving icons. Undoubtedly, you'll think of things that should have been included. We readily agree. But our attempt here is simply to give you a representative look at the century to enhance your appreciation of who we were and how we're likely to be remembered.

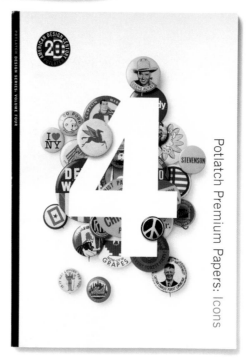

Potlatch Premium Papers: Icons

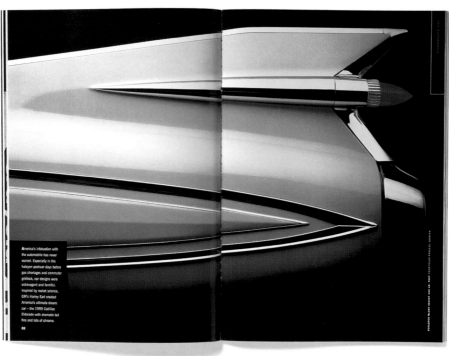

America's infatuation with the automobile has never waned. Especially in the halcyon postwar days before gas shortages and commuter gridlock, car designs were extravagant and fanciful. Inspired by rocket science, GM's Harley Earl created America's ultimate dream car – the 1959 Cadillac Eldorado with dramatic tail fins and lots of chrome.

32

1910s

Music:
Victrola

Toys & Games:
Kewpie Doll

Magazine:
True Story

Packaging:
Lucky Strike

Automobile:
Cadillac

Telephone:
Candlestick Phone

Chair:
Swivel Armchair

Household Item:
Electric Iron

Office Equipment:
Manual Typewriter

As a consultant to Bell Telephone Laboratories, Henry Dreyfuss worked with engineers to design an ergonomically comfortable phone. His Model # 302, introduced in 1937, departed from the awkward shapes of the past and became the standard tabletop phone in American homes and offices.

Model 302 Telephone
U.S.A., introduced in 1937

Designed by Henry Dreyfuss (American, 1904–1972)

Manufactured by Western Electric Co. for Bell Telephone

Metal Housing

Cooper-Hewitt, National Design Museum, Smithsonian Institution/Art Resource, NY

The Decorative Arts Association Acquisition Fund, 1984-73-2

48

< Invented in 1903 by Binney & Smith of Pennsylvania, Crayola has become the ubiquitous drawing tool for children worldwide. More than 100 billion crayons have been sold to date, and even adults recall favorite Crayola colors from their youth.

G.I. Joe 1964 Teddy Bear c. 1903 Barbie 1959 Mr. Potato Head 1952

No matter how high-tech toys get or which beanie baby is in greatest demand, some toys never go out of favor. At 40, Barbie is as popular as ever with little girls, and 35-year-old G.I. Joe still appeals to little boys. Toddlers find stuffed teddy bears (named for Teddy Roosevelt in 1902 after he refused to shoot a bear) irrepressibly cuddly. And Mr. Potato Head continues to offer great interactive fun

45

1920s

VINTAGE VELVET 100 LB. TEXT FOUR-COLOR BLACK, FOUR-COLOR PROCESS, VARNISH

Music:
Console Phonograph

Toys & Games:
Radio Flyer Wagon

Magazine:
The New Yorker

Packaging:
Hershey's Kisses

Automobile:
Jordan Blue Boy

Telephone:
Candlestick Rotary Phone

Chair:
Peacock Chair

Household Item:
Alarm Clock

Office Equipment:
Ticker Tape Machine

VINTAGE VELVET 100 LB. TEXT FOUR-COLOR PROCESS, MATCH GREY, VARNISH

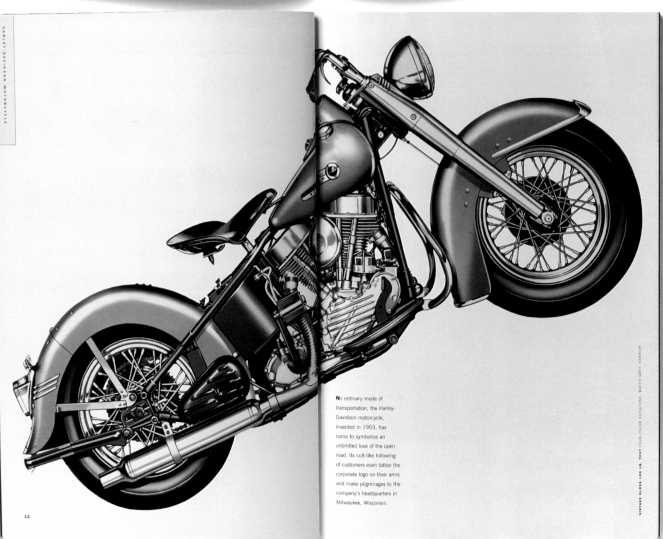

No ordinary mode of transportation, the Harley-Davidson motorcycle, invented in 1903, has come to symbolize an unbridled love of the open road. Its cult-like following of customers even tattoo the corporate logo on their arms and make pilgrimages to the company's headquarters in Milwaukee, Wisconsin.

VINTAGE GLOSS 100 LB. TEXT FOUR-COLOR DUOTONE, MATCH GREY, VARNISH

Music:
Wurlitzer Jukebox

Toys & Games:
Scrabble

Magazine:
The Saturday Evening Post

Packaging:
Cat's Paw

Automobile:
WWII Jeep

Telephone:
Dreyfuss Rotary Phone

Chair:
Naval Chair

Household Item:
Hoover Washing Machine

Office Equipment:
Adding Machine

1940s

68

69

< The secrets of rocket technology that surfaced at the end of World War II started the space race between America and the Soviet Union in earnest. In 1961, astronaut Alan Shepard became the first American to journey into space. By 1981, the space shuttle Columbia successfully circumnavigated the globe and landed back on earth. Today shuttle launches are so commonplace that they barely make the news.

America's most popular spectator sports – baseball, football and basketball – attract a national following, thanks to television and radio. Now avid fans can lie on their couches with their pretzels and beer and watch their favorite major league team vie for the championship.

39

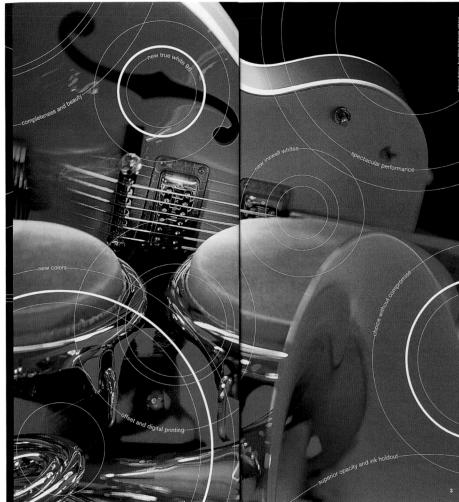

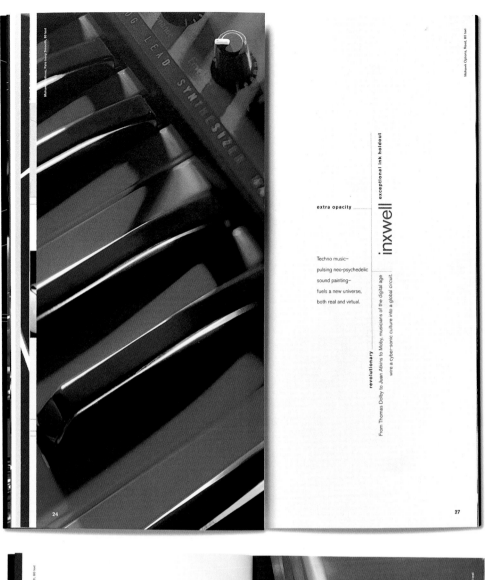

Mohawk Options, Pale Ivory Smooth, 80 text

Mohawk Options, Reed, 80 text

extra opacity

exceptional ink holdout

inxwell

Techno music—
pulsing neo-psychedelic
sound painting—
fuels a new universe,
both real and virtual.

revolutionary

From Thomas Dolby to Juan Atkins to Moby, musicians of the digital age were a cyber-sonic culture into a global circuit.

24

27

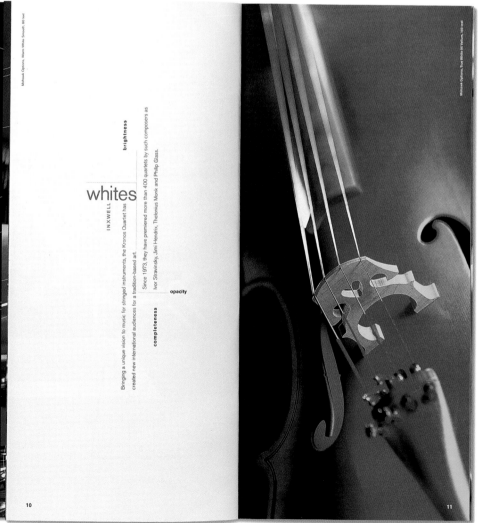

Mohawk Options, Warm White Smooth, 80 text

Mohawk Options, Bright White 94 Vellum, 100 text

brightness

whites

INXWELL

Bringing a unique vision to music for stringed instruments, the Kronos Quartet has
created new international audiences for a tradition-based art.

Since 1973, they have premiered more than 400 quartets by such composers as
Ivor Stravinsky, Jimi Hendrix, Thelonius Monk and Philip Glass.

opacity

completeness

10

11

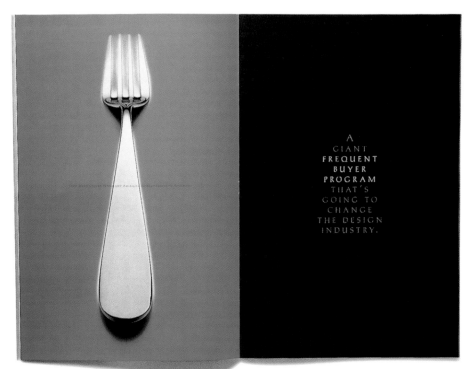

A
GIANT
FREQUENT
BUYER
PROGRAM
THAT'S
GOING TO
CHANGE
THE DESIGN
INDUSTRY.

The SIGNATURE Card

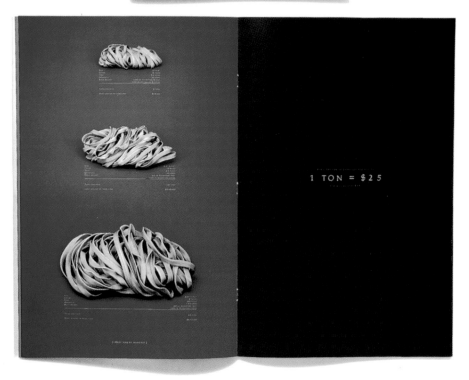

1 TON = $25

Design Firm: **Oliver Kuhlmann** Art Director: **Deanna Kuhlmann** Copywriter: **Mead Coated Papers** Photographer: **David Gill** Client: **Mead Coated Papers**

Paper Companies 180,181

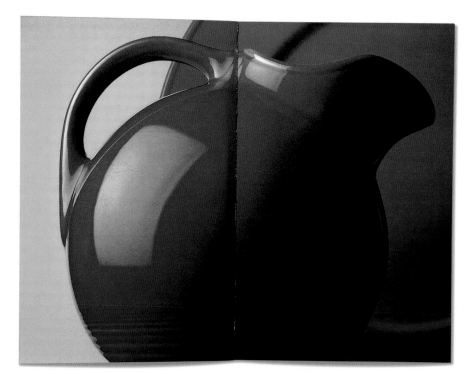

COLLECTIONS on SOLUTIONS®
SUPER SMOOTH
GEORGIA·PACIFIC

Design Firm: **Besser Design Group** Creative Director, Art Director and Designer: **Rik Besser** Copywriters: **Rik Besser** and **Risa De Gorgue** Client: **Georgia-Pacific Corporation**

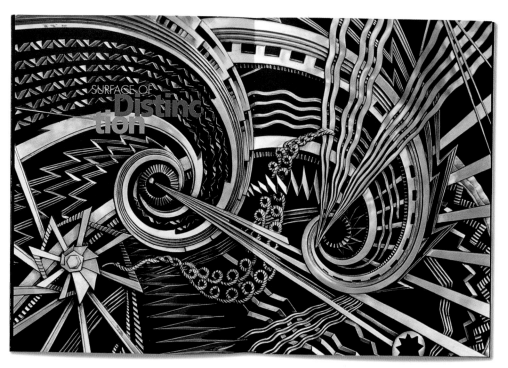

Design Firm: **Sibley Peteet Design** Creative Director, Art Director and Copywriter: **Don Sibley** Designers: **Don Sibley** and **Donna Aldridge** Client: **Weyerhaeuser Paper**

Picture Letter Books
Small Parts. Big Parts.

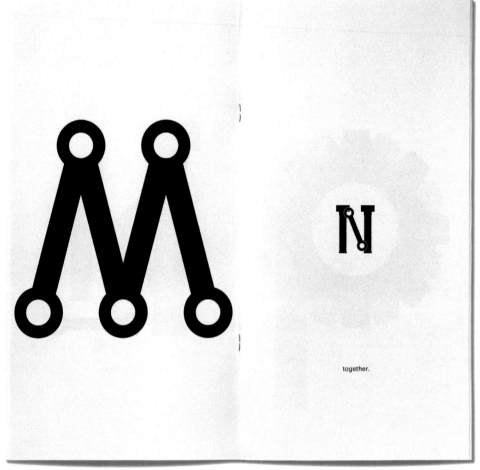

together.

(this spread) Design Firm: **Packaging Create Inc.** Art Director: **Akio Okumura** Designer: **Takako Okemoto** Photographer: **Mitsuru Ueda** Copywriter: **Manami Maeda** Client: **MUSA**

We combine

we put

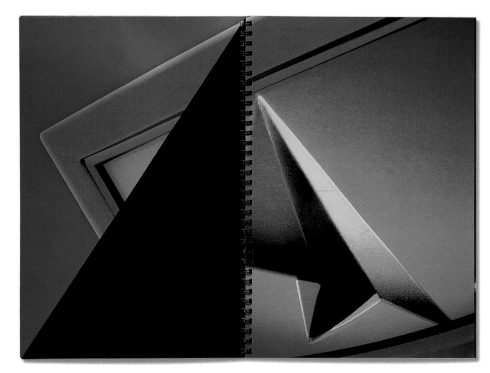

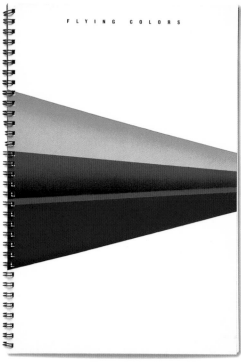

FLYING COLORS

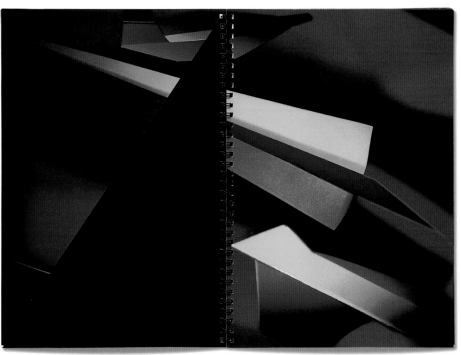

Design Firm: **Balance Design** Designer: **Scott Dvorak** Photographer: **John Wilkes** Copywriter: **Keith Christianson** Client: **Flying Colors**

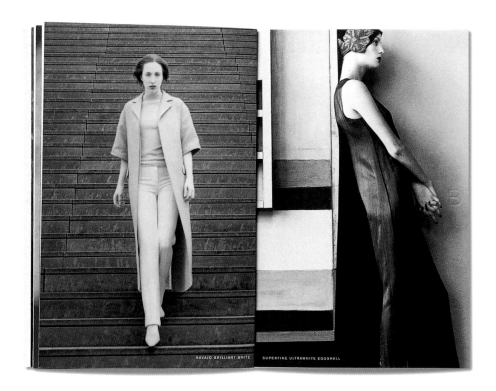

NAVAJO BRILLIANT WHITE SUPERFINE ULTRAWHITE EGGSHELL

WHAT'S WRITE?

MOHAWK PAPER MILLS

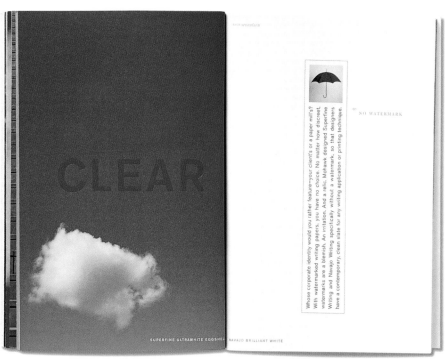

CLEAR

Whose corporate identity would you rather feature—your client's or a paper mill's? With watermarked writing papers, you have no choice. No matter how discreet, watermarks are a blemish. An irritation. And a relic. Mohawk designed Superfine Writing and Navajo Writing specifically without a watermark, so that designers have a contemporary, clean slate for any writing application or printing technique.

NO WATERMARK

SUPERFINE ULTRAWHITE EGGSHELL NAVAJO BRILLIANT WHITE

Design Firm: **USA Partners** Art Director: **Jamie Koval** Designers: **Dan Knuckey** and **Nichole Dillon** Illustrator: **Darrin Marzorati** Copywriter: **Andy Blankenburg** Client: **Mohawk Paper Mills**

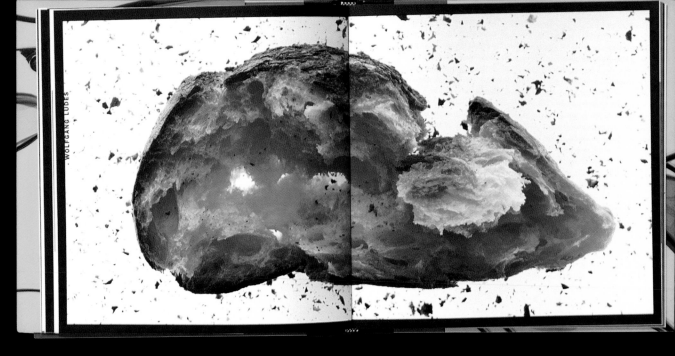

spread) Design Firm: **Designframe, Inc.** Creative Director: **James Sebastian** Art Director: **Michael McGinn** Designer: **Sharon Giresh** Client: **Strathmore Papers**

JOHN HUET

Meaning is something we acquire by collecting different pieces.

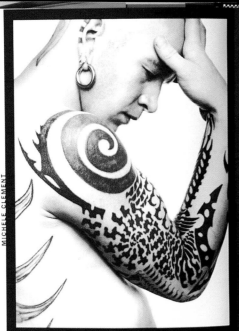

MICHELE CLEMENT

ARTHUR MEYERSON

JAMES WOJCIK

God, we have been told, is in the details. And it is the precise manner in which he—or she—has taken up residence there that interests us here.

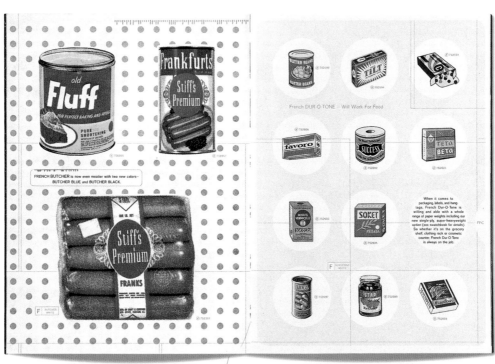

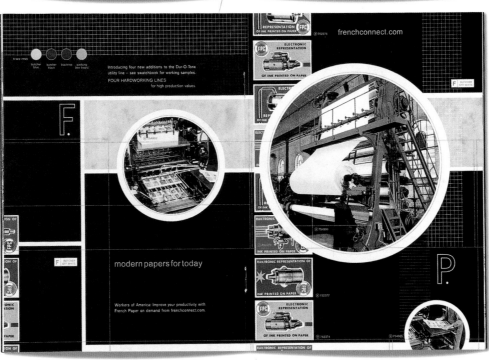

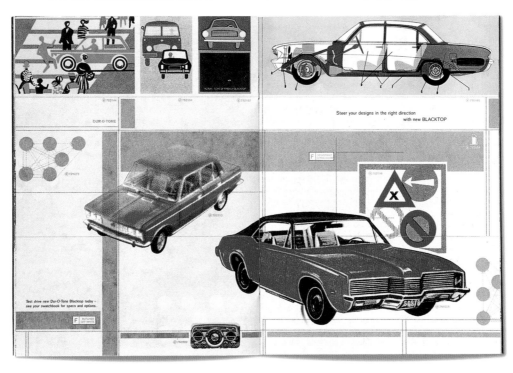

(this spread): Design Firm: **Wood Design** Creative Directors, Designers and Copywriters: **Tom Wood** and **Clint Bottoni** Art Director: **Tom Wood** Photographer: **Craig Cutler** Client: **Craig Cutler/Hennegan**

breakfast anytime.

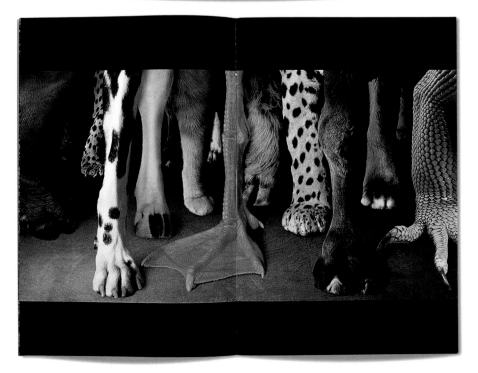

(this spread) Design Firm: **Liska & Associates Inc.** Art Director: **Steve Liska** Designer: **Andrea Wener** Photographer: **Steve Grubman** Client: **Steve Grubman Photography**

NO: 1

a tale
of TWO SQUASH

———

Claude and Cara Crookneck

were like two peas in a pod. They both appreciated the joys
of damp weather, and the sun on their skins. Sometimes
the wind would hook their necks together in a lovely hug,
fitting them together just so. Each day they grew yellower,
softer, and all the more beautiful to each other.

One morning, Claude and Cara felt a violent
quaking along the vine. Their heads throbbed. Their bodies
yanked and twisted and suddenly,
craaaack!

They flew through space untethered, reaching
for each other. But they landed in separate barrels.

PG 3

MARK WEISS STUDIO
628 broadway ny, ny 10012

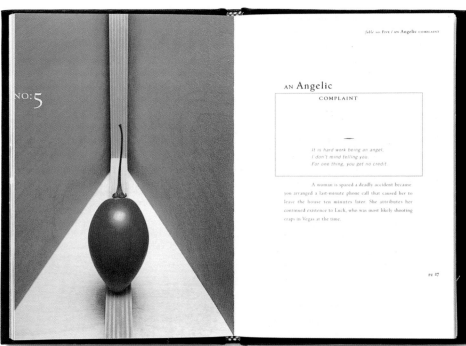

NO: 5

AN Angelic

COMPLAINT

———

*It is hard work being an angel,
I don't mind telling you.
For one thing, you get no credit.*

A woman is spared a deadly accident because
you arranged a last-minute phone call that caused her to
leave the house ten minutes later. She attributes her
continued existence to Luck, who was most likely shooting
craps in Vegas at the time.

PG 27

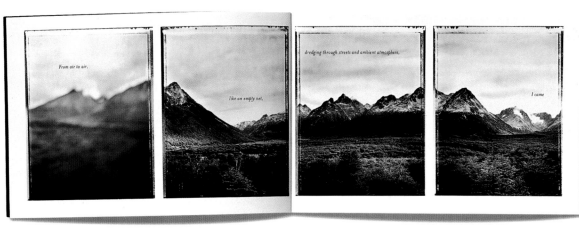

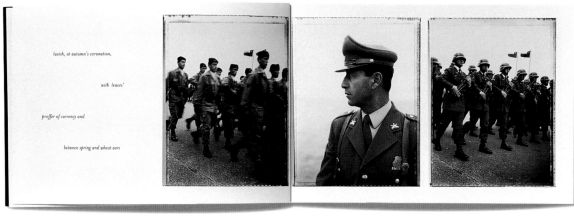

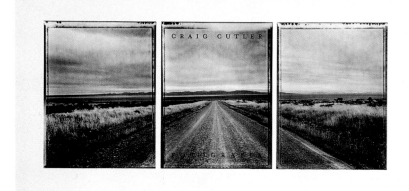

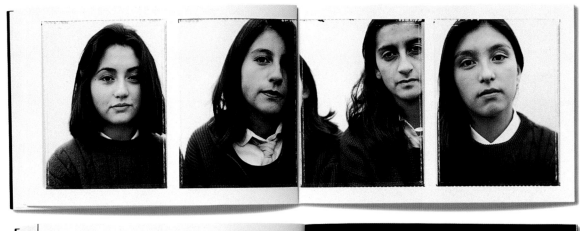

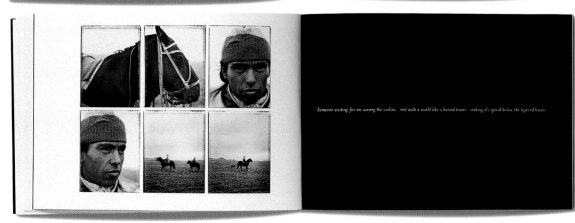

Design Firm: **Bremner Design** Art Directors: **Craig Cutler** and **Scott Bremner** Designer: **Scott Bremner** Photographer: **Craig Cutler**

Jody Dole

Jody Dole

Jody Dole

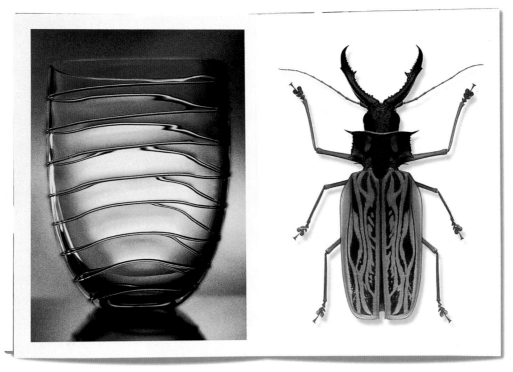

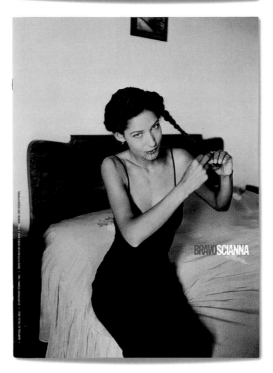

(this spread) Design Firm: **Emerson Wajdowicz Studios** Creative Director: **Jurek Wajdowicz** Art Director: **Jurek Wajdowicz** Designers: **Lisa LaRochelle** and **Jurek Wajdowic** Photographers and Copywriters: **Deborah Turbeville, Ferdinando Scianna** and **Steve McCurry**

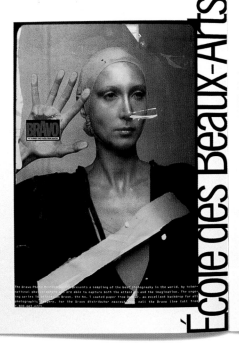

École des Beaux-Arts

French Vogue PARIS

BRAVO

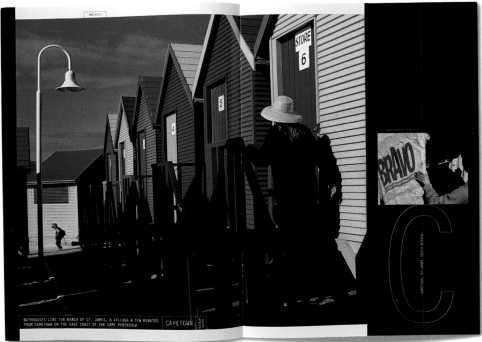

BATHHOUSES LINE THE BEACH OF ST. JAMES, A VILLAGE A FEW MINUTES FROM CAPETOWN ON THE EAST COAST OF THE CAPE PENINSULA | CAPETOWN

CAPETOWN, ST. JAMES, SOUTH AFRICA

mOda

Design Firm: **Oliver Kuhlmann Design** Art Director and Photographer: **Mark Katzman** Designer: **Michael Thede** Illustrator: **Matthew Katzman** Copywriters: **Betty Manlin, Mark Katzman** and **Craig Ward** Client: **Ferguson & Katzman**

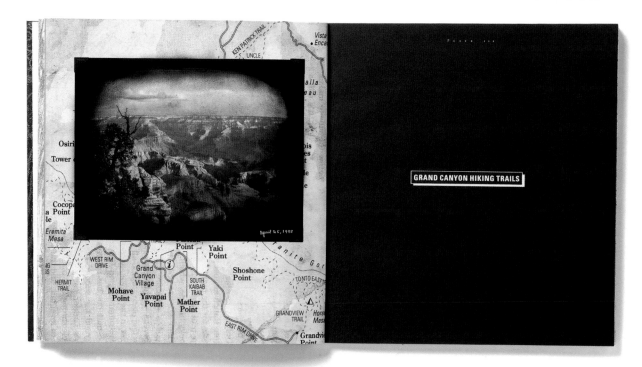

GRAND CANYON HIKING TRAILS

Photographs

Utah, 1998

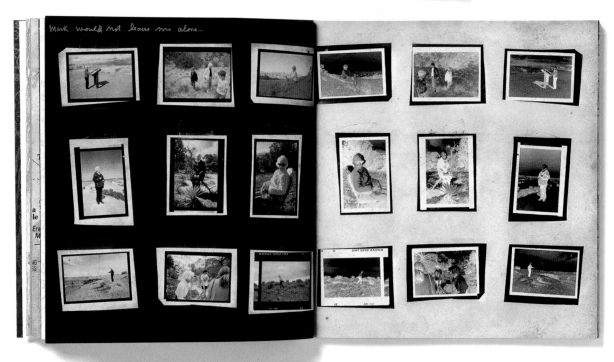

Mark would not leave me alone...

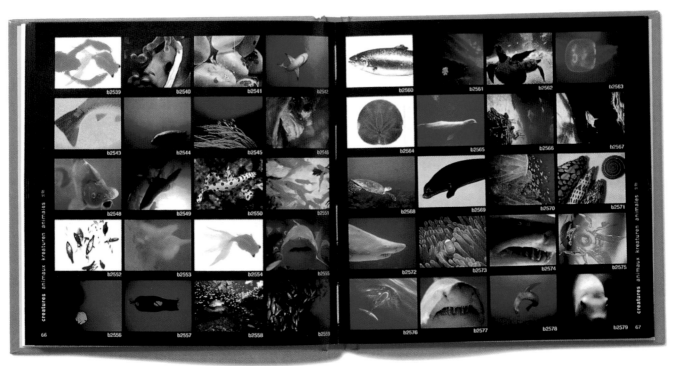

Design Firm: **Belk Mignogna Associates** Creative Director: **Hans Neubert** Designers: **Hans Neubert** and **Jutta Kirchgeorg** Production: **Alberta Jarane** Client: **Nonstock** Paper Companies 202, 203

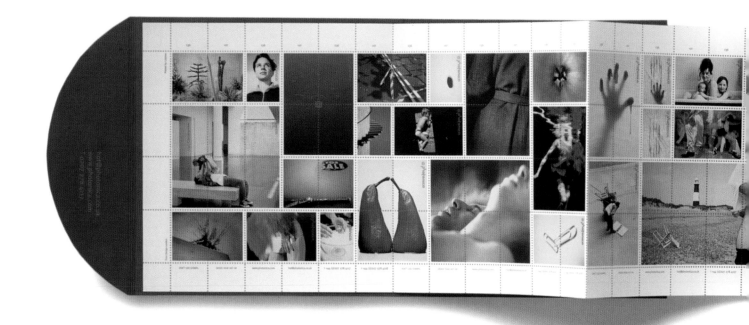

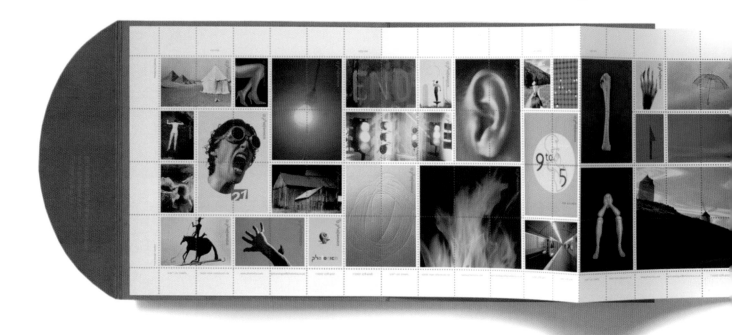

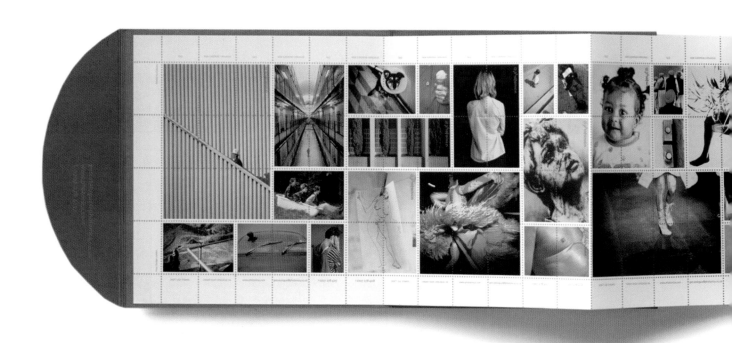

(this spread) Design Firm: **Frost Design Ltd.** Creative and Art Director: **Vince Frost** Designers: **Vince Frost** and **Melania Mues** Client: **Photonica**

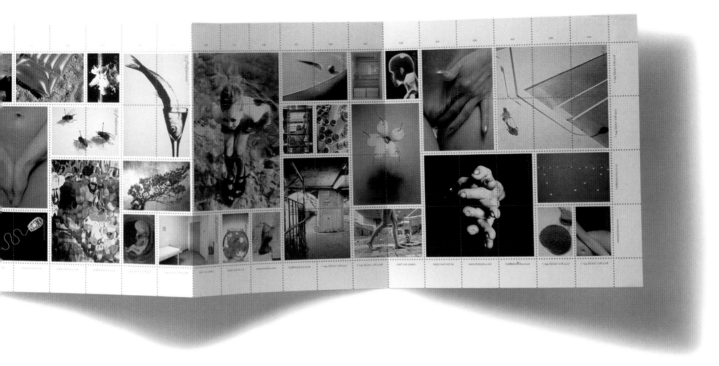

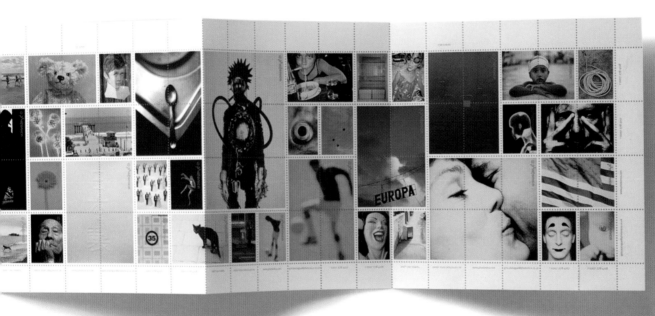

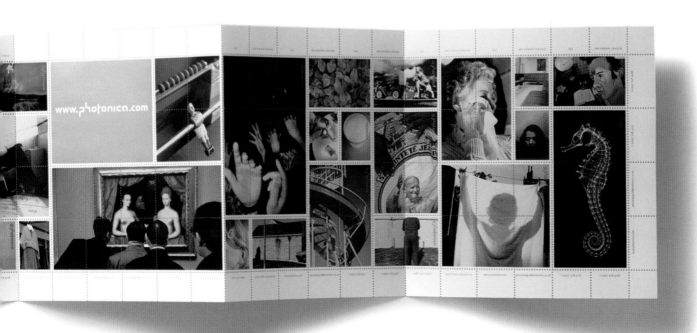

lise metzger

sample works 1

sample works 2

hugh kretschmer

Design Firm: **Cahan & Associates** Creative and Art Director: **Bill Cahan** Designer: **Sharrie Brooks** Photographers: **Lise Metger** and **Hugh Kretchmer** Client: **Sharpe & Associates**

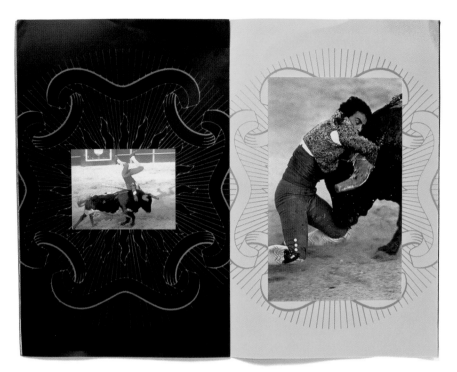

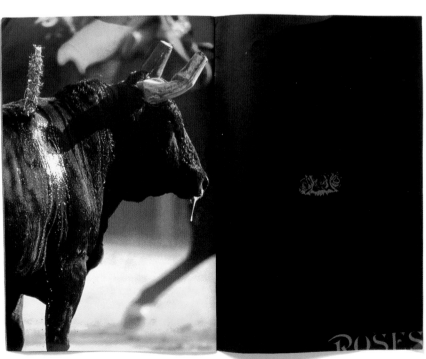

Design Firm: **RBMM** Designer: **Tanya Freach** Photographer: **Joe Patronite** Client: **Joe Patronite**

Photographers 206,207

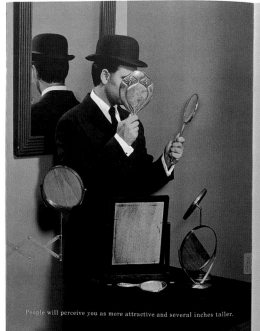

People will perceive you as more attractive and several inches taller.

PRINTING WITH GAC CAN MAKE YOU
A HAPPIER PERSON OVERNIGHT.

HOW WOULD YOU like to enjoy a dramatic improvement in your quality of life? To eliminate stress and tension from your job? To hear words of praise instead of words of criticism from your superiors? To have a thick, luxurious head of hair?

It's easier than you think.

Simply bring your next printing job to GAC.

That's it.

Almost immediately your life will begin to improve.

Total strangers will smile at you, sensing your ability to get things done. Your sleep will be more restful, as all worries are banished from your mind. You'll stop pulling your hair out as deadlines for important jobs approach. People will perceive you as more attractive, smarter, wittier, more successful. Did we say more attractive? We meant much more attractive.

How can your choice of a printer have such an enormous impact in your life? Read on to find out.

The GRAPHIC ARTS CENTER GUIDE to
Better Living Through Printing

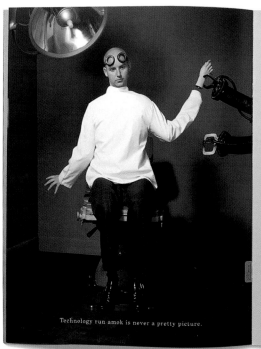

Technology run amok is never a pretty picture.

OLD PROS. NEW TECHNOLOGY.

WHAT GOOD IS state-of-the-art equipment if the people running it don't have the talent or experience to know how to get the most out of it?

No good, that's what.

Instead of a utopian dream your project can turn out like a sci-fi horror film, sophisticated technology run amok. Remember *2001*? Remember *Brazil*? Remember *Jurassic Park*? Is that what you want your printing job to become...a bloody, disastrous nightmare?

It never will at GAC.

We don't just have technicians at the controls, we have craftspeople with 20 and 30 years of experience who know how to take advantage of all the ridiculously expensive hi-tech equipment that fills our building.

So you end up with better looking printing; faster, less expensive and easier than you've ever imagined possible.

Doesn't that sound better than terror, destruction and global annihilation?

Design Firm: **Sandstrom Design** Creative and Art Director: **Steve Sandstrom** Designer: **Andre Burgoyne** Photographer: **Hugh Kretschmer** Copywriter: **Steve Sandoz** Client: **Graphic Arts Center**

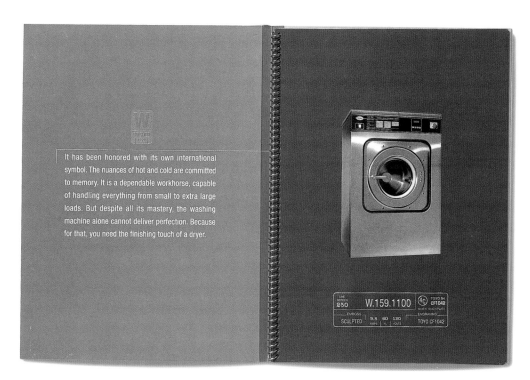

It has been honored with its own international symbol. The nuances of hot and cold are committed to memory. It is a dependable workhorse, capable of handling everything from small to extra large loads. But despite all its mastery, the washing machine alone cannot deliver perfection. Because for that, you need the finishing touch of a dryer.

W

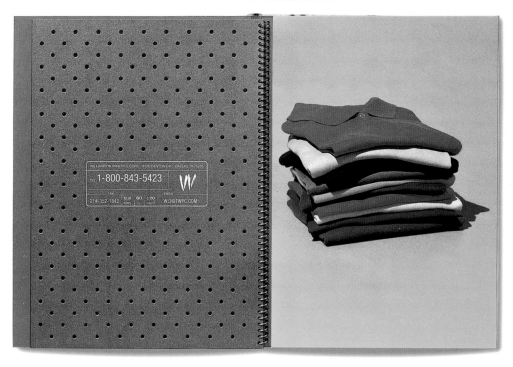

WILLIAMSON PRINTING CORP. • 6700 DENTON DR. • DALLAS TX 75235

TEL 1-800-843-5423

FAX 214-352-1842

EMAIL WD@TWPC.COM

Design Firm: **EAI/Atlanta** Creative Director: **Phil Hamlett** Designers: **Lee Nichols** and **David Cannon** Photographer: **Greg Llater** Copywriter: **Robert Roth** Client: **Dickson's/Williamson**

Bleeding. DO! If...

Trapping. DON'T! Even though some layout programs let you set trapping, it's best to let Bell Press handle this sensitive area of the pre-press operation...

"Life is like software.
Version upgrades
are available."

THE BELL PRESS GUIDE TO SCITEX
PRE-PRESS

God bless the computer. Thanks to this wonderful tool, all of the processes that contribute to the realization of the literature we print, and the responsibilities of the people who create them – and who hire Bell Press – have changed forever. ❖ Modern hardware and software have given us new tools and new freedom, and has even helped transform the way many graphic designers think and see things. Sophisticated facets of the print production process formerly trusted only to highly trained, experienced and exacting pre-press experts are now in the hands of desktop publishers at their computer terminals. ❖ There's been a dynamic change in the workflow process that's begun to cloud the lines of responsibility. ❖ And unfortunately, along with the promise of more control, cost effectiveness and time savings, digitally prepared files can also leave the door wide open for misinterpretations, miscommunications, unforeseen headaches, missed deliveries and overtime expenses that might eat up the savings you could realize by doing a lot of the work yourself. ❖ To help prevent that from happening (and because we're good guys), we've prepared this booklet addressing many of the more common oversights made by people preparing and supplying electronic layouts and pre-press specs. It attempts to set forth an easy-to-follow set of standards to ensure clear communications between Bell Press and the growing number of clients who choose to prepare their layouts and mechanicals on the computer. ❖ Please read it. And refer to it when preparing your files. ❖ I hope the information contained on the following pages will make you say, "God bless the computer." (Instead of something else.) Scott Harvin

I N T R O D U C T I O N

THE BELL
PRESS
GUIDE TO
SCITEX
PREPRESS

FIRST EDITION

For Professional Designers and Corporations

FILE PREP STEPS FOR HASSLE-FREE
OUTPUT

We know you spent long hours working on your document to get it just right, and now that it's finally done, you're anxious to get it printed. But please, spend an extra few minutes to prepare your package with care so that we can pay more attention to making the printing stage go hassle free.

1 Back-up your original. Send us a copy of your disk and keep the original in a safe place. There's always a possibility that media may get damaged in transport and become unusable and your back-up copy is your only insurance.

2 Label your disks. Put your company name, address and phone number on your disks and containers so we can reach you if any questions arise. If there is more than one disk, please indicate "one of three", "two of three", etc. This also makes it easy to rapidly return these disks to you after your job has been printed.

3 Make sure the file is proper in the Page Set-up window. Make sure the size is set at 100%, or if not 100%, whatever size it's supposed to output at. Set the screen resolution if appropriate. Include these specifications on a separate instruction sheet to verify these are exactly what you are wanting.

4 Trapping. DON'T! Even though some layout programs let you set trapping, with our Scitex output system and special press requirements, it's best to let Bell Press handle this sensitive area of the pre-press operation. If any special techniques such as mock-duotone or other overprinting or shadow creations are needed, please discuss this with us in the pre-planning stages and indicate it on your marked-up proofs.

5 Bleeding. DO! If images and/or backgrounds require bleeds, please add 1/8" to the trim (Quark XPress & PageMaker let you do this in the program). Also make your files as complete as possible. Try not to rely on us to do things like adding bleeds, changing trim sizes, extending rules, adding or changing copy, etc. This is time consuming and we will have to charge you.

6 Use Style Sheets in Page Layout Programs. Taking the time to set up style sheets reduces many repetitive tasks and the chance for specification errors. Maintain a master document that has every style sheet defined with sample text blocks for each style supplied. This can help avoid surprises later down the road. »

F I L E P R E P A R A T I O N

CMYK
SPECS

F I L E P R E P A R A T I O N

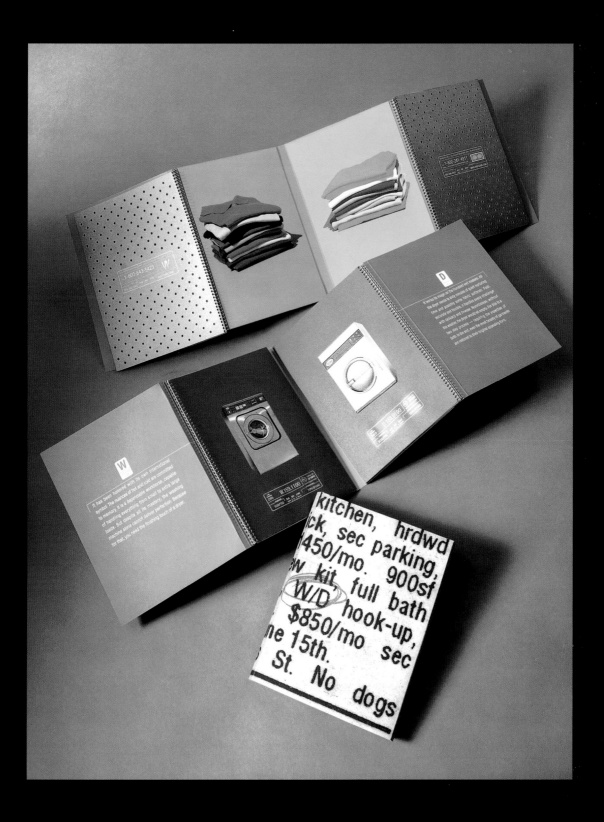

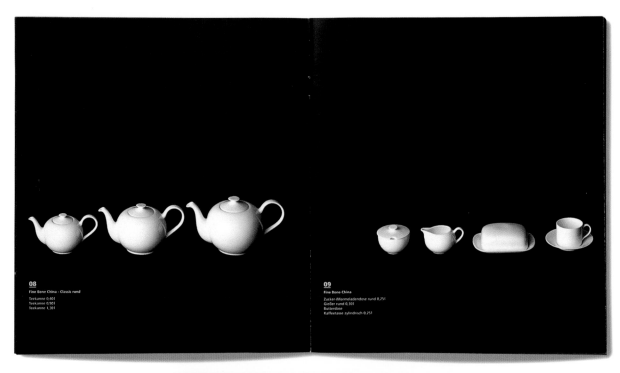

08
Fine Bone China - Classic rund

Teekanne 0,40l
Teekanne 0,90l
Teekanne 1,30l

09
Fine Bone China

Zucker-/Marmeladendose rund 0,25l
Gießer rund 0,30l
Butterdose
Kaffeetasse zylindrisch 0,25l

DIBBERN
Fine Bone China

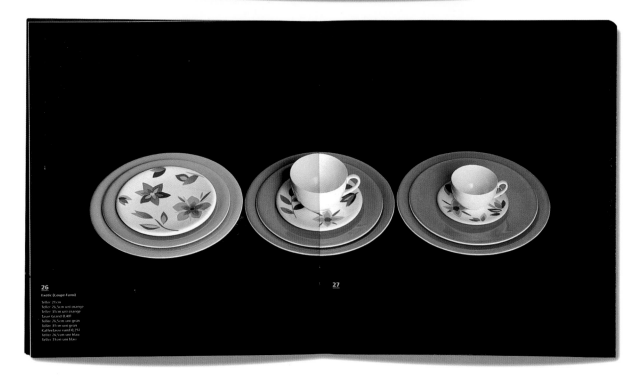

26
Exotic (Loupe-Form)

Teller 21cm
Teller 26,5cm uni orange
Teller 31cm uni orange
Tasse Grand 0,40l
Teller 26,5cm uni grün
Teller 31cm uni grün
Kaffeetasse rund 0,25l
Teller 26,5cm uni blau
Teller 31cm uni blau

27

(this spread) Design Firm: **Haase & Knels** Creative Director: **Sibylle Haase** Art Director and Designer: **Katja Hirschfelder** Photographer: **Hans Hansen**

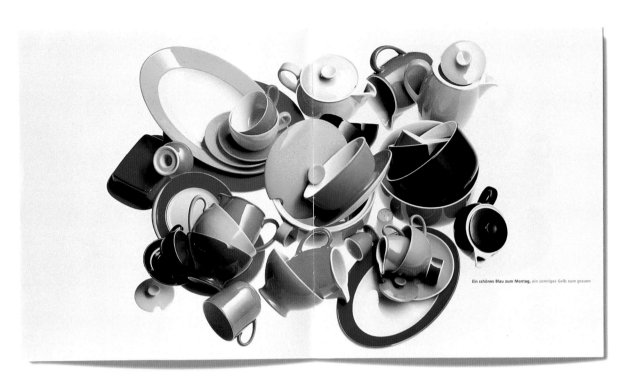

Ein schönes Blau zum Montag, ein sonniges Gelb zum grauen

DIBBERN
Solid Color

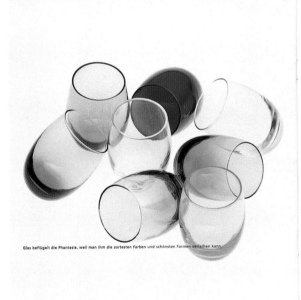

Glas beflügelt die Phantasie, weil man ihm die zartesten Farben und schönsten Formen verleihen kann.

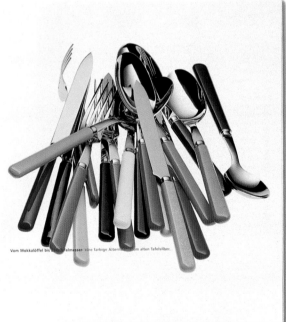

Vom Mokkalöffel bis zum Tafelmesser: eine farbige Alternative zum alten Tafelsilber.

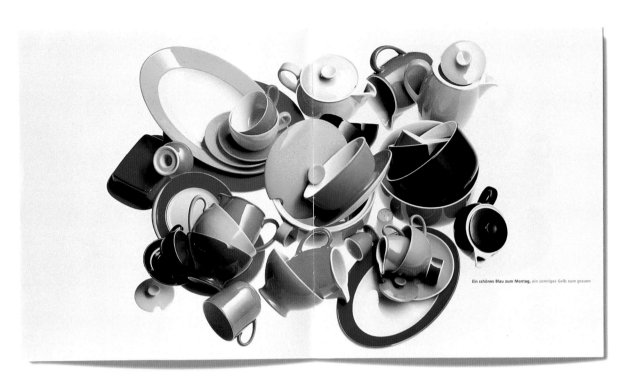

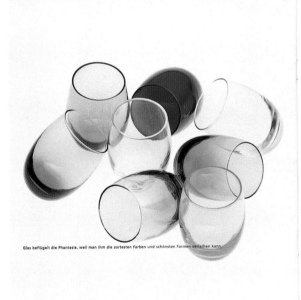

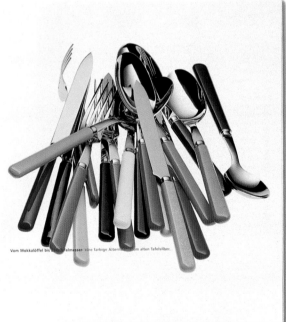

Design Firm: **Schneider/Waibel** Creative Director: **Barbara Waibel** Designers: **Barbara Waibel** and **Uwe Schneider** Photographer: **Peter Schumacher** Copywriters: **Marisa Arzt** and **Uwe Schneider** Client: **D&B Audiotechnik Ag**

Transmission of lines.

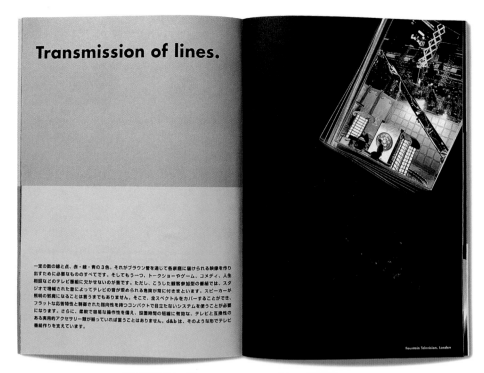

一定の数の線と点、赤・緑・青の3色。それがブラウン管を通じて各家庭に届けられる映像を作り出すために必要なもののすべてです。そしてもう一つ、トークショーやゲーム、コメディ、人生相談などのテレビ番組に欠かせないのが音です。ただし、こうした観客参加型の番組では、スタジオで増幅された音によってテレビの音が歪められる危険が常に付きまといます。スピーカーが照明の邪魔になることは言うまでもありません。そこで、全スペクトルをカバーすることができ、フラットな応答特性と制御された指向性を持つコンパクトで目立たないシステムを使うことが必要になります。さらに、柔軟で容易な操作性を備え、設置時間の短縮に有効な、テレビと互換性のある実用的アクセサリー類が揃っていれば言うことはありません。d&bは、そのような形でテレビ番組作りを支えています。

Fountain Television, London

Sound visions.

The manifestations.

Just loudspeakers.

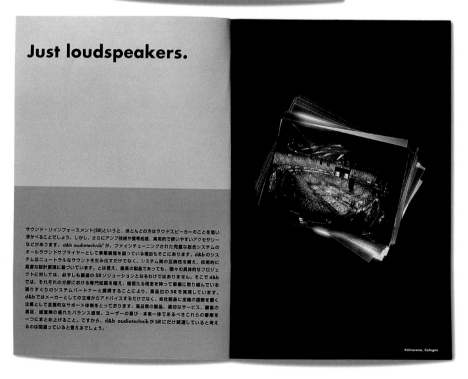

サウンド・リインフォースメント（SR）というと、ほとんどの方はラウドスピーカーのことを思い浮かべることでしょう。しかし、さらにアンプ技術や信号処理、実用的で使いやすいアクセサリーなどがあります。d&b audiotechnik が、ファインチューニングされた完璧な総合システムのオールラウンドサプライヤーとして事業展開を図っている理由もそこにあります。d&bのシステムはニュートラルなサウンドを生み出すだけでなく、システム間の互換性を備え、技術的に高度な設計原理に基づいています。とは言え、最高の製品であっても、個々の具体的なプロジェクトに対しては、必ずしも最適のSRソリューションとなるわけではありません。そこでd&bでは、それぞれの分野における専門知識を備え、確固たる信念を持って事業に取り組んでいる選りすぐりのシステムパートナーと提携することにより、高品位のSRを実現しています。d&bではメーカーとしての立場からアドバイスするだけでなく、自社製品に全幅の信頼を置く企業として全国的なサポート体制をとっております。高品質の製品、適切なサービス、顧客の満足、経営陣の優れたバランス感覚、ユーザーの喜び—本来一体であるべきこれらの要素を一つにまとめ上げること。ですから、d&b audiotechnik がSRにだけ関連していると考えるのは間違っていると言えるでしょう。

Kölnarena, Cologne

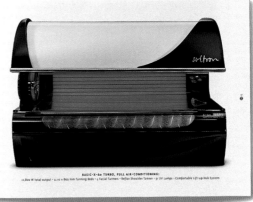

BASIC-X

BASIC-X-60 TURBO, FULL AIR-CONDITIONING:
12,800 W total output • 2,110 x 860 mm tanning beds • 4 Facial Tanners • Reflex Shoulder Tanner • 51 UV Lamps • Comfortable Lift-up Hub System

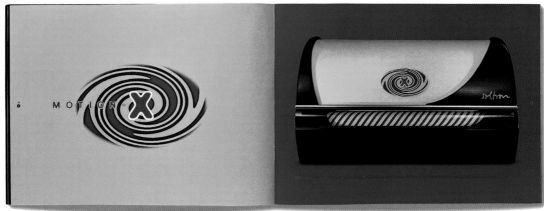

MOTION-X

soltron
THE SUNMAKER

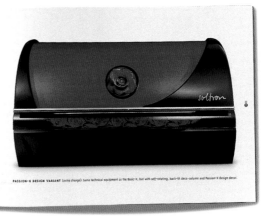

PASSION-X

PASSION-X DESIGN VARIANT (extra charge): Same technical equipment as the Basic-X, but with self-rotating, back-lit deco-column and Passion-X design decor.

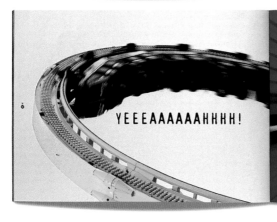
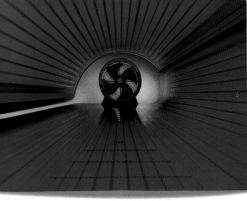

YEEEAAAAAAHHHH!

Design Firm: **Zink & Kraemer** Creative Director, Art Director, Designer and Illustrator: **Michael Eiden** Photographers: **Arts Unlimited** and **Ralf Haselich** Copywriter: **Ulli Eiden** Client: **Soltron GmbH**

Ludwig Seufert Werkstätten für Möbel und Innenausbau

Design Firm: **Claus Koch Corporate Communications** Creative Director: *Claus Koch* Art Directors: **Patrick Koch** and **Jochen Theurer** Designers: **Patrick Koch** and **Jochen Theurer** Client: **Ludwig Seufert GmbH & Co.**

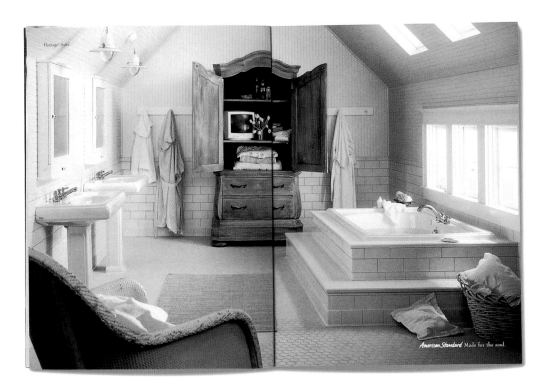

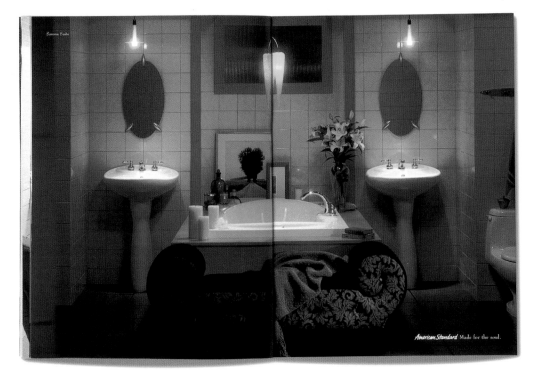

Design Firm: **Carmichael Lynch** Creative Director: **Brian Kroehing** Art Director: **Penny Duerr** Photographers: **Mowers Photography** and **Steve Henke** Copywriter: **Michael Hart** Client: **American Standard**

(this spread) Design Firm: **Eleven Inc.** Creative Directors: **Paul Curtin** and **Rich Silverstein** Copywriter: **Eric Osterhaus** Client: **Greg Lemond**

FOR THOSE WHO THINK ROAD RACING IS NO MORE A THAN A FAIR WEATHER TOUR OF THE FRENCH COUNTRYSIDE, WE OFFER THE CLASSIC PARIS-ROUBAIX RACE. IT WINDS THROUGH WINTER'S MUD AND RAIN FOR 165 MILES, 40 OF WHICH ARE OVER BIKE-AND-BONE-BREAKING COBBLESTONES THAT RISE OUT OF THE GROUND LIKE A MILLION JAGGED SPEED BUMPS. IT MAKES GROWN MEN CRY. OR IN THIS CASE, SMILE.

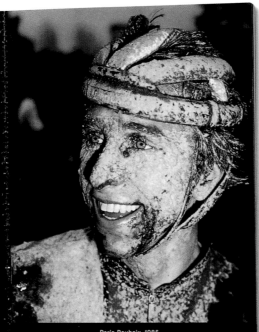

Paris-Roubaix, 1985.

THE TOUR DE FRANCE IS A HIGH-SPEED ROLLERCOASTER POWERED BY HUMAN PAIN AND SUPERHUMAN EFFORT.

THREE WEEKS. 2500 MILES.

OVER BONE-JARRING COBBLESTONES. OVER THE HIGH-ALTITUDE PASSES OF THE PYRÉNÉES AND THE ALPS WHERE YOU CLIMB AND CLIMB AND CLIMB ONLY TO FIND THAT THE MORE OXYGEN YOU NEED, THE LESS OXYGEN THERE IS.

WHEN YOU COMPLETE ALL YOUR GOALS, WHAT DO YOU DO NEXT? IF YOU'RE LEMOND, YOU SET NEW GOALS:

1. TURN ONE OF AMERICA'S FAVORITE ROAD BIKE COMPANIES (GREG LEMOND BICYCLES) INTO AMERICA'S #1 ROAD BIKE COMPANY.

2. PUT TOGETHER A WINNING TOUR DE FRANCE TEAM.

3. BECOME A TOP DRIVER IN THE TOYOTA ATLANTIC RACING SERIES.

4. RACE IN THE INDIANAPOLIS 500.

BEFORE YOU SHAKE YOUR HEAD WITH POLITE SKEPTICISM, GO BACK A FEW PAGES AND TAKE ANOTHER LOOK AT THE GOALS LEMOND SET IN HIGH SCHOOL. THEN ASK YOURSELF, HONESTLY, WHETHER YOU WOULD HAVE BELIEVED IT BACK THEN.

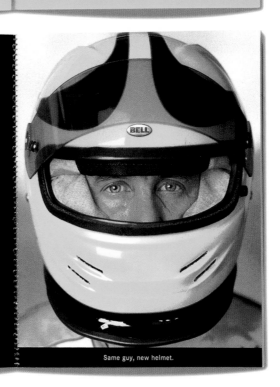

Same guy, new helmet.

DAS HEBE PORTRÄT

(this spread) Design Firm: **HEBE Werbung & Design** Creative Director and Copywriter: **Reiner Hebe** Art Director: **Joerg Bauer** Photographers: **Schubert** and **Pawlok** Client: **HEBE Werbung & Design**

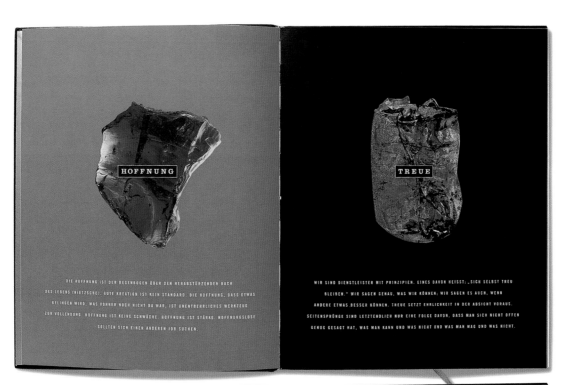

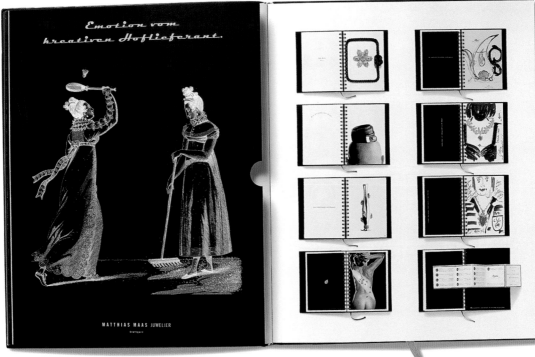

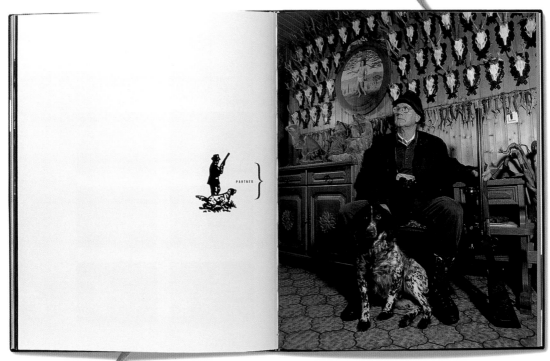

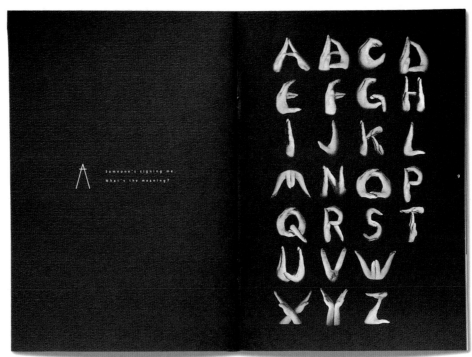

Affonso Serra Jr. Nesses mais de 20 anos de profissão, eu soube fazer apenas uma coisa na vida: vender boas idéias. Foi assim na DPZ, na W e, principalmente, na DM9. Esse foi o sonho que uniu o criativo do atendimento e o atendimento da criação na construção da marca DM9. E não existe outra forma de a DM9 continuar, se não for a de continuar sendo criativa, ousada, arrojada, uma agência sem medos. Foi isso que nos trouxe aqui, e é isso que vai nos levar cada vez mais

A

Affonso

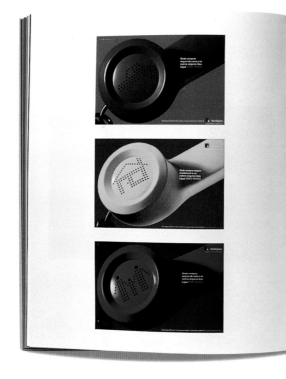

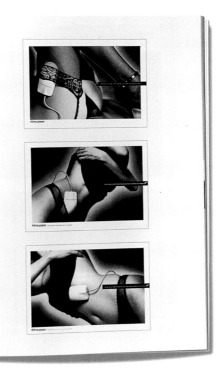

Design Firm: **DM9DDB** Creative Directors: **Erh Ray** and **Sergio Valente** Art Directors: **Pedro Cappeletti** and **Erh Ray** Photographers: **Solon Miranda, Alexandre Harakawa** and **Andre Andrade** Copywriter: **Sergio Valente** Client: **DM9DDB**

Design Firm: **Blok Design** Creative and Art Director: **Vanessa Eckstein** Designers: **Vanessa Eckstein** and **Frances Chen** Photographer: **Don Miller** Client: **The Partners Film Company**

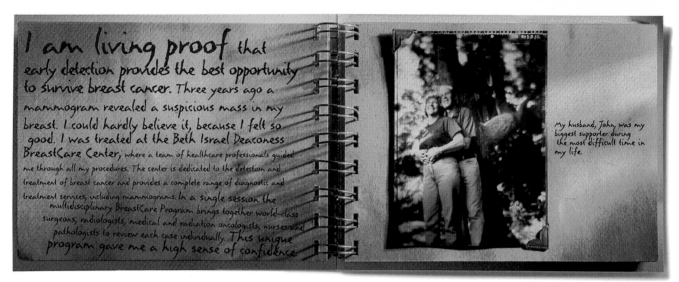

I am living proof that early detection provides the best opportunity to survive breast cancer. Three years ago a mammogram revealed a suspicious mass in my breast. I could hardly believe it, because I felt so good. I was treated at the Beth Israel Deaconess BreastCare Center, where a team of healthcare professionals guided me through all my procedures. The center is dedicated to the detection and treatment of breast cancer and provides a complete range of diagnostic and treatment services, including mammograms. In a single session the multidisciplinary BreastCare Program brings together world-class surgeons, radiologists, medical and radiation oncologists, nurses and pathologists to review each case individually. This unique program gave me a high sense of confidence.

My husband, John, was my biggest supporter during the most difficult time in my life.

How can I have Cancer, when I feel so good?
(One woman's story)

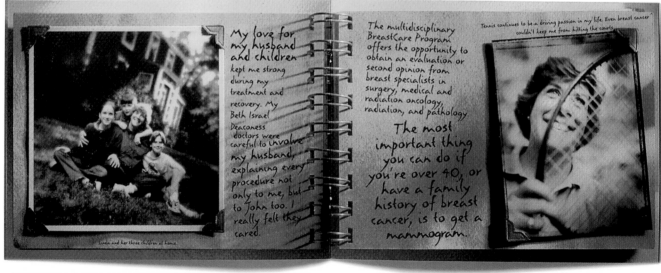

My love for my husband and children kept me strong during my treatment and recovery. My Beth Israel Deaconess doctors were careful to involve my husband, explaining every procedure not only to me, but to John too. I really felt they cared.

Linda and her three children at home

The multidisciplinary BreastCare Program offers the opportunity to obtain an evaluation or second opinion from breast specialists in surgery, medical and radiation oncology, radiation, and pathology.

The most important thing you can do if you're over 40, or have a family history of breast cancer, is to get a mammogram.

Tennis continues to be a driving passion in my life. Even breast cancer couldn't keep me from hitting the courts.

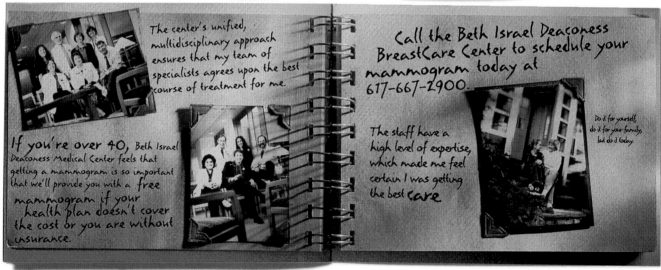

The center's unified, multidisciplinary approach ensures that my team of specialists agrees upon the best course of treatment for me.

If you're over 40, Beth Israel Deaconess Medical Center feels that getting a mammogram is so important that we'll provide you with a free mammogram if your health plan doesn't cover the cost or you are without insurance.

Call the Beth Israel Deaconess BreastCare Center to schedule your mammogram today at 617-667-2900.

The staff have a high level of expertise, which made me feel certain I was getting the best care.

Do it for yourself, do it for your family, but do it today.

Design Firm: **Haggman Advertising** Creative Director and Copywriter: **Eric Haggman** Art Director and Designer: **Amy Farr** Photographer: **David Zadig** Client: **Beth Israel Hospital**

ARTHUR
✳ 1915
Miller Clarendon

MEN OF LETTERS

JAMES
✳ FEBRUARY 1882 † JANUARY 1941
Joyce Baskerville

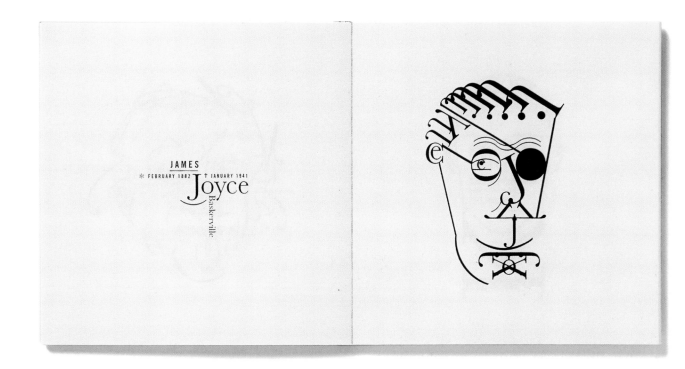

Creative Director and Designer: **Roberto De Vicq De Cumptich** **Promotions** 226, 227

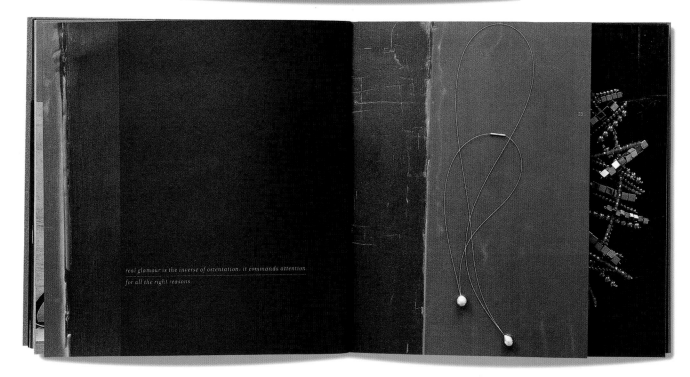

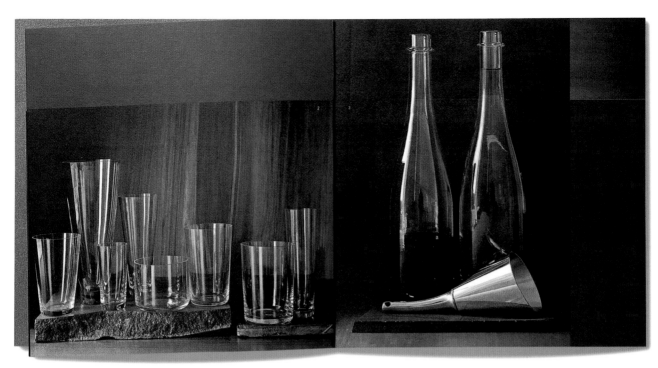

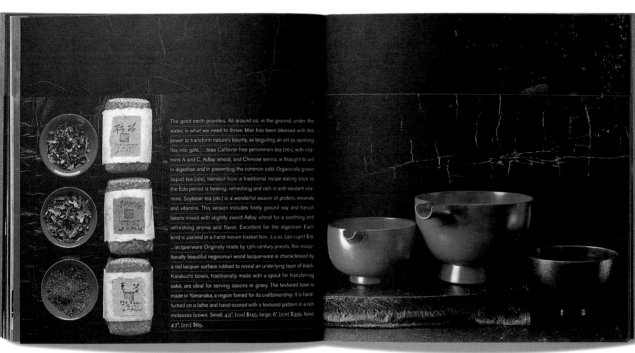

The good earth provides. All around us, in the ground, under the water, is what we need to thrive. Man has been blessed with the power to transform nature's bounty, as beguiling an art as spinning flax into gold. ...teas Caffeine-free persimmon tea [264], with vitamins A and C, Adlay wheat, and Chinese senna, is thought to aid in digestion and in preventing the common cold. Organically grown loquat tea [266], blended from a traditional recipe dating back to the Edo period is healing, refreshing and rich in anti-oxidant vitamins. Soybean tea [262] is a wonderful source of protein, minerals and vitamins. This version includes finely ground soy and haricot beans mixed with slightly sweet Adlay wheat for a soothing and refreshing aroma and flavor. Excellent for the digestion. Each kind is packed in a hand-woven basket box, 2.4 oz. (40 cups) $18. ...lacquerware Originally made by 13th-century priests, this exceptionally beautiful negoronuri wood lacquerware is characterized by a red lacquer surface rubbed to reveal an underlying layer of black. Katakuchi bowls, traditionally made with a spout for transferring sake, are ideal for serving sauces or gravy. The textured bowl is made in Yamanaka, a region famed for its craftsmanship. It is hand-turned on a lathe and hand-scored with a textured pattern in a rich molasses brown. Small, 4.5", [27A] $145; large, 6", [27B] $395; bowl, 4.7", [27C] $65.

Design Firm: **Design Guys** Art Director and Copywriter: **Steven Sikora** Designer: **Dawn Selg** Client: **Target Stores**

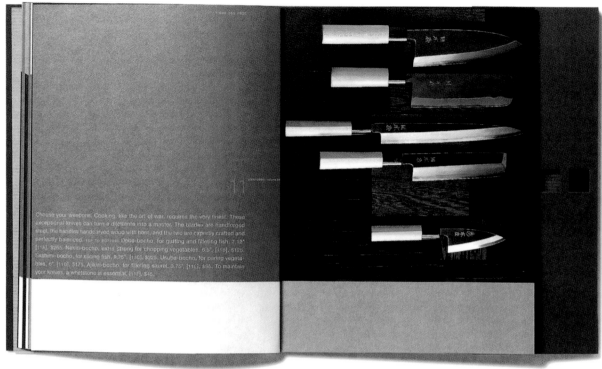

Choose your weapons. Cooking, like the art of war, requires the very finest. These exceptional knives can turn a dilettante into a master. The blades are handforged steel, the handles handcarved wood with horn, and the two are expertly crafted and perfectly balanced. top to bottom: Deba-bocho, for gutting and fileting fish, 7.12", [11A], $265. Nakiri-bocho, extra strong for chopping vegetables, 6.5", [11B], $125. Sashimi-bocho, for slicing fish, 9.25", [11C], $225. Usuba-bocho, for paring vegetables, 6", [11D], $175. Ajikiri-bocho, for fileting saurel, 3.75", [11E], $55. To maintain your knives, a whetstone is essential, [11F], $45.

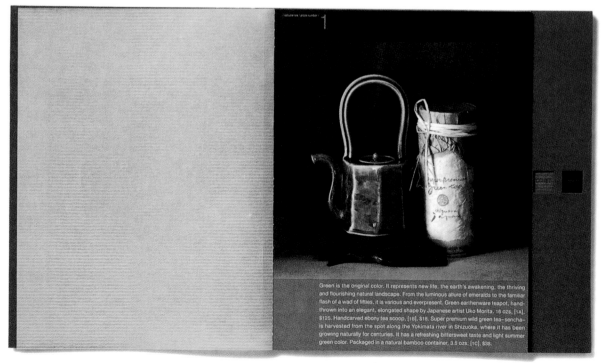

Green is the original color. It represents new life, the earth's awakening, the thriving and flourishing natural landscape. From the luminous allure of emeralds to the familiar flash of a wad of fifties, it is various and everpresent. Green earthenware teapot, hand-thrown into an elegant, elongated shape by Japanese artist Uko Morita, 16 ozs., [1A], $125. Handcarved ebony tea scoop, [1B], $18. Super premium wild green tea—sencha—is harvested from the spot along the Yokimata river in Shizuoka, where it has been growing naturally for centuries. It has a refreshing bittersweet taste and light summer green color. Packaged in a natural bamboo container, 3.5 ozs., [1C], $38.

Creative Directors: **Allison Williams** and **J.P. Williams** Art Director: **Allison Williams** Designers: **Allison Williams** and **Mats Hakansson** Design Assistant: **Abigail Clawson** Photographer: **Geof Kern** Client: **Takashimaya New York**

Design Firm: **Design M/W**

(this spread) Design Firm: **Industrial & Corporate Profiles srl** Creative Director: **Guido Grugnola** Art Director: **Mario Piazza** Designer: **Andrea Fanti** Copywriters: **Andrea Digregorio** and **Colin Wood** Client: **Wally Yachts**

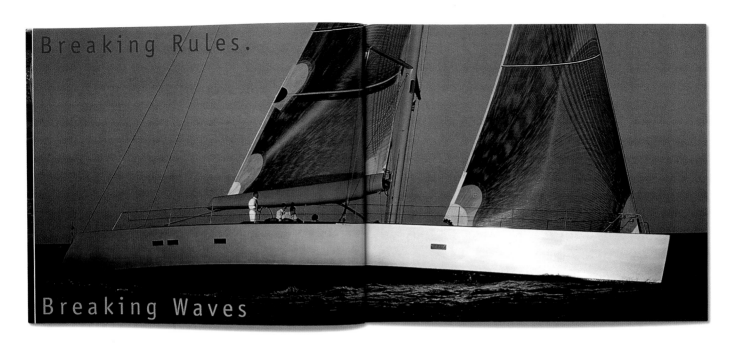

Breaking Rules.

Breaking Waves

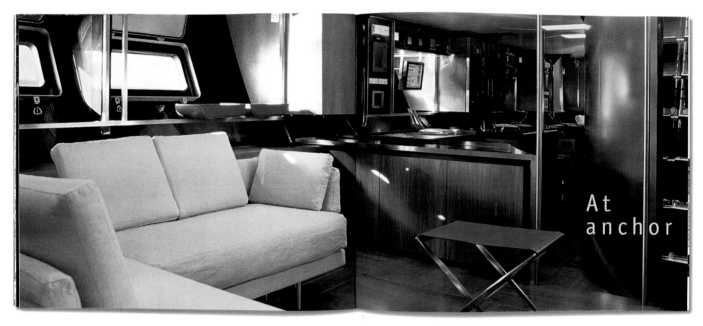

At anchor

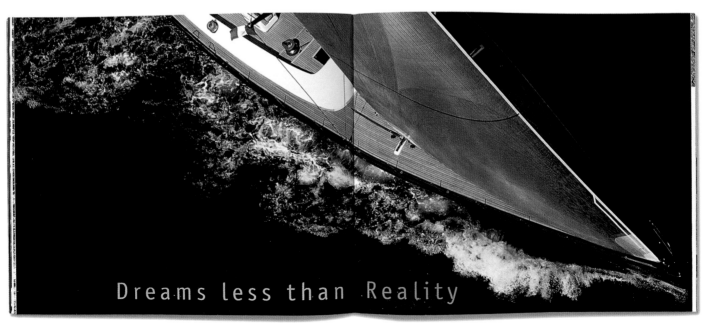

Dreams less than Reality

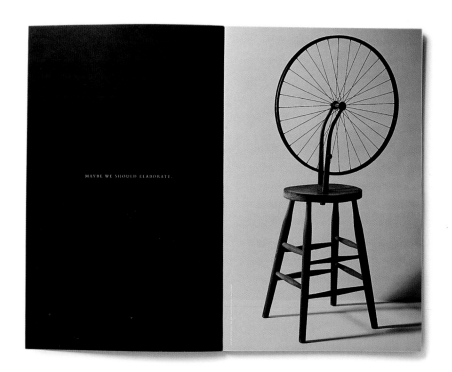

MAYBE WE SHOULD ELABORATE.

JUST BECAUSE A BIKE IS MADE BY HAND,
DOESN'T MEAN YOU'D WANT TO RIDE IT.

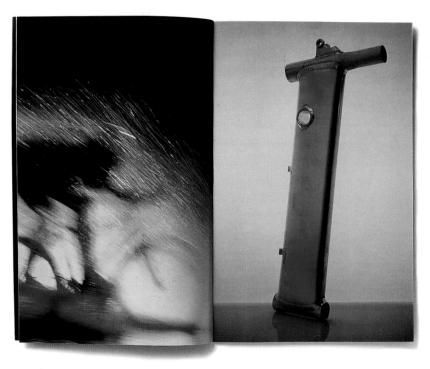

Design Firm: **Cahan & Associates** Creative and Art Director: **Bill Cahan** Designer: **Bob Dinetz** Photographer: **Robert Schlatter** Copywriter: **Lisa Jhung** Client: **Trek Bicycles**

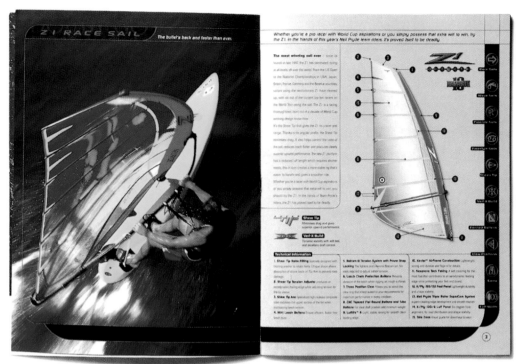

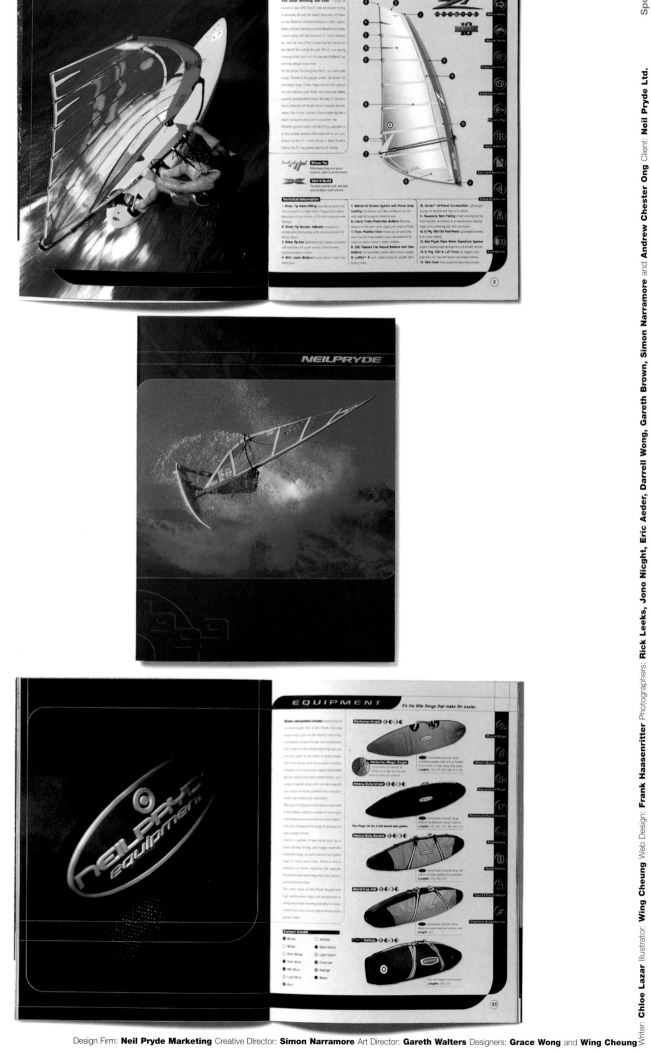

Design Firm: **Neil Pryde Marketing** Creative Director: **Simon Narramore** Art Director: **Gareth Walters** Designers: **Grace Wong** and **Wing Cheung**

Writer: **Chloe Lazar** Illustrator: **Wing Cheung** Web Design: **Frank Haasenritter** Photographers: **Rick Leeks; Jono Nicght, Eric Aeder, Darrell Wong, Gareth Brown, Simon Narramore** and **Andrew Chester Ong** Client: **Neil Pryde Ltd.**

Sports 234,235

darjeeling

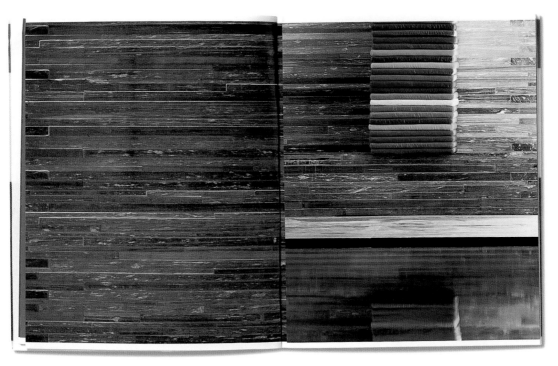

Milliken Carpet

HEALTHCARE

(in your image)

Milliken Carpet

AVIATION

(in your image)

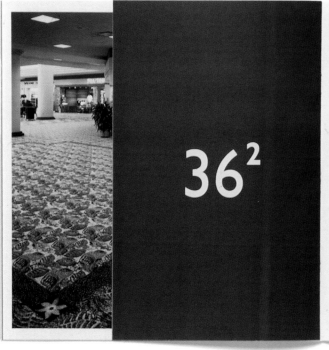

36²

Design Firm: **Copeland Hirthler Design** Creative Director: **Brad Copeland** Designers: **Lionel Ferreira** and **Rebecca D'Attilio** Illustrator: **Lionel Ferreira** Copywriters: **Rodney Rogers** and **Juliet Sink** Client: **Milliken Carpet**

memo¹

Design Firm: **Designframe** Creative Team: **Kazuo Akiyama, Michael McGinn** and **Alexander Polakov** Photographer: **Jim Sebastian** Client: **Designtex**

Textiles 238,239

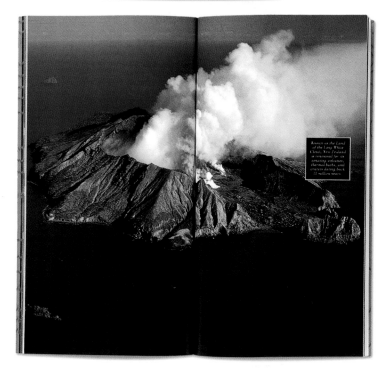

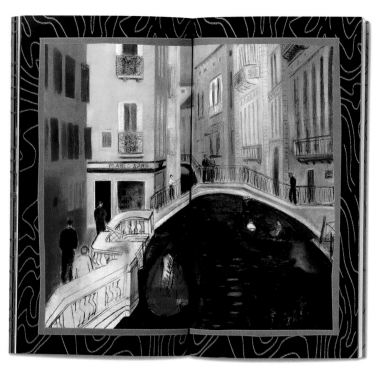

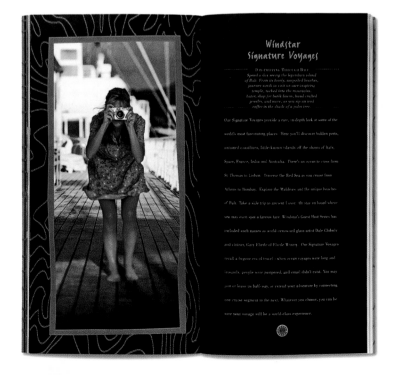

Barcelona.

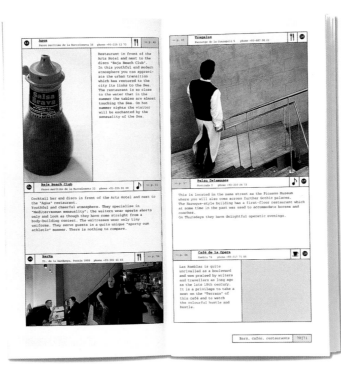

Locations

Bars, cafés, restaurants	64
Shopping	74
Sights	84

Locations

Shopping

Worth a visit

Shopping is often a question of love at first sight.
In Barcelona it's worth risking another glance...

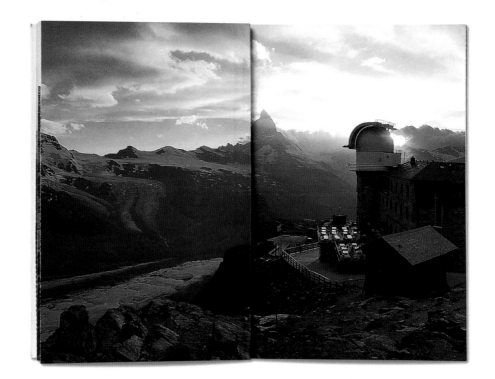

ENTDECKEN SIE
DAS WALLIS

DÉCOUVREZ
LE VALAIS

DISCOVER THE
VALAIS

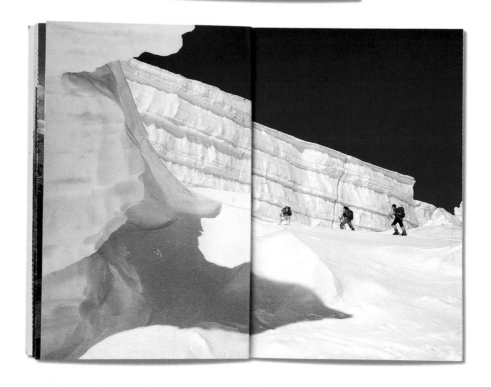

Design Firm: **Visucom** Art Director: **Frank Lynch** Designer: **Juri Zaegta** Photographer: **Thomas Andenmattew** Copywriter: **Erich Heynen** Client: **Valais Tourism**

DesignersCreativeDirectorsArtDirectors

Copywriters

Photographers Illustrators

Design Firms

Clients

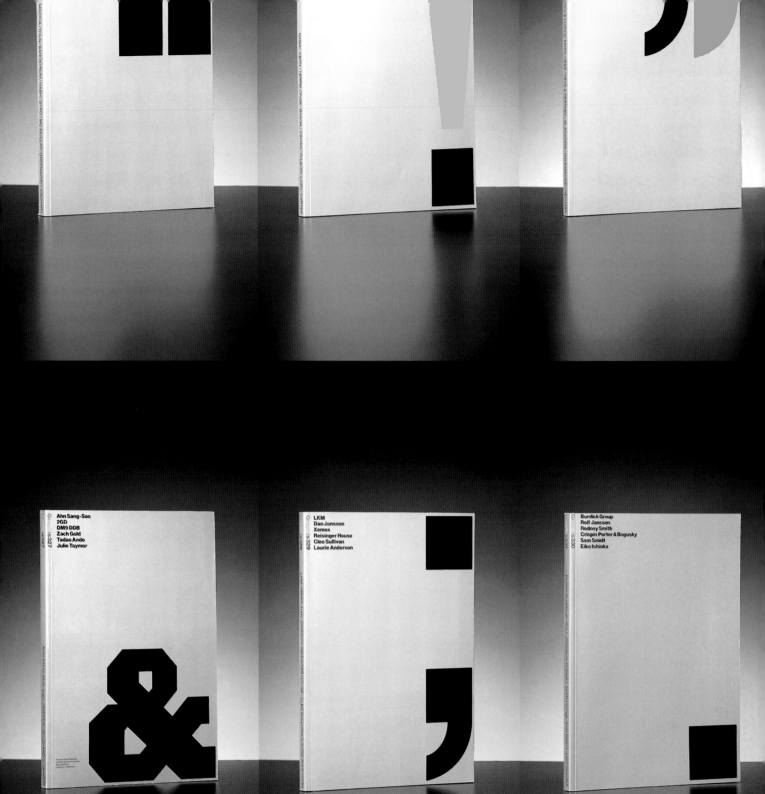

Graphis 327

Ahn Sang-Soo
2GD
DM9 DDB
Zach Gold
Tadao Ando
Julie Taymor

Graphis 329

LKM
Dan Jonsson
Xemex
Reisinger House
Cleo Sullivan
Laurie Anderson

Graphis 330

Burdick Group
Rolf Jansson
Rodney Smith
Crispin Porter & Bogusky
Sam Smidt
Eiko Ishioka

Book Design 2

Advertising Annual 2001

Annual Report 7

Poster Annual 2000

Design Annual 2001

New Talent Design Annual 2000

"Caution: don't read this book unless you want to change your life. On the other hand, if you have work published here… pack your bags; you're already on your way."

Interactive Design 1

Corporate Identity 3

Packaging Design 8

Order Graphis on the Web from anywhere in the world: www.graphis.com